FRESH IDEAS IN
INVITATIONS, POSTERS & ANNOUNCEMENTS

GAIL DEIBLER FINKE

NORTH LIGHT BOOKS
CINCINNATI, OHIO

Library of Congress Cataloging-in-Publication Data

Finke, Gail.
 Fresh ideas in invitations, posters, and announcements / by Gail Deibler Finke.
 p. cm.
 Includes index.
 ISBN 0-89134-906-5 (hc. : alk. paper)
 1. Posters—Design. 2. Invitation cards—Design. 3. Birth announcements—Design
4. Business Announcements—Design. I. Title.
NC1810.F56 1998
741.6'7—dc21 98-17937
 CIP

Edited by Kate York
Production edited by Amanda Magoto
Interior designed by Candace Haught
Interior art production by Kathleen DeZarn
Cover designed by Kellie Schroeder

about the author Gail Deibler Finke, a mother of two, writes about graphic and environmental design from her home office in Cincinnati.

acknowledgments No design book can be produced without the hard work of the many designers whose work appears in it, and without the clients who go to them for outstanding design. My profound thanks go to all the people and firms credited here, whose talent and dedication ensured that the recipients of their work felt a part of something special. I hope their works will inspire many more creative and engaging invitations, announcements and posters. Thanks, also, to my editors at North Light Books, who have three times now given me the chance to share with designers and their clients the kind of work that I, as a non-designer, only wish I could do. And finally, thanks to my family. You've taught me that graphic design, like writing, is best when it enhances "real life," not when it's primarily an end in itself.

table of contents

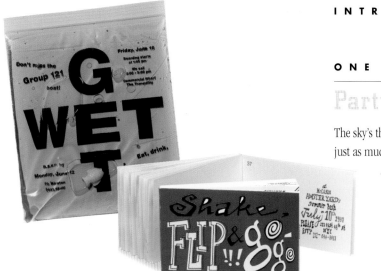

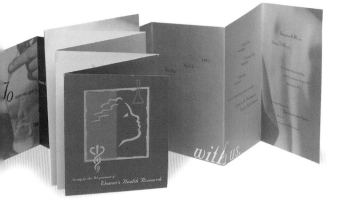

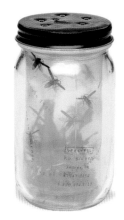

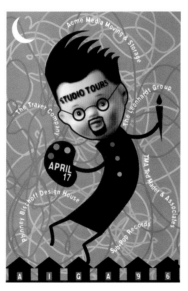

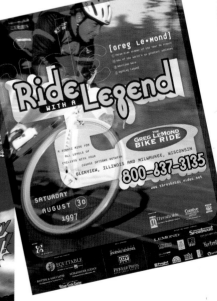

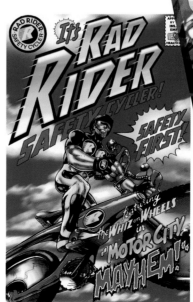

introduction

Invitations, posters and announcements, though they come in different sizes, shapes and materials, all do the same vital job. They deliver the all-important first impression of an event, activity or happening to the unsuspecting masses. It's important that the design created to provide this first impression does it right.

As an art form, posters have been around longer than invitations or announcements. Messages scrawled on the walls of Pompeii qualify as posters, as do the painted murals in ancient buildings and the carved commemorations of battles on ancient monuments. Today, the poster still stops people in their tracks to see what concert they can attend, what political position they can support or protest, what religious festival they can celebrate, or what sport they can cheer.

Written invitations are newer than posters. In the Middle Ages, princes would invite their neighbors to tournaments by sending a gorgeously apparelled herald to speak the invitation in person, provide the rules, answer questions and give gifts. Such invitations were public and entertaining spectacles.

Today, printed invitations still "herald" occasions great and small. The growth of the printing industry has led to many styles of invitations, from the formal wedding invitation with its engraved text, multiple envelopes and small reply cards, to the endless variety of shapes, inks and designs now favored by corporations or nonprofits with money to pay for them.

This creativity is spilling over into the once-staid realm of "traditional" invitations. More and more, people are choosing playful or daring designs for invitations to their weddings, bar mitzvahs, graduations and other social occasions where printing specs were once ruled by etiquette books.

The same is true for announcements. Whether for personal or business use, announcements are jumping beyond the boundaries of the standards offered by specialty printers. New colors and shapes, new design elements such as photography, and even unusual substrates mean that an announcement can take almost any form. Given enough money to spend, new parents can (and do) send out tiny champagne bottles with specially printed labels conveying all the information about their baby's birth, or companies can distribute T-shirts imprinted with a new name or location.

Computers are behind much of the new wealth of design options. While creative typesetting, image layering and photographic elements were once beyond many budgets, thanks to computers they are now part of almost any designer's stock in trade. The proliferation of font houses, the drop in price of stock photography, and the explosion of computerized collections of photographs and line drawings in every style and subject give designers easy and inexpensive access to imagery they could only dream of a decade ago.

All of these design options, however, mean more responsibility for the designer. All design choices are not equal, and much is riding on a poster, invitation or announcement. True, a bizarre wedding invitation isn't likely to mean that no one will come to the ceremony, and a baby announcement that's difficult to read doesn't mean that

relatives and friends will forget the baby's name.

But a poor poster may mean that no one comes to a concert. An invitation to a charity dinner that gives the wrong impression may mean that an organization loses rather than makes money. A flip announcement for a serious event, a serious announcement for a fun gathering, or an inscrutable announcement for anything can mean the target audience for the activity doesn't find out about it.

Despite a new design freedom for this kind of project, anything doesn't go. Designers must ask the same careful questions they would in any design project: Who is the audience? What do they like? Will they be intrigued or put off by something new? What are similar pieces like, and how must this be different? What is the budget?

And it's important for designers and their clients to know when traditional design is best. Using traditional sizes, colors, inks and papers doesn't mean a designer has failed. The traditional look of the block-printed poster, the flowing "wedding" typefaces, and the gleaming raised ink and thick, creamy paper of formal invitations are well-loved and easily understood. For the creative designer, they simply provide a frame to work within, not a straitjacket restricting ideas.

Finally, it's important to remember the short life of invitations, posters and announcements. Like so much of what graphic designers labor to produce, most of these pieces are destined for a life as short as a few seconds—in the case of a party invitation the recipient decides to decline—to a few weeks. Posters are a different story; they're often designed

as keepsakes and sometimes end up as framed art. Ironically, the pieces with the longest life may be the most traditional and graphically uninteresting—wedding invitations, birth announcements and invitations to dances or graduation ceremonies. Framed, stored in albums, or tucked away in boxes of mementos, they become loved reminders of something precious and are often treasured for decades.

It's a little humbling, but also a valuable reminder that in the end the message, not the design, is the most important part of any invitation, poster or announcement. Deliver that message in the right way, and you'll have done your job.

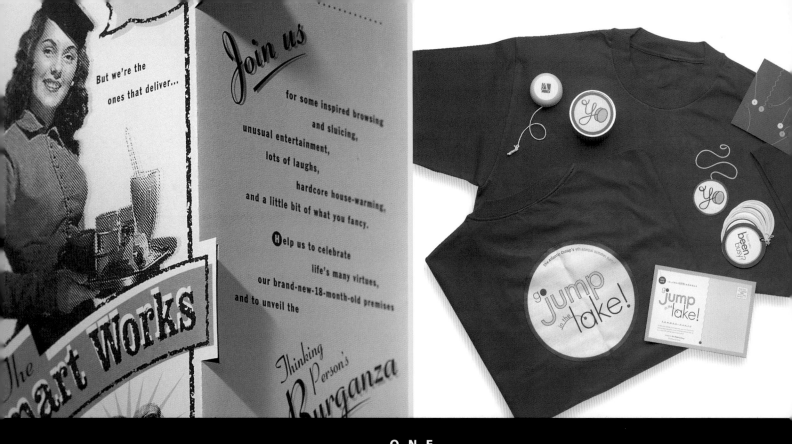

PARTY INVITATIONS

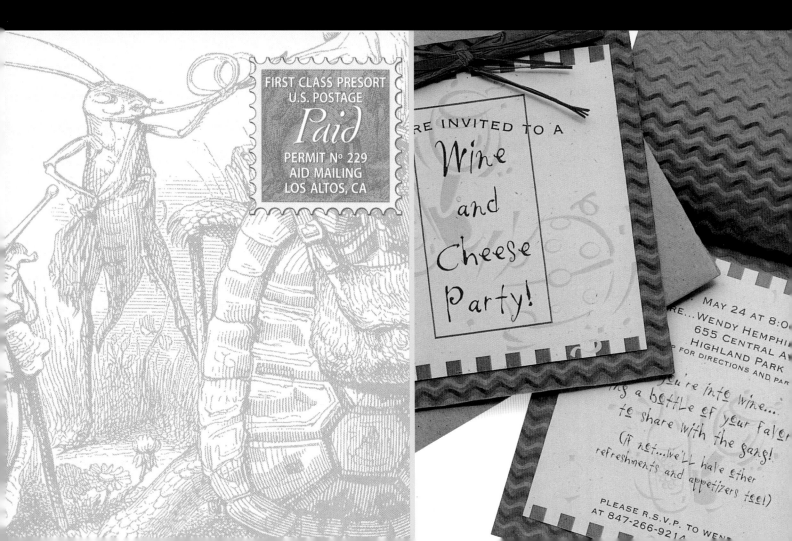

STUDIO Back Yard Design

CLIENT McCann Amster Yard/Advertising agency

DESIGNER Irina Kogan

ILLUSTRATOR Irina Kogan

CREATIVE DIRECTOR Lorna Stovall

TYPE Hand-lettered

PRINTING Fiery and Canon color copies

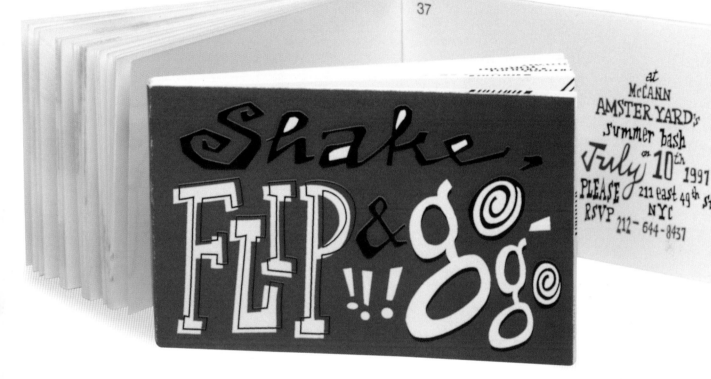

CONCEPT This invitation for an advertising agency party has two themes: 1960s animation (an agency specialty) and alcohol (the business of many clients). Produced on a low budget, the flip book depicts two male hands shaking a martini and pouring the words "your presence is requested." A female hand scoops up the words with a martini glass, revealing the agency name, party location and time.

COST-SAVING TECHNIQUES With no funds for an illustrator, the design firm did the illustrations in-house. The book was printed on a Fiery printer in two colors to simulate two-color printing. The staff then cut, assembled and bound the book.

STUDIO 30sixty design, inc.

CLIENT Self

ART DIRECTOR Henry Vizcarra

DESIGNER Pär Larsson

PAPER Centura 100-lb. (288 g/m²) Dull (ticket jacket), Med Carbonless (ticket), Classic Laid Avon Brilliant White (letterhead)

COLOR Three PMS colors (one metallic), gloss varnish

PRINTING Offset

CONCEPT For the design firm's annual summer party, held at an airport, clients and guests received complimentary "airline tickets" for flight 3060 to an undetermined destination. The designers created a 1930s-style airline logo, used on the tickets, letterhead, workers' T-shirts, signs and a check-in counter at the site. Guests turned in their tickets for the highlight of the party: a free helicopter ride.

COST-SAVING TECHNIQUE Staff assembled the multiple-part ticket.

SPECIAL VISUAL EFFECTS Like real airline tickets, the invitation includes a ticket jacket and a three-part form.

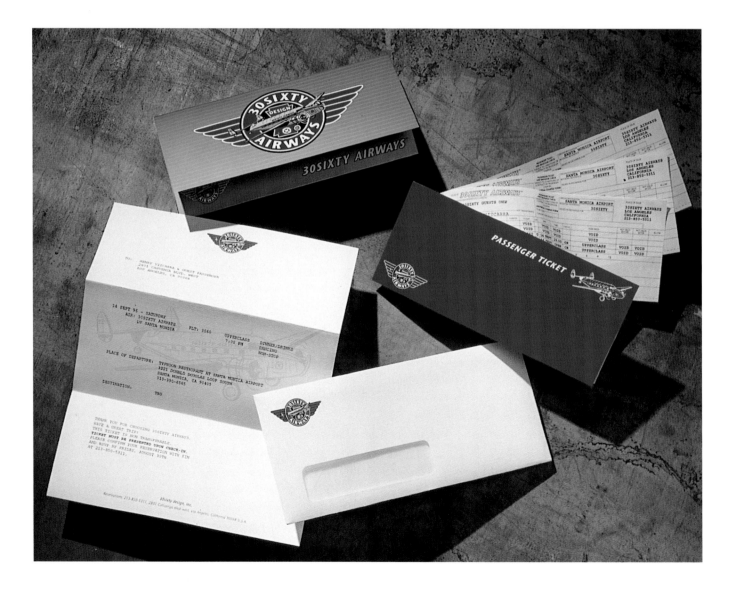

STUDIO Ingalls one to one marketing

CLIENT Self

ART DIRECTOR Emily Gallardo

DESIGNER Emily Gallardo

COPYWRITER Kirsten Bradley

PAPER Clear acetate

TYPE Helvetica Bold and Bold Rounded

COLOR Black

PRINTING Photocopied

CONCEPT For a fun summer outing following a turbulent year, the agency principals decided on a staff boat ride. With no budget, the staff photocopied the invitation on acetate and put the sheets in reclosable plastic bags with water, seashells and plastic fish.

SPECIAL VISUAL EFFECT Blue food coloring gave the tapwater an oceanic look.

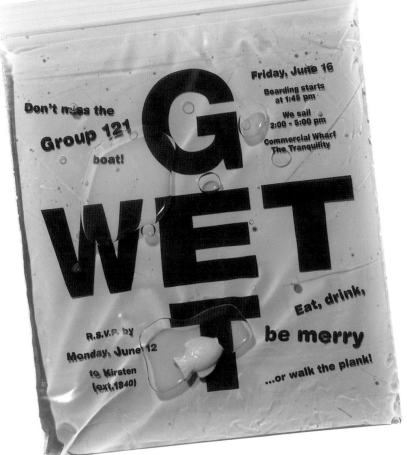

STUDIO Mires Design

CLIENT Self

ART DIRECTOR John Ball

DESIGNERS John Ball, Kathy Carpentier-Moore, Miguel Perez

PHOTOGRAPHER John Johnson

COPYWRITER John Kuraoka

TYPE Franklin Gothic

COLOR Black, one PMS

PRINTING Offset

CONCEPT For a surprise party for the principal's tenth year in business, the design firm staff "messed with his head" on the invitation. Instructions include how to maintain secrecy and where to park without being seen, as well as traditional time, place and response information.

SPECIAL VISUAL EFFECTS The duotones and photo distortion were done in Adobe Photoshop by the staff.

SPECIAL PRODUCTION TECHNIQUE Instead of using colored paper stock, designers printed on white paper with match tan to better produce the highlights and halos.

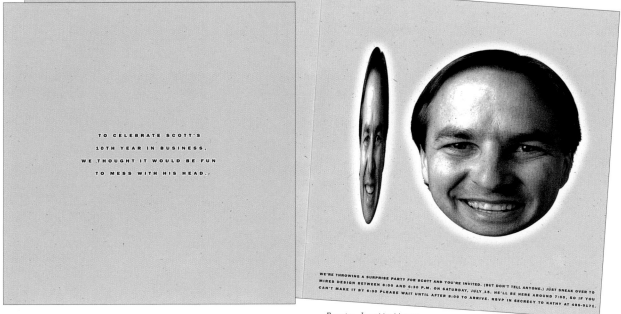

Smart Works Office Party

STUDIO Smart Works Pty. Ltd.

CLIENT Self

ART DIRECTORS Andrea Rutherford, Zan Shadbolt

DESIGNERS Andrea Rutherford, Zan Shadbolt

COPYWRITER John Hindle

PHOTOGRAPHER Photodisc

PAPER Dur-O-Tone Aged

TYPE Ribbon 131, News Gothic Bold

COLOR Three PMS

PRINTING Offset

CONCEPT A fun and retro look for this office party invitation gives clients a glimpse at the firm's light-hearted side. Imagery and copy based on fast food advertising promotions promise even more than "the works" and play on the firm's name. Colored stock and deliberately off-registration printing create the impression of more than three ink colors.

COST-SAVING TECHNIQUE The staff cut and folded all the invitations.

SPECIAL VISUAL EFFECTS The designers used rubber stamps of the two heads to decorate the envelopes and embellished name tags with a rubber stamp of the starburst.

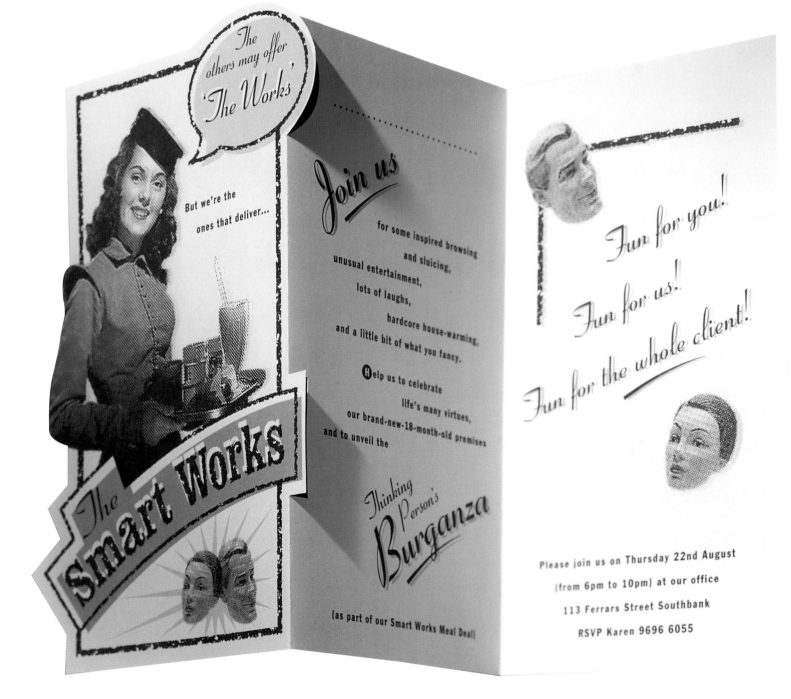

STUDIO The Atlantic Group

CLIENT Self

ART DIRECTOR Laura Bloom

DESIGNER Laura Bloom

ILLUSTRATOR Laura Bloom

PAPER Strathmore Elements Dots

TYPE Futura, Triplex Serif

COLOR Four PMS

PRINTING Offset, Screenprinting

CONCEPT A brightly colored postcard is only the introduction to this multi-media party invitation. Bright purple T-shirts, tied with twine and decorated front and back with the party logo, date and time, provide a wearable memento. The centerpiece is a basic and almost irresistible toy: a yo-yo. Screenprinted with the party logo, each yellow plastic yo-yo comes packaged with a round, die-cut booklet of instructions for yo-yo tricks. Their titles are cleverly incorporated into the invitation copy. Together, the items make up a marketing tool for the agency that displays its personality and provides a tangible example of its creative capabilities.

SPECIAL VISUAL EFFECT Each yo-yo comes packaged in a tin, surrounded by strips of black packing paper and topped with the invitation booklet.

SPECIAL PRODUCTION TECHNIQUE The die-cut invitation pages are bound with a metal grommet. A piece of string tied through it adds to the yo-yo theme.

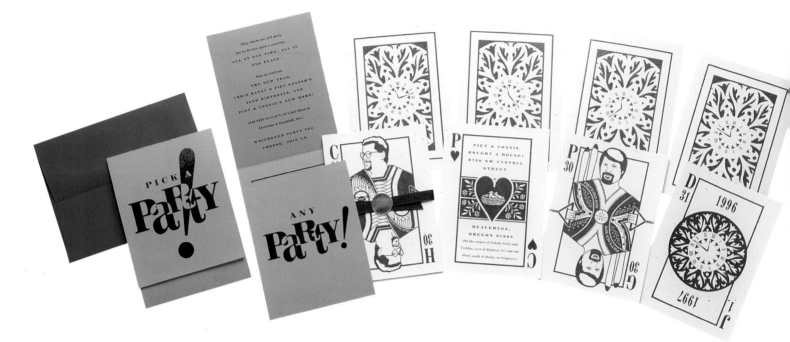

STUDIO Lightner Design

CLIENTS Connie Lightner, Pieter Ganzer, Chris and Lori Haney

ART DIRECTOR Connie Lightner

DESIGNER Connie Lightner

ILLUSTRATOR Connie Lightner

PAPER Fox River Confetti

TYPE Century 725 Family

COLOR Two PMS

PRINTING Thermography

CONCEPT For a party celebrating four occasions — the purchase of the designer's and her husband's first home, two thirtieth birthdays and New Year's Eve — the designer created a pack of cards and invited recipients to "pick a party." The back of each card is printed with a clock face, its hands almost at midnight.

COST-SAVING TECHNIQUE Thermography gives the piece, printed by a quickprinter, a distinctive look at a low price.

SPECIAL VISUAL EFFECTS Three paper colors add visual interest. The cards are sealed with black ribbon and gold foil stickers. The same stickers also seal the envelopes.

STUDIO Wendy Hemphill

CLIENT Self

ART DIRECTOR Wendy Hemphill

DESIGNER Wendy Hemphill

ILLUSTRATOR Wendy Hemphill

PAPER French Speckletone Sand, handmade paper, Kraft

TYPE Copperplate Gothic BT, Bon Guia Regular

COLOR Two PMS

PRINTING Canon color copier

YOU'RE INVITED TO A

Wine and Cheese Party!

MAY 24 AT 8:00 P.M.
...WENDY HEMPHILL'S
655 CENTRAL AVENUE
HIGHLAND PARK
(...P FOR DIRECTIONS AND PARKING)

...u're into wine...
...g a bottle of your favorite
to share with the gang!
(if not...we'll have other
refreshments and appetizers too!)

PLEASE R.S.V.P. TO WENDY
AT 847-266-9214 BY MAY 15

CONCEPT Handmade green paper, imprinted with a wave pattern, is the basis for this invitation to a party at the designer's home. The earthy color palette matches the decor of her loft apartment, while the stylized illustrations and typefaces add a jazzy note. Square Kraft paper envelopes give the piece a distinctive look from the start.

COST-SAVING TECHNIQUES The designer printed the text on a Canon color copier and assembled the invitations herself.

SPECIAL PRODUCTION TECHNIQUE The two-piece invitation is bound with purple raffia.

Mardi Gras Party

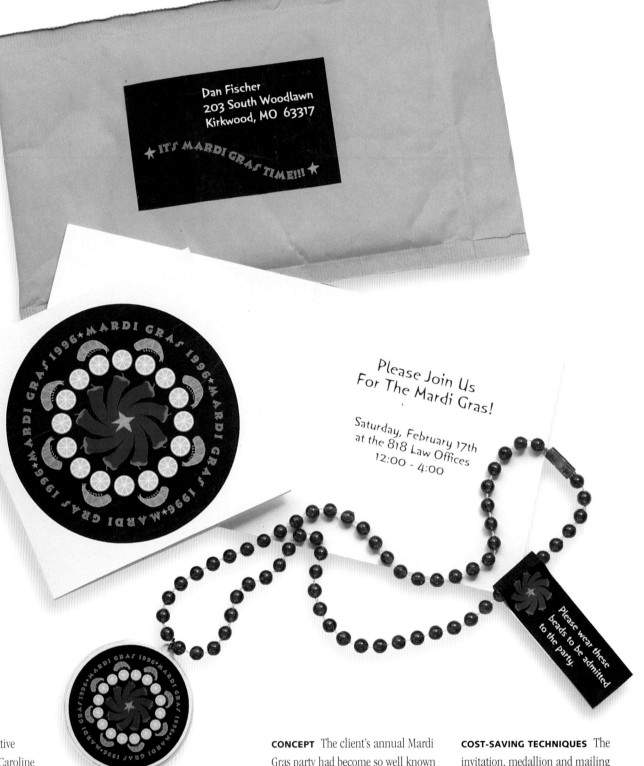

STUDIO Pea Pod Creative

CLIENT Norman and Caroline Wehmer

ART DIRECTOR Heather Speckhard/Pea Pod Creative

DESIGNER Heather Speckhard

ILLUSTRATOR Heather Speckhard

PAPER Bright White 80-lb. (230 g/m²) Cover, Tektronix Coated

TYPE Jazz Poster, Orange Plain

PRINTING Ink jet

CONCEPT The client's annual Mardi Gras party had become so well known that uninvited "crashers" had become a problem. The designer's solution was a token attached to a string of Mardi Gras beads, which would act as both an entrance ticket and a souvenir. The firm printed the small run of sixty pieces on a Tektronix ink jet printer, then cut and assembled the parts by hand. All were wrapped in red tissue paper and mailed in padded envelopes.

COST-SAVING TECHNIQUES The invitation, medallion and mailing labels were printed with a color ink jet printer and assembled by hand.

SPECIAL PRODUCTION TECHNIQUES The invitations are printed on card stock, and the colored medallions are printed on coated Tektronix paper. The designer glued the invitation cover to the card stock, then laminated and cut the medallions by hand and attached them (with an explanatory band) to the beads.

Feelin' frisky?
Come join in the fun. It's a puppy party
Let's celebrate as Megan turns 3

date: Saturday

place

treats

CONCEPT The client requested a dalmatian theme for her birthday party. The designer/mother created the invitations on her computer, assembling and cutting them by hand. Each invitation came with a silver "dog tag" printed with the child's name, and a paper bone with an attached magnet. Both were used for games at the party, where the children enjoyed puppy face paint and assembled their own "dog collars" from string and beads.

COST-SAVING TECHNIQUES The designer printed all pieces on her laser printer, and assembled and cut them herself.

SPECIAL VISUAL EFFECTS A red ribbon attached to the invitation adds color. The twelve invitations were mailed in clear Mylar envelopes (also assembled by the designer), so the recipients would be excited to see what was inside.

STUDIO Uncommon Design
CLIENT Three-year-old Megan
ART DIRECTOR Carla Conway
DESIGNER Carla Conway
ILLUSTRATOR Carla Conway
PAPER Wausau Astrobright Red, Environment Text 80-lb. (230 g/m²) Desert Storm
TYPE Garamond Italic, Helvetica Light
COLOR Black
PRINTING Laser printing

FIRST CLASS PRESORT
U.S. POSTAGE
Paid
PERMIT Nº 229
AID MAILING
LOS ALTOS, CA

Stanford Bachelors
Post Office Box 2345
Stanford, Ca. 94309

THE STANFORD BACHELORS
Kindly request the pleasure of your company for our

Pacific Garden Party

Friday, June 7, 1996
8:00 p.m. until 1:30 a.m.

@Pacific Club
200 Redwood Shores Parkway in Redwood City.

Dancing under the Stars... to...
D.J. Dance Mix · Calypso Dance Band Indoors

Dressy Evening Attire NO HOST BAR ~AGE 21 & OVER

Hors d'oeuvres
from 6:30~9:30 p.m.

Holly St. Exit
from Hwy 101
← to San Jose To San Francisco →
Pacific Club

Thank you for not Smoking!

Gentlemen $25 · Ladies $20 Please Pay at the Door ~ Cash Only
Our Pacific Garden Party at the magnificent Pacific Club will feature outdoor dancing and cocktails under the stars as well as an indoor conversation area. (If by chance the weather is stormy, the party will be limited to indoor areas.)

CONCEPT The client wanted a fun and slightly upscale look for this invitation to a garden party. The designer used an old woodcut illustration of garden insects at a social gathering to create the desired atmosphere. A spidery typeface completes the look.

COST-SAVING TECHNIQUE The inexpensive paper is given an upscale look by printing a different background screen on each side.

STUDIO Shelby Designs & Illustrates
CLIENT Stanford Bachelors
DESIGNER Shelby Putnam Tupper
PAPER Simpson Evergreen 80-lb. (230 g/m²) Cover Natural, vellum
TYPE Fontesque
COLOR Two PMS
PRINTING Offset

STUDIO Ingalls Moranville Advertising

CLIENT Self

DESIGNER Baiba Owens

COPYWRITER Rob Ingalls

PAPER Earthcast Kraft, Light Kraft, Crescent Chipboard Single Ply

TYPE Orator, Golden Cockerel Italic

COLOR Black (laser), blue (stamp)

PRINTING Laser printing, rubber stamp

CONCEPT Inexpensive materials and a surprising form introduce an ambitious summer outing for staff and select friends. Using scrap and low-cost materials, the staff managed to create the run of forty-five invitations for only thirty-three dollars. The fold-down panel, printed on an office laser printer, gives all the details of the whitewater rafting trip, including what to wear and specifics of the terrain. The grainy Kraft paper and chipboard fit the back-to-nature theme.

COST-SAVING TECHNIQUES The firm used leftover paper from other jobs and other low-cost materials, and assembled the pieces themselves.

SPECIAL VISUAL EFFECTS A specially made rubber stamp decorates the front and adds color. A black envelope also adds an unusual touch.

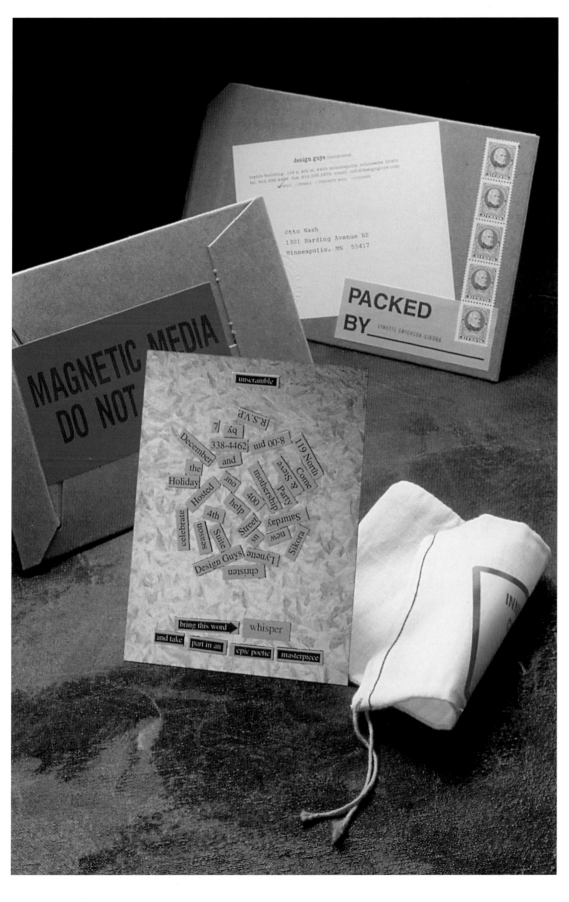

STUDIO Design Guys

CLIENT Self

ART DIRECTOR Lynette Erickson-Sikora

DESIGNERS Lynette Erickson-Sikora, Steven Sikora

MATERIALS Galvanized metal, magnetic stock

TYPE Times Roman

COLOR Black

PRINTING Screenprinting

CONCEPT In order to make their office's grand opening and holiday party invitation stand out from other seasonal greetings, the designers sent out magnetic "puzzles" for recipients to unscramble. Besides being stylish, the galvanized metal "stock" gave guests a preview of the office design. Each guest also received a special magnetic word to use in creating poems at the party. These were not low-budget invitations; each cost $1.60 to mail.

COST-SAVING TECHNIQUES The designers scrambled the messages and assembled the piece's many parts in-house.

SPECIAL VISUAL EFFECTS Invitations were mailed in cloth pouches stamped with the party date. Large red and white stickers asserted that "inner packages comply with prescribed specifications." Official-looking fluorescent warning and label stickers were affixed to the cardboard mailers.

SPECIAL PRODUCTION TECHNIQUE To keep the message from being too difficult to decipher, several key words were left connected after the die cutting.

Laura & Joe's Party

STUDIO Stewart Monderer Design, Inc.

CLIENT Laura and Joe

ART DIRECTOR Stewart Monderer

DESIGNER Jeffrey Gobin

ILLUSTRATOR Jeffrey Gobin

PAPER Mohawk Superfine

TYPE Dizzy, Thingbat

COLOR Two PMS

PRINTING Offset

cordially invited
are
you and a guest
to an evening of

dinner and drink

friendship and fun

from
LAURA & JOE

revelry and cheer

at
LAURA AND JOE'S
ON
MAY 17
at
7:00pm
r.s.v.p. 617-374-9600 extension 337

CONCEPT The client requested something fun, bright and different, with a maximum of two colors. The clients also provided the text. The design challenge of achieving the look of more than two colors was solved by using a 1950s-style overall pattern. The technical challenge was coming up with screen percentages that would work well on the different panels.

COST-SAVING TECHNIQUES The second side was printed in only one color, delivering an upscale look at a small price. Illustrations came from an artwork font.

SPECIAL VISUAL EFFECT The envelope is printed in blue with the pattern and an illustration, giving it a custom look.

SPECIAL PRODUCTION TECHNIQUE The sheet is accordion folded.

STUDIO Gardner Design

CLIENT Goldsmith Office Design

ART DIRECTOR Bill Gardner

DESIGNERS Bill Gardner, Jason Gardner

ILLUSTRATOR Bill Gardner

COPYWRITER Bart Wilcox

PAPER Genesis Cover

TYPE Trixie

COLOR Four-color process

PRINTING Offset, two-color press

CONCEPT To reintroduce its business to customers, the client held a Halloween open house. The accordion-folded invitations contain four Halloween masks, each representing a key area of the client's business: facilities management, installation, move management and space design. Masks are held on the invitation by die-cut tabs. Rhymed copy invites guests to see the new office space through "new eyes."

COST-SAVING TECHNIQUES The entire piece, including masks, was printed in two passes on a small-format two-color press, then die cut. The client's staff inserted the elastic bands in the masks.

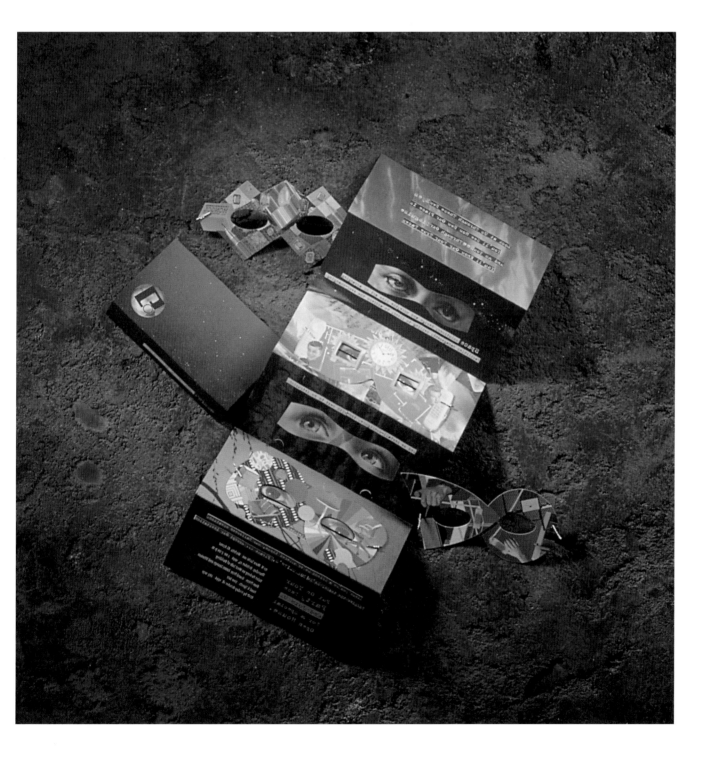

STUDIO Crain Communications

CLIENT Self

DESIGNER Jeannette Gutierrez

CREATIVE DIRECTOR Colleen Robar

PAPER French Speckletone 80-lb. (230 g/m²) Cover Chalk White

TYPE Lithos Black, Nuptial Script

COLOR Three PMS

PRINTING Offset

CONCEPT The illustrations for this accordion-folded invitation, used at four Crain offices in four cities, use vintage advertising art to show an employee headed for the office holiday party at the end of the work day. The art style reflects the company's business, magazine production. Tomato red and celery green are a sophisticated variation on traditional Christmas colors.

SPECIAL PRODUCTION TECHNIQUE The eight hundred cards were printed with match red and green, then distributed to the four offices for office-specific information, printed with the black plate.

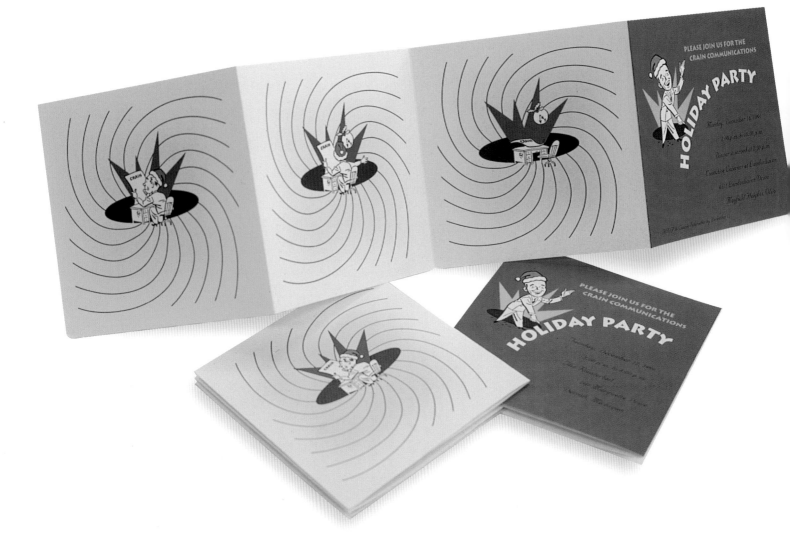

STUDIO Designation Inc.

CLIENT *Entertainment Weekly* magazine

ART DIRECTOR Gail Chen

DESIGNER Mike Quon

ILLUSTRATOR Mike Quon

PAPER 12 Pt. Krome Kote Coated 2/S

TYPE Meta

COLOR Four-color process, varnish

PRINTING Offset

CONCEPT The client requested a fun, eye-catching, one-piece invitation without folds. The two-sided card uses blocks of bright color and a whimsical illustration to suggest holiday fun. Gloss varnish adds to the festive look.

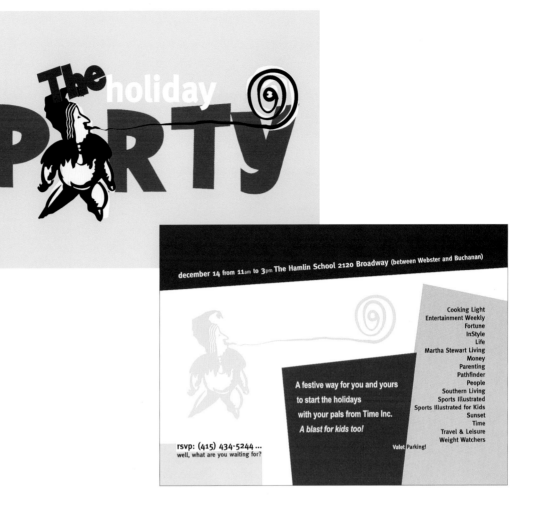

december 14 from 11am to 3pm The Hamlin School 2120 Broadway (between Webster and Buchanan)

Cooking Light
Entertainment Weekly
Fortune
InStyle
Life
Martha Stewart Living
Money
Parenting
Pathfinder
People
Southern Living
Sports Illustrated
Sports Illustrated for Kids
Sunset
Time
Travel & Leisure
Weight Watchers

A festive way for you and yours
to start the holidays
with your pals from Time Inc.
A blast for kids too!

Valet Parking!

rsvp: (415) 434-5244 ...
well, what are you waiting for?

30

Lisa Weston turns thirty this year,
please join us to celebrate Saturday,
September 6, 1997 at 7:30PM.

28 Clayton Street at Fulton
San Francisco

(Parking is available at 2199 Fulton Street at Cole.)

STUDIO Oh Boy, A Design Company

CLIENT Lisa Weston

ART DIRECTOR David Salanitro

DESIGNER David Salanitro

PAPER Bond, gift wrap, vellum

TYPE Minion, Minion Expert

COLOR Two PMS

PRINTING Fiery

CONCEPT This hand-assembled invitation used materials already in the studio, including gift wrap and red ribbon. A vellum envelope adds to the sophisticated look of the piece and reveals the elegant pattern of the gift wrap glued to the cardboard cover. The keepsake invitation resembles a book, complete with ribbon marker.

STUDIO Insight Design Communications/Perfectly Round Productions

CLIENT Self

ART DIRECTORS Sherrie Holdeman, Tracy Holdeman

DESIGNERS/ILLUSTRATORS Sherrie Holdeman, Tracy Holdeman

CREATIVE DIRECTOR/COPYWRITER Bart Wilcox

PAPER Printer's stock

TYPE Hand-drawn

COLOR Black and match metallic gold

PRINTING Offset

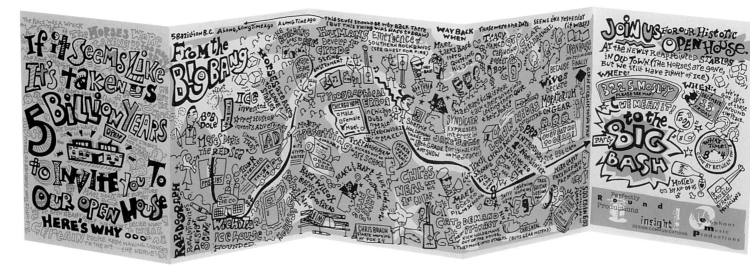

CONCEPT The Stables, a creative cooperative made up of three companies, kept putting off its first open house. When the time came to "do it or forget it," the firms met for a planning brainstorm session. The copywriter suggested an invitation explaining why it had taken so long for the party, and the timeline "from the Big Bang to the Big Bash" was born. Illustrations poke fun at other agencies, studios and friends, as well as at the three businesses.

SPECIAL VISUAL EFFECT Designers used the stamp filter in Adobe Photoshop to give the scanned illustrations a more painterly look.

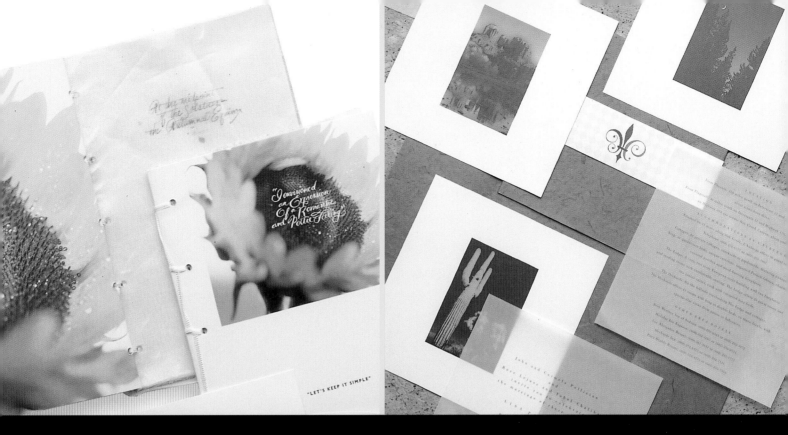

WEDDING INVITATIONS

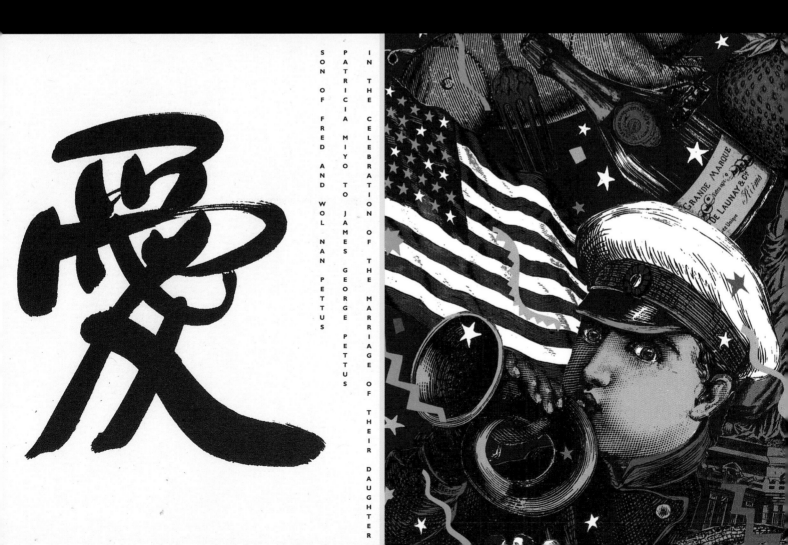

Jane and Bill Smith
113 Ferrars Street
Southbank
Victoria 3006
Australia

andrea and chris request the pleasure
of the company of

Jane and Bill

on the occasion of their marriage
at blakes, southgate
(opposite the foot bridge)
on sunday 31st august 1997 at 3pm
and afterwards to celebrate until 7pm

rsvp 18th august 1997
telephone 9874 4258

no confetti or rice please

STUDIO Andrea Rutherford

CLIENT Andrea Rutherford and Chris Capetanakis

ART DIRECTOR Andrea Rutherford

DESIGNER Andrea Rutherford

ILLUSTRATOR Andrea Rutherford

PAPER Threads Natural, Gilclear Fragments

TYPE Mrs. Eaves

COLOR Black

PRINTING Laser

CONCEPT The simple, child-like drawing of a wedding couple becomes elegant when rendered in copper and combined with two sophisticated papers. The designer produced each invitation separately, allowing her to type each recipient's name on the invitation. This creates an intimate feel, and helps make the handmade cards even more memorable.

COST-SAVING TECHNIQUES Both sheets were paper samples, printed on a laser printer and assembled by hand. The only expenses were the copper sheet and the copper-colored envelopes.

SPECIAL PRODUCTION TECHNIQUES The designer drew each stick figure couple by hand on the back side of the copper sheet, then cut and glued them to the heavy, velvety white card stock.

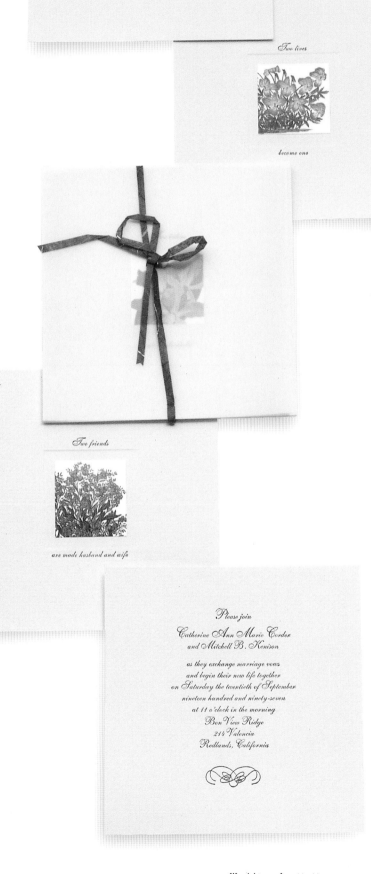

STUDIO A-Hill Design

CLIENT Mitch and Cathy Kenison

ART DIRECTOR Sandy Hill

DESIGNER Emma Roberts

PAPER Strathmore Grandee, Classic Crest, Gilclear

TYPE Shelley Allegro Script

COLOR Four-color process, black

PRINTING Offset, Letterpress

CONCEPT A wedding gift from the design firm to a customer, this invitation cuts no corners. The five textured paper cards, protected by a vellum sheet, include three miniature botanical prints suitable for framing. The classic text is printed in black on a letterpress. The hand-assembled package ties with a red paper ribbon.

SPECIAL PRODUCTION TECHNIQUE Each four-color print rests in a debossed square frame, adding to the piece's understated elegance.

Tupper Wedding Suite

STUDIO Shelby Designs & Illustrates
CLIENT Dr. and Mrs. Jack W. Tupper
DESIGNER Shelby Putnam Tupper
ILLUSTRATOR Shelby Putnam Tupper
PAPER Champion Benefit, Hopper Proterra, Arches Natural, Pastelle
TYPE Centaur, Chanson d'Amour
COLOR Various PMS, metallics
PRINTING Offset, Letterpress

CONCEPT The anchor for the many pieces in this set of invitation, announcement and thank-you cards is a pattern of maple leaves and seeds, sentimental symbols for the bride and groom. Printed on some of the pieces and embossed on others, it provides continuity to the eclectic collection of pieces.

COST-SAVING TECHNIQUE All envelopes are embossed with the same maple seed image and are printed with the appropriate names and addresses.

SPECIAL VISUAL EFFECT The unusual combination of green and purple inks with dark and off-white papers adds interest and a contemporary look.

SPECIAL PRODUCTION TECHNIQUES The square announcement envelopes are die cut in a custom shape. The envelopes are sealed with square stickers printed in purple and metallic copper.

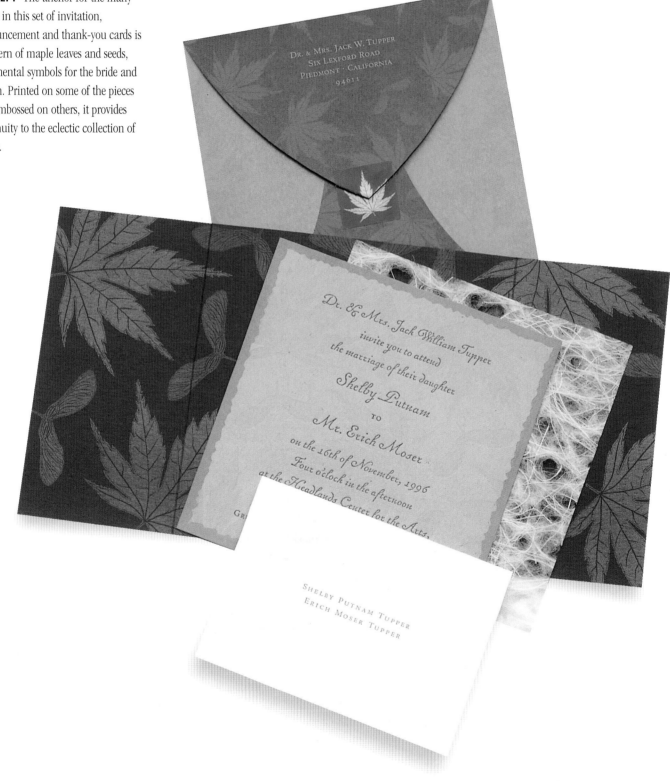

Dr. & Mrs. Jack W. Tupper
Six Lexford Road
Piedmont · California
94611

Dr. & Mrs. Jack William Tupper
invite you to attend
the marriage of their daughter
Shelby-Putnam
TO
Mr. Erich Moser
on the 16th of November, 1996
Four o'clock in the afternoon
at the Headlands Center for the Arts,

Shelby Putnam Tupper
Erich Moser Tupper

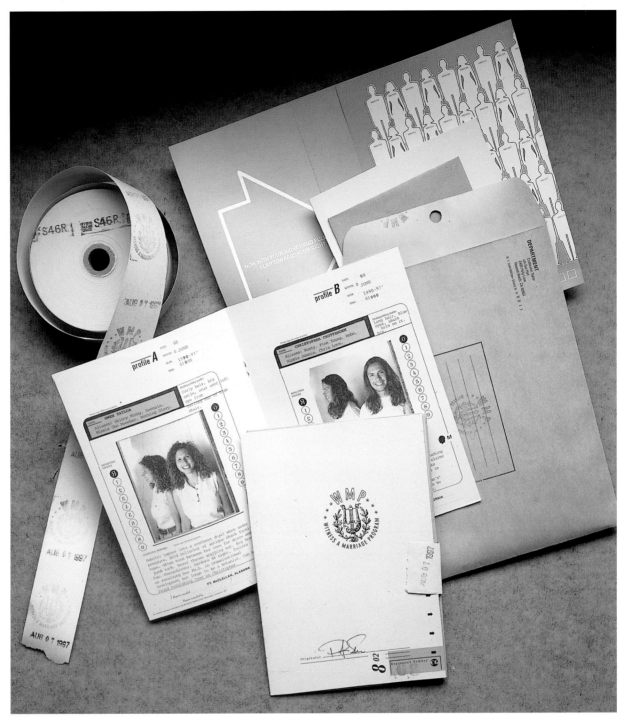

STUDIO Labbé Design Co.

CLIENT Chris and Gwen Cruttenden

ART DIRECTOR Jeff Labbé

DESIGNERS Jeff Labbé, Chris D'Amico

ILLUSTRATOR Jeff Labbé

PHOTOGRAPHER Peter Samuals

COPYWRITER Chris Cruttenden

PAPER French Newsprint White, Cement Green and Recycled White

TYPE BeLucian, Trade Gothic, Courier, Machine

COLOR One PMS, black

PRINTING Offset

CONCEPT The designer, a friend of the couple, worked with the groom (a copywriter) to create a memorable piece that would both emphasize the importance of wedding guests and get as many of the recipients to respond and attend as possible. The official-looking booklet from the fictional "Witness a Marriage Program Committee" includes a test to see if recipients have the "exceptional" qualities needed to be witnesses. The booklet also includes photos and profiles of the wedding couple, a chart of "witness positions," time and location information and a governmental-looking reply form and envelope. Rubber stamps, red ink and penciled comments complete the look. More than 90 percent of the recipients came.

COST-SAVING TECHNIQUE The wedding couple tipped in the perforated, trifold response sheet.

SPECIAL PRODUCTION TECHNIQUE Custom rubber stamps add to the illusion of a government agency.

STUDIO Brown Design

CLIENT George A. Brown and Glenda R. Westmoreland

ART DIRECTOR George A. Brown

WRITER Glenda R. Westmoreland

PAPER Glama Natural, Strathmore Renewal

TYPE DearJohn, Berkeley, ITC Stone Sans

COLOR Two PMS metallics

PRINTING Offset

CONCEPT The short, evocative quotation ("Two souls with but a single thought, two hearts that beat as one") provided the inspiration for this announcement and thank-you card set. For the announcement, three overlapping sheets of vellum each contain parts of the quote, the words "two" and "one," and the couple's address. The vellum sheets were backed by a sheet of card stock printed with a Renaissance-style pattern and the announcement, and were mailed with dried flower petals from the wedding. The thank-you notes were similarly constructed and mailed with confetti made from wrapping paper from the wedding gifts. Both cards were mailed in inner vellum envelopes inside plain white envelopes printed with the return address.

COST-SAVING TECHNIQUE Printing was donated.

SPECIAL VISUAL EFFECT The typeface DearJohn was essential in creating an interactive effect with the broken letters and vellum sheets.

STUDIO Shapiro Design Associates Inc.

CLIENT Halina and Boris Rubinstein, Rachel Rubinstein and Justin Cammy

DESIGNER Ellen Shapiro

ILLUSTRATORS Betty Ng, Alex Acker, Ellen Shapiro

PAPER Vicksburg Starwhite 100-lb. (288 g/m²) Tiara Text, Cross Pointe Genesis Rose

TYPE Party, Bergamo, Petrucci music notation

COLOR One PMS, black

PRINTING Offset

CONCEPT Two families, from Mexico City and Ottawa, plus friends from around the United States — a total of three hundred guests — were invited to a New Rochelle, New York wedding. The bride's family planned an elaborate weekend of activities, and the designer, a family friend, created an accordion-folded invitation to show the weekend "unfolding." The rosy brown-and-white color scheme matches the formal engraved invitations. A matching booklet explained Jewish wedding ceremony rituals to the many non-Jewish guests.

COST-SAVING TECHNIQUES To hold down costs the designer used icons developed for other projects, chose paper the printer had left over from another job and picked in-stock envelopes from the paper supplier. Printing was provided at cost.

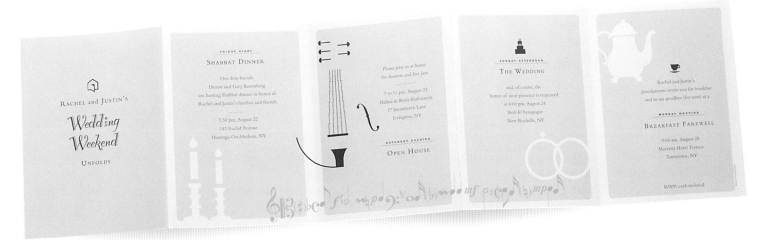

Harvin Wedding

STUDIO Jendras Design

CLIENT Doug Harvin and Judy Jendras

ART DIRECTOR Jendras Design

DESIGNER Judi Jendras

ILLUSTRATOR Mary Lempa/Flock Illustration

PAPER Swiss Clear (envelopes), SihlClear 101-lb. (291 g/m²) (invitation), Crain's Old Money Mint (map)

TYPE Sabon Roman SC, Sabon Italic, Carpenter

COLOR Two PMS

PRINTING Offset

CONCEPT The woodcut illustrations and freeform typesetting add a casual note to the formality of the typefaces and text of this invitation. They form a pleasant balance, reflecting the spirit of the event.

SPECIAL VISUAL EFFECT The translucent paper, chosen partly because of its availability in small quantities, creates a watery effect that complements the illustrations.

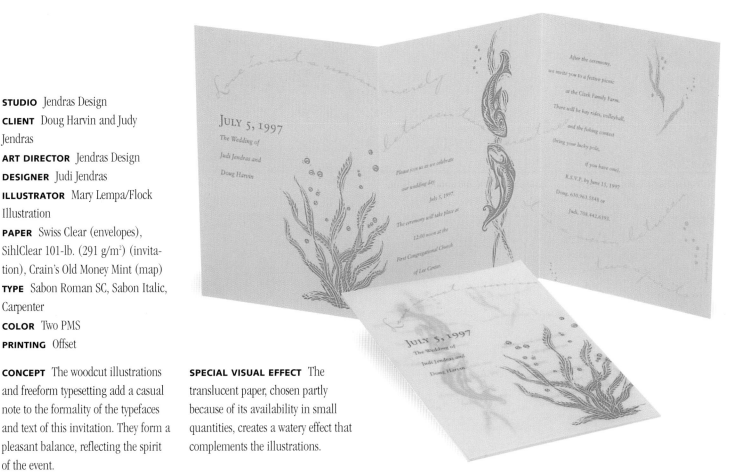

James & Patricia's Wedding

STUDIO Keiler & Co.

CLIENT The Pettus and Tam Lung Families

ART DIRECTORS James Pettus, Patricia Tam Lung

DESIGNERS James Pettus, Patricia Tam Lung

ILLUSTRATOR James Pettus

CREATIVE CONSULTANTS Miyoko Sasaki and Daniel Tam Lung, Fred and Wol Nan Pettus

PAPER Simpson Equinox, Spring Mist Cover

TYPE Gill Sans

COLOR PMS gold, black

PRINTING Offset

CONCEPT This elegant, trifold card mixes Eastern and Western traditions with elements from Chinese, Japanese, Korean and English cultures. Two Biblical quotations create a Christian framework, while the central character (love) gives an Eastern focus. The formal text on the right is set vertically and read right to left, like Japanese characters. Humorous directions on the back guide wedding guests from Connecticut, where the couple lives, to the wedding site in California.

SPECIAL PRODUCTION TECHNIQUE
The red seal, or "hanko," was stamped by hand, adding a third color.

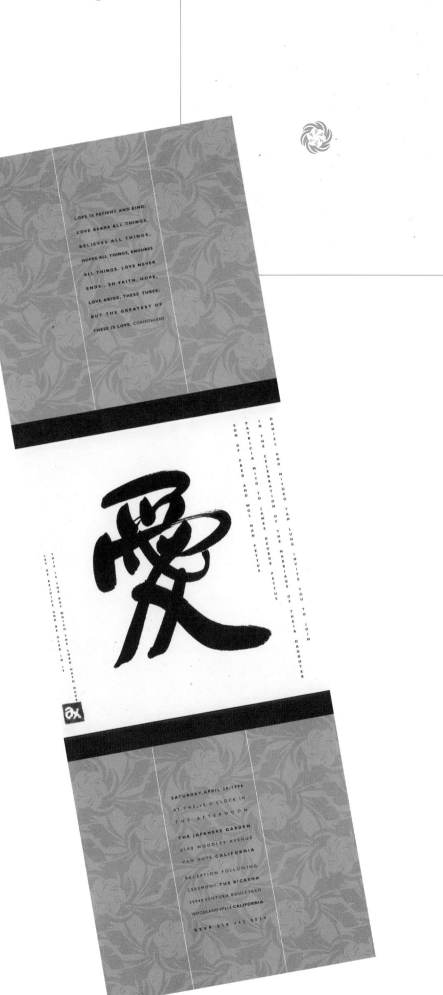

STUDIO Sibley/Peteet Design

CLIENT Pierre and Lisa Chaliha

ART DIRECTOR David Beck

DESIGNER David Beck

ILLUSTRATOR David Beck

PHOTOGRAPHER Gary McCoy

PAPER Mohawk Superfine, Canson Satin

TYPE Bodoni Book

COLOR Four PMS

PRINTING Offset

CONCEPT The textured, rust-colored paper acts as a portfolio for the invitation: a series of square vellum sheets printed with the text, backed by dramatic photographs of the Arizona desert printed on card stock. Whimsical illustrations printed in off-white and diamond-patterned backs of the photo cards reflect the wedding site, a French-style inn in Sedona, Arizona.

SPECIAL PRODUCTION TECHNIQUE For greater depth and clarity, the photographs were printed as duotones.

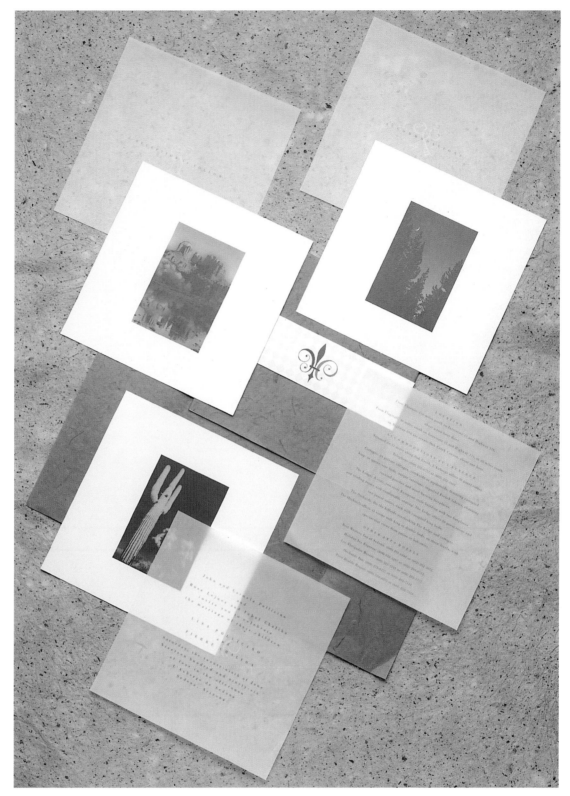

Tina & Bennett's Wedding

STUDIO Sibley/Peteet Design

CLIENT Tina Smith

ART DIRECTOR John Evans

DESIGNER John Evans

ILLUSTRATOR John Evans

PAPER Simpson

TYPE Antique Engraved

COLOR Four-color process

PRINTING Offset

CONCEPT Tradition gets a twist in this invitation booklet, decorated with nineteenth-century woodcuts and lettered in old-fashioned type. Guests to the July 3 wedding are promised something old, something new, something borrowed, and something "red, white and blue." The post-wedding barbecue bash, the invitation promises, will be "something else."

SPECIAL VISUAL EFFECT Garish colors and an energy-filled collage of vintage woodcuts create a real Fourth of July surprise, effectively communicating the wedding's casual atmosphere.

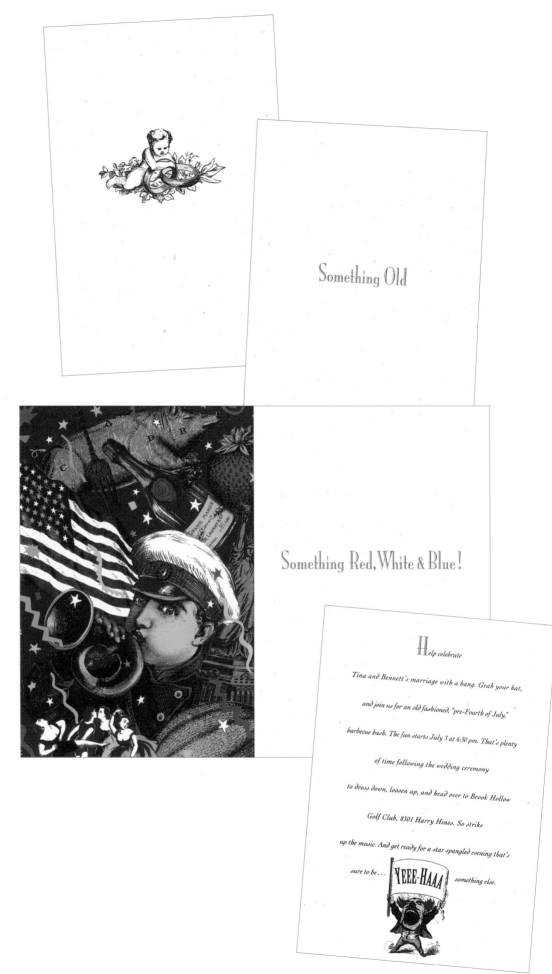

Something Old

Something Red, White & Blue!

Help celebrate

Tina and Bennett's marriage with a bang. Grab your hat, and join us for an old fashioned, "pre-Fourth of July," barbecue bash. The fun starts July 3 at 6:30 pm. That's plenty of time following the wedding ceremony to dress down, loosen up, and head over to Brook Hollow Golf Club, 8301 Harry Hines. So strike up the music. And get ready for a star spangled evening that's sure to be... YEEE-HAAA something else.

STUDIO Pollard Creative

CLIENT Jake Pollard, Melanie Bass

ART DIRECTORS Pollard Creative, Bass Designs

DESIGNER Melanie Bass Pollard

ILLUSTRATOR Melanie Bass Pollard

PHOTOGRAPHER Jerry Burns

COPYWRITER/CONCEPT Jake Pollard

PRODUCTION MANAGER Laura Perlee

PAPER Karma

TYPE Futura, Hand-lettering

COLOR Four-color process

PRINTING Offset

CONCEPT Celebrating the very different personalities of the designer/bride and copywriter/groom, this invitation booklet manages to be both ornate and spare, flowery and simple, poetic and declarative. The "bride's half" includes soft images and romantic calligraphy. The "groom's half" keeps to black sans serif type and white space. The result is both amusing and touching. A thank-you note repeats the theme.

COST-SAVING TECHNIQUE Photography and printing were donated.

SPECIAL VISUAL EFFECT The bride did the calligraphy, using a paper stock that allowed the ink to bleed for a soft, romantic look.

SPECIAL PRODUCTION TECHNIQUES Low-resolution scans of the calligraphy softened it even more. The booklets are bound with white ribbon, with gold mesh fabric for fly-leaves. A hand-cut pocket in the back holds a card, also bound with white ribbon, containing a map and directions to the site.

David and Yolanda's Wedding

STUDIO David Lomeli

CLIENT Self

DESIGNER David Lomeli

PAPER Teton Cover Warm White

TYPE Matrix Script Regular, Book and Bold

COLOR One PMS

PRINTING Letterpress

CONCEPT As the recipients remove the leather straps from this gatefold invitation, the wedding couple "opens their hearts." The designer chose the heart motif as a sacred symbol of love and life. The two small crows flanking the invitation copy symbolize the crows that circled in the air when the designer proposed.

SPECIAL VISUAL TECHNIQUE Rather than an afterthought, the reply card and map are an integral part of the piece. They cover the invitation text and are themselves covered by a sheet of textured paper and bound with a purple mesh fabric ribbon. Only after these pieces are admired and removed can the recipient see the invitation.

SPECIAL PRODUCTION TECHNIQUES To emphasize the heart image, the designer had an ancient Mexican icon of the sun (repeated inside) debossed behind the heart image. The leather straps crossing over the heart, inserted through hand-cut rectangles, reinforce the idea that the heart is precious and sacred, like the wedding itself.

STUDIO Scott Thares Design

CLIENT Anna Weber, Scott Thares

ART DIRECTORS Scott Thares, Anna Weber

DESIGNER Scott Thares

ILLUSTRATORS Scott Thares, Anna Weber

PHOTOGRAPHER Scott Thares

COPYWRITER Anna Weber

PAPER French Parchtone White, blotter paper

TYPE Garamond, News Gothic, Fink Roman

COLOR One metallic PMS, black

PRINTING Offset

CONCEPT The bride and groom wanted an invitation that reflected their quirky humor while remaining sophisticated and elegant. The wedding was in the spring, so a blossoming flower and ladybug, a symbol of luck, were chosen to grace the cover. The inside story captures the magic, joy and celebration of the wedding.

COST-SAVING TECHNIQUES Each invitation has a one-of-a-kind, hand-drawn flower on the cover with a tipped in illustration. The inside shows head shots of the couple that were hand-applied onto illustrated figures. The invitation was hand-assembled. Invitations, programs, thank-you cards and response cards were ganged on press.

SPECIAL VISUAL EFFECT Tipped-in photos and illustrations were used on the cover and inside.

SPECIAL PRODUCTION TECHNIQUES Debossing the cover and duotoning photos using metallic ink and black added interest.

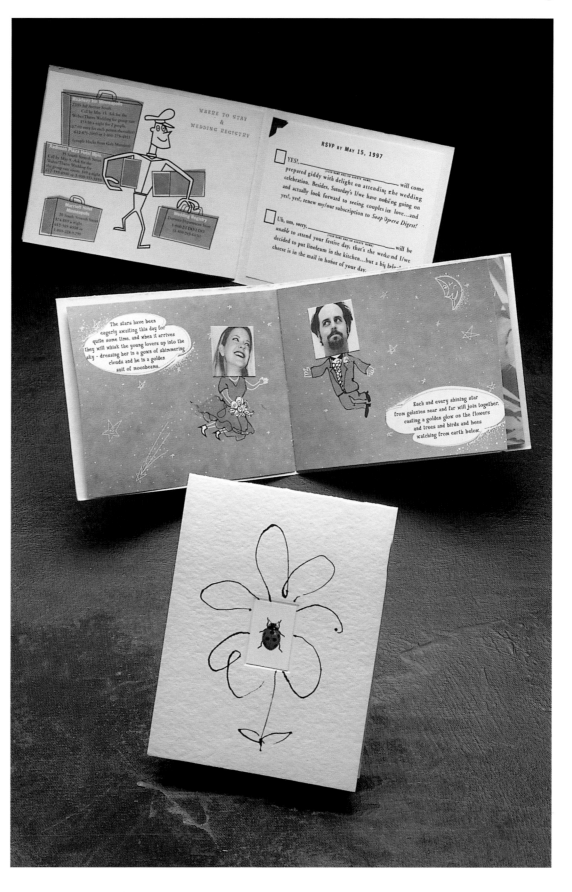

United

STUDIO Ellen Kendrick Creative, Inc.

CLIENT Ellen Spalding, Michael Storeim

ART DIRECTOR Ellen Spalding

DESIGNER Ellen Spalding

PHOTOGRAPHER Lee P. Thomas

COPYWRITERS Ellen Spalding, John Spalding

PHOTOSHOP EFFECTS Jerri Self

PAPER Potlatch Quintessence 65-lb. (187 g/m²) Dull Cover

TYPE Weiss

COLOR Three PMS metallics, black

PRINTING Offset

CONCEPT The bride and groom's long-distance courtship was the inspiration for this piece, which makes a pun on the word "united" and the saying "love is in the air." The long narrow shape of the invitation and its rounded corners suggest the shape of an airline ticket, further reinforcing the pun.

COST-SAVING TECHNIQUES Photography and pre-press were donated, as was part of the printing cost.

SPECIAL VISUAL EFFECTS Photographic effects, some created with the camera and others with Adobe Photoshop, are integral to this piece. All of the photos were retouched to create a sense of motion matching the invitation's "high flying" copy. The airline tickets on the cover were also retouched, because United Airlines does not actually offer direct flights between Lexington and Denver. The invitation was mailed in a translucent vellum envelope that revealed the back, printed with clouds.

After four years
of getting United
to see each other

We've decided to
see each other forever
by getting united

Love, as they say, is in the air

STUDIO Lightner Design

CLIENT Connie Lightner and Pieter Ganzer

ART DIRECTOR Connie Lightner

DESIGNER Connie Lightner

PHOTOGRAPHERS Family and friends

PAPER Classic Crest Sawgrass, B/W Riblaid Eggplant, UV Ultra

TYPE Trajan, Vivaldi

COLOR Two PMS

PRINTING Offset

CONCEPT The saying "life is a journey" was the inspiration for this small wedding booklet, bound in a purple die-cut cover tied with a matching fabric ribbon. Printed in metallic ink on uncoated stock for a subtle sheen, the book unfolds to reveal a short text about life, friends and love, ending in the formal invitation. Photographs of the couple and a subtle background pattern listing events in their lives, end with a short pueblo prayer facing the perforated response card. A gold seal is printed with the couple's initials and a design representing two roads joining together.

COST-SAVING TECHNIQUE The seals, used on both the invitation and envelopes, were printed on a Tektronix color printer.

SPECIAL PRODUCTION TECHNIQUES Envelopes are hand-folded vellum. The die-cut cover complements the curving roads depicted on the seals.

STUDIO Nancy Yeasting Design

CLIENT Michael and Amanda Ho

ART DIRECTOR Nancy Yeasting

DESIGNER Nancy Yeasting

ILLUSTRATOR Nancy Yeasting

RIBBONS AND HAND BINDING DESIGN Amanda Ho

PAPER Neenah Environment Moonrock Wove Cover

TYPE Liberty, Matrix Script, Manson, Minion Ornaments, Arbitrary Sans, Metro

COLOR Two PMS

PRINTING Offset, laser printing

CONCEPT This extensive, bilingual wedding package includes separate wedding and wedding banquet invitations and response cards, a program, a map card, bookmarks, favor tags, thank-you cards, menu cards and two business cards. The classic look marries two cultures and languages with enough variety for some pieces to be strictly formal and others to add a little casual humor. Every attempt was made to hold down costs while creating a print extravaganza.

COST-SAVING TECHNIQUES Design and production were donated. All items were gang-printed on two forms. Invitations were sent in plain envelopes, and reply cards were self-mailers. Business cards and stand-up table cards were printed on printer's stock. Vellum sheets for menus were laser printed and bound in commercially printed covers. The bride's family and friends assembled and bound all pieces.

SPECIAL VISUAL EFFECT Plum-colored fabric ribbons added another texture to the printed pieces.

SPECIAL PRODUCTION TECHNIQUES Chocolate favors were decorated with paper tags, decoratively cut with special shears. To fit all the pieces on two sheets while using art with bleeds, the designer created film with only ¼" between trim marks.

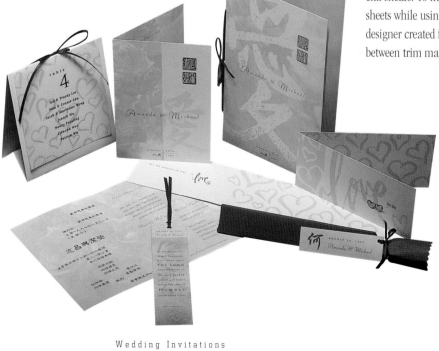

Winnick Wedding

STUDIO Fullburner Design

CLIENT Barbara Jones and
Andrew Winnick

ART DIRECTORS Kurt Thesing,
Gene Valle

DESIGNERS Kurt Thesing, Gene Valle

COPYWRITER Barbara Jones

PAPER Strathmore, Gilbert Gilclear

TYPE Universe Condensed Bold,
Caslon 540

COLOR Three PMS

PRINTING Offset

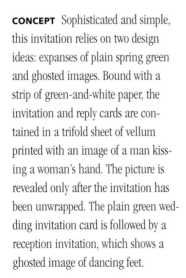

CONCEPT Sophisticated and simple, this invitation relies on two design ideas: expanses of plain spring green and ghosted images. Bound with a strip of green-and-white paper, the invitation and reply cards are contained in a trifold sheet of vellum printed with an image of a man kissing a woman's hand. The picture is revealed only after the invitation has been unwrapped. The plain green wedding invitation card is followed by a reception invitation, which shows a ghosted image of dancing feet.

SPECIAL PRODUCTION TECHNIQUE
The rectangles holding invitation and reply information were debossed for a subtle, elegant effect.

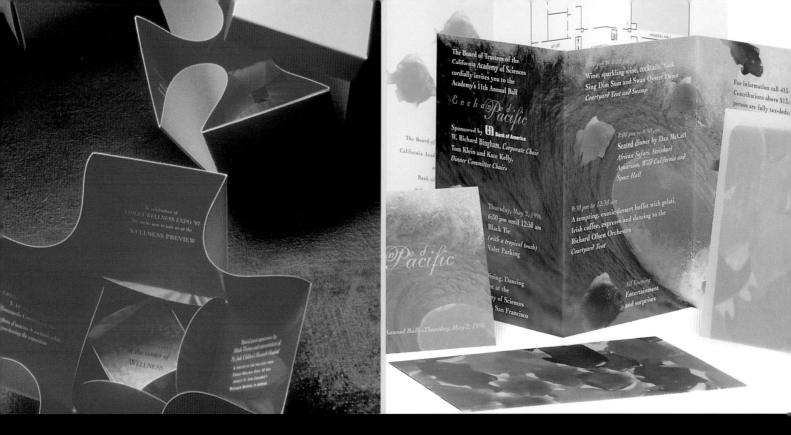

NONPROFIT AND FUNDRAISING INVITATIONS

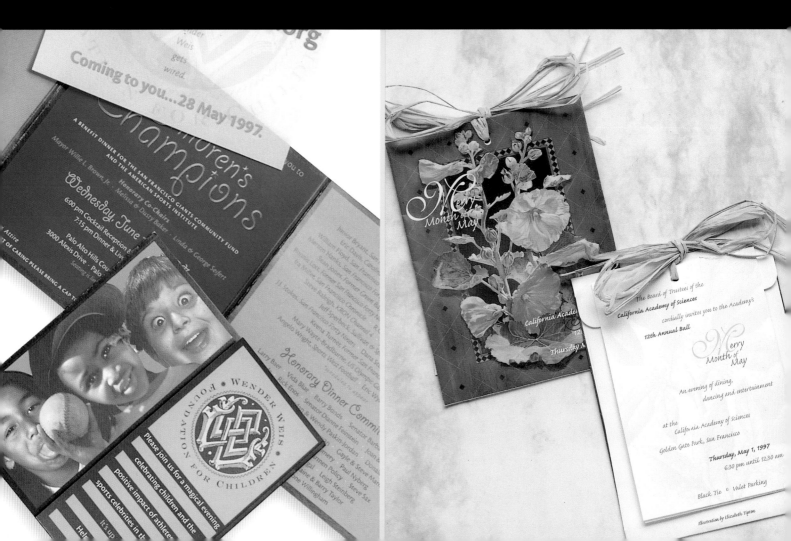

AIDS Walk Poster and Invitation

STUDIO Vaughn Wedeen Creative

CLIENT New Mexico AIDS Services

ART DIRECTOR Steve Wedeen

DESIGNER Steve Wedeen

PHOTOGRAPHER Julie Dean

COMPUTER PRODUCTION Adabel Kaskiewicz

PAPER Speckletone Kraft

TYPE Trade Gothic, Letter Gothic

COLOR Three PMS

PRINTING Offset

CONCEPT Printed on speckled Kraft paper, these pieces use naive imagery and a typewriter font to create a hand-made look that invites ordinary people to get involved in a cause. The brown paper calls attention to itself, while the tennis shoes and red ribbon sum up the event in one succinct image. Invitation copy urges people to "have a heart, walk the walk."

COST-SAVING TECHNIQUE Design and printing were donated.

SPECIAL PRODUCTION TECHNIQUE White underprinting beneath the tennis shoe image adds dimension.

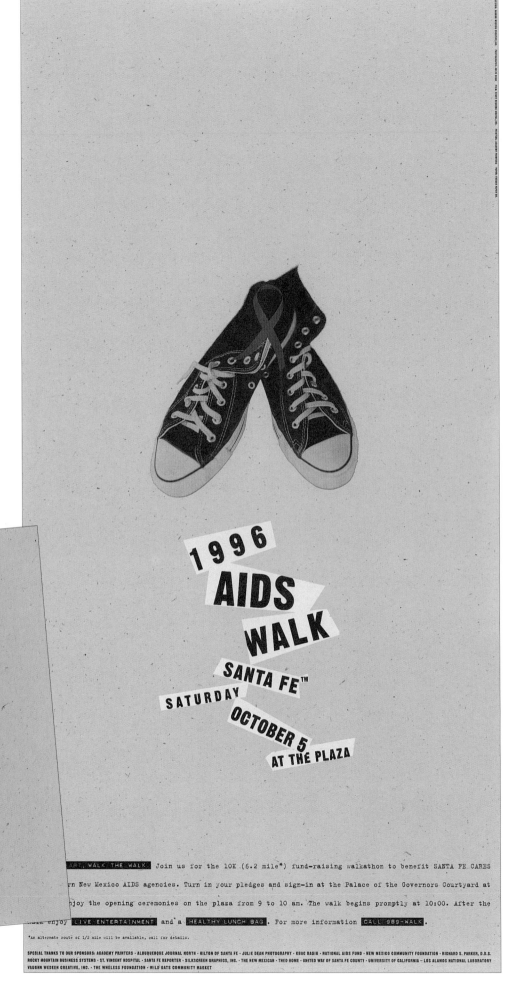

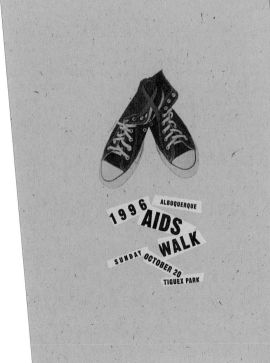

STUDIO Kiku Obata & Co.

CLIENT California Academy of Sciences

ART DIRECTOR Amy Knopf

DESIGNER Amy Knopf

ILLUSTRATOR Elizabeth Tipton

PAPER Mohawk Superfine (cards), Consort Royal Silk (seed packet)

TYPE Caflisch Script, Triplex

COLOR Two PMS (cards), four-color process (seed packet)

PRINTING Offset

CONCEPT Spring was the inspiration for this four-page invitation for a benefit ball. Each guest received a giant, four-color packet of hollyhock seeds for his or her garden. Tied to it with a raffia bow was the invitation, four sheets of white paper printed with a botanical illustration in spring green ink and lettered in purple script. The same cheerful colors were printed on the response card and its envelope. A coral red envelope drew attention to itself and contrasted with the piece inside.

COST-SAVING TECHNIQUES The artist donated an illustration from her portfolio in exchange for printed samples. The botanical print was from a book of copyright-free images.

SPECIAL PRODUCTION TECHNIQUE The invitation is bound with a raffia bow.

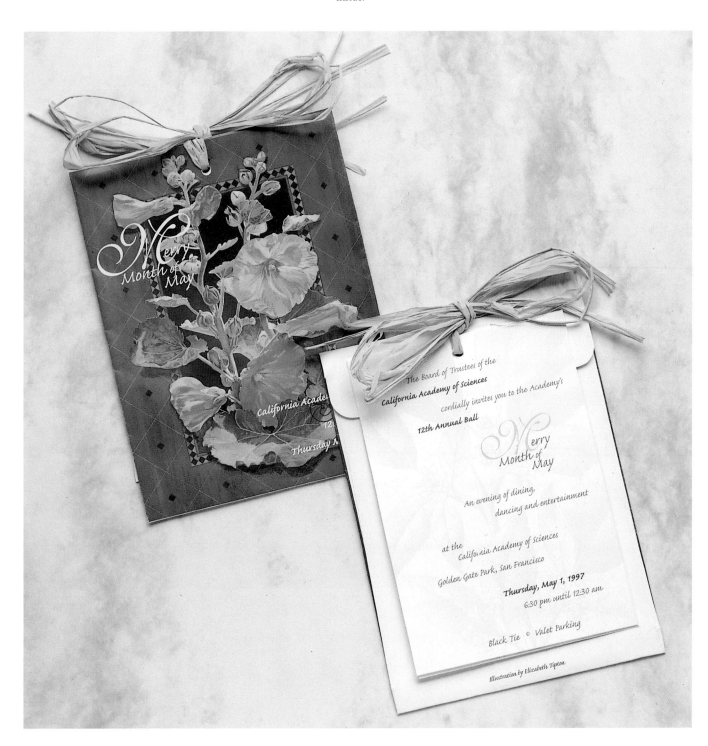

Wellness Expo Gala Invitation

STUDIO Design Guys

CLIENT Target Stores

ART DIRECTOR Steven Sikora

DESIGNER Amy Kirkpatrick

PHOTOGRAPHER Darrell Eager

PAPER Vintage Velvet

TYPE ITC Cheltenham

COLOR Six PMS

PRINTING Offset

CONCEPT The client wanted an invitation that expressed the idea of being healthy, and that could not be turned down. The result was a box that opens like a flower to reveal the event information.

SPECIAL PRODUCTION TECHNIQUE
The same flower image was set up as several different duotone combinations and registered to three die templates.

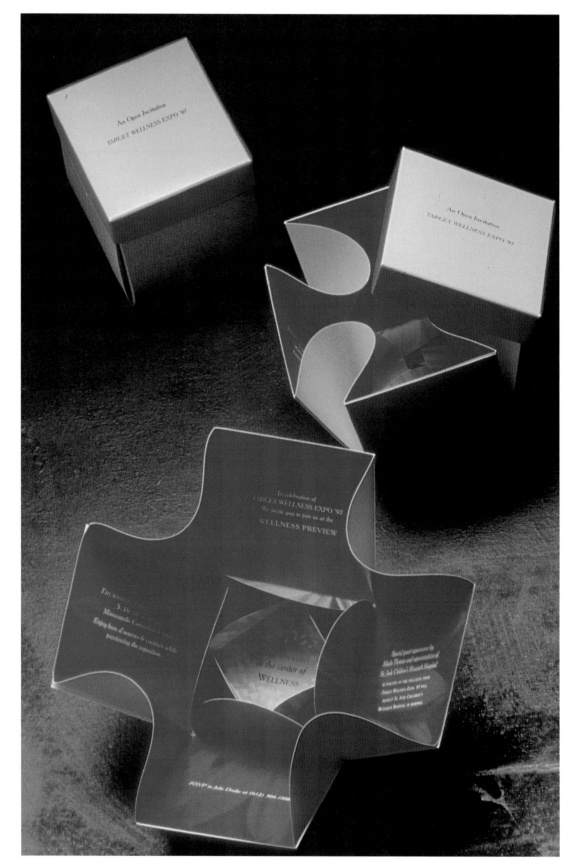

STUDIO Shelby Designs & Illustrates

CLIENT Wender-Weis Foundation for Children

DESIGNER Shelby Putnam Tupper

PAPER Simpson Evergreen White, Matte Coated vellum

TYPE Kronos, Giddyup

COLOR Four-color process

PRINTING Offset

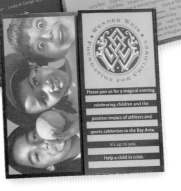

CONCEPT The charity foundation client needed an invitation that would hold many discrete bits of information, and would also be playful and credible. The designer combined photography, the organization's logo and blocks of color in an accordion-folded piece that presented the information in digestible pieces. A matching reply card and a companion vellum sheet announcing the organization's new Web site were mailed in the same envelope.

COST-SAVING TECHNIQUE The blocks of color were printed as process colors rather than match colors.

Outsiders Inside Benefit Invitation

STUDIO Mark Oldach Design, Ltd.

CLIENT Lakefront SRO

ART DIRECTOR Mark Oldach

DESIGNER Guido Mendez

ILLUSTRATOR Guido Mendez

PAPER Neenah Classic Columns

TYPE Syntax, Katfish

COLOR One PMS, black

PRINTING Offset

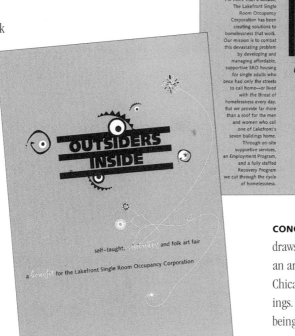

CONCEPT An unusual orange color draws attention to this invitation for an art show and sale benefiting seven Chicago single-room occupancy buildings. The design was inspired by pieces being shown, created by "outsider" folk, and other self-taught artists. Much of the piece's impact comes from creative typesetting. The low-budget project also includes a response card, an exhibit catalog, T-shirts and banners.

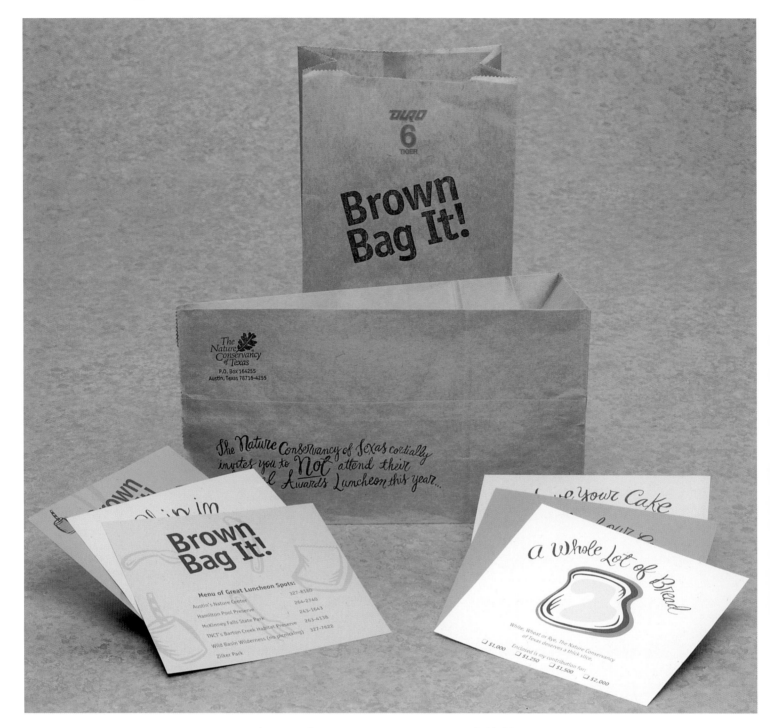

STUDIO Klassen Graphic Designs

CLIENT The Nature Conservancy of Texas

ART DIRECTOR Alison Klassen

DESIGNERS Alison Klassen, Missi Rice

ILLUSTRATOR Missi Rice

CONCEPT AND COPYWRITER Lynn Skinner

PAPER Genesis Text, brown paper bag

TYPE Officina Sans Bold and Normal, Zapf Dingbats, Hand-lettering

COLOR Black

PRINTING Offset

CONCEPT Instead of holding its annual awards and fundraising luncheon, the client, a nonprofit nature conservancy, asked for donations and invited its members to have their own luncheon in an area park or nature preserve. A brown lunch bag holds the "non-invitation," printed in black on five different colors of the same paper stock.

SPECIAL VISUAL EFFECTS Hand-lettering on the bags and donation cards match the casual style of the illustrations. Brown lunch bags were used as mailing envelopes.

STUDIO Sayles Graphic Design

CLIENT Iowa State Fair Blue Ribbon
Foundation

ART DIRECTOR John Sayles

DESIGNER John Sayles

ILLUSTRATOR John Sayles

COPYWRITER Linda Ruble

PAPER Neenah Classic Crest White

TYPE Various

COLOR Three PMS

PRINTING Offset

CONCEPT Named for the Iowa State
Fair's perennial favorite food, the corn
dog, the corn dog kickoff party and
auction began the fair's annual
fundraising campaign. The designer
created a logo featuring a corn dog-
shaped rocket and further used the
image in a poster and invitation.
Bright colors, wood type-style lettering
and old-fashioned imagery recall turn-
of-the-century graphics, but have a
1990s sensibility.

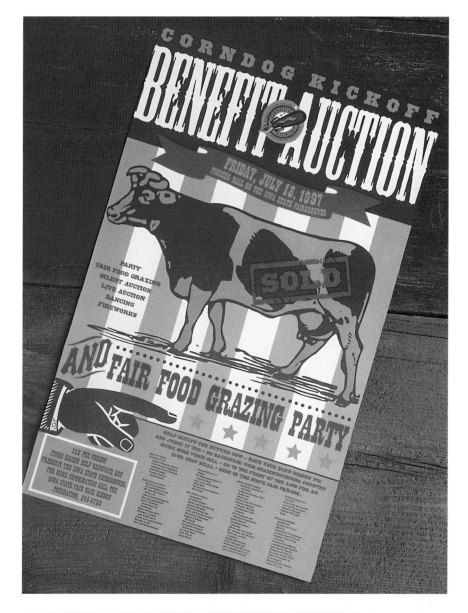

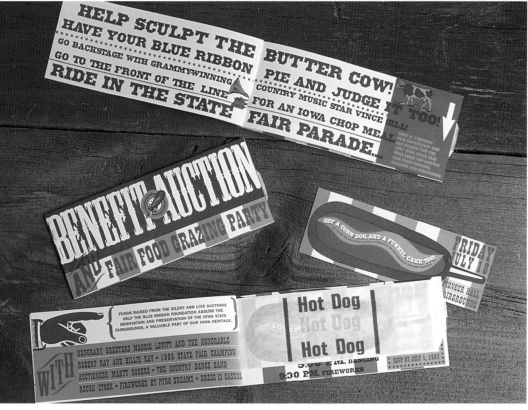

COST-SAVING TECHNIQUE The invi-
tation was mailed in a No. 10 glassine
envelope, an inexpensive stock item
typically used by stamp collectors.

SPECIAL VISUAL EFFECT A cello-
phane hot dog wrapper was bound
into the invitation. The wrapper held
a paper corn dog, a promise of good
food at the party.

art aid 4 life

STUDIO Greteman Group

CLIENT ConnectCare AIDS Program

ART DIRECTOR Sonia Greteman

DESIGNER Sonia Greteman, Jo Quillen

PAPER Kraft

TYPE Fragile, Franklin Gothic

COLOR Four-color process

PRINTING Offset

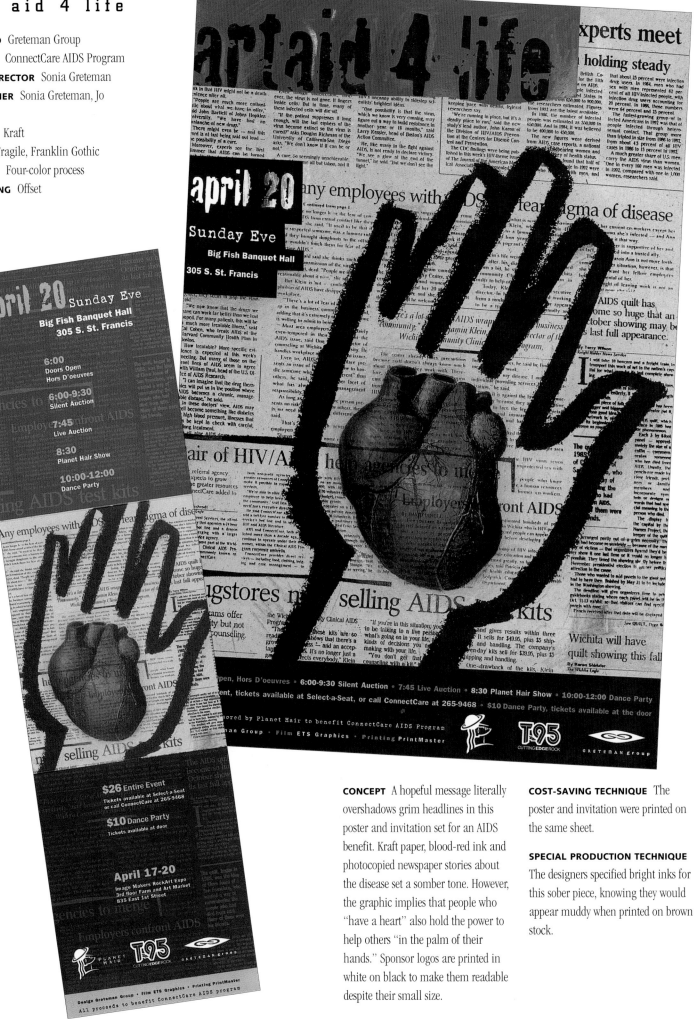

CONCEPT A hopeful message literally overshadows grim headlines in this poster and invitation set for an AIDS benefit. Kraft paper, blood-red ink and photocopied newspaper stories about the disease set a somber tone. However, the graphic implies that people who "have a heart" also hold the power to help others "in the palm of their hands." Sponsor logos are printed in white on black to make them readable despite their small size.

COST-SAVING TECHNIQUE The poster and invitation were printed on the same sheet.

SPECIAL PRODUCTION TECHNIQUE The designers specified bright inks for this sober piece, knowing they would appear muddy when printed on brown stock.

STUDIO The Traver Company
CLIENT The MS Society
ART DIRECTOR Anne Traver
DESIGNER Margo Sepanski
PAPER Champion Benefit
TYPE Bauer Bodoni, Futura
COLOR Three PMS
PRINTING Offset

CONCEPT The annual fundraising auction's theme was "possibility and promise," referring to the continuing medical advancements in treating multiple sclerosis. That theme and the function's spring date were the inspirations for the floral artwork. Photographs show tulips budding and blooming.

COST-SAVING TECHNIQUE While the invitation is printed in three colors, the response cards and envelopes are printed in one color on several colored papers.

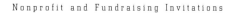

A New Age of Discovery Invitation

STUDIO Smith & Jones

CLIENT Clark University

ART DIRECTOR Christine Tiery

DESIGNER Christine Tiery

ILLUSTRATOR Christine Tiery

ACCOUNT EXECUTIVE Jean Giguere/Smith & Jones

CREATIVE SERVICES MANAGER Kay Hartnett/Clark University

DIRECTOR OF COMMUNICATIONS Kate Chesley

DIRECTOR OF DEVELOPMENT OPERATIONS Kathleen Dunlee

PAPER Strathmore Elements, Zig Zag Soft White

TYPE Goudy

COLOR Four-color process

PRINTING Indigo digital printing

CONCEPT Airline tickets were the design inspiration for this piece, an invitation to a reception opening Clark University's $100 million capital campaign. The ticket envelope invites recipients to "be a guest on a journey to A New Age of Discovery." Each recipient's name was printed on his or her ticket, both to make the ticket seem more authentic and to involve the guests personally.

COST-SAVING TECHNIQUES Designers had the small (450 invitations) press run done on a digital printer, which allowed the tickets to be customized. All four pieces — the ticket jacket, two tickets and accommodations card — were printed on the same sheet.

SPECIAL VISUAL EFFECTS The paper's zigzag pattern helped make the tickets seem more authentic and added another visual element at no cost.

SPECIAL PRODUCTION TECHNIQUES Jackets were die cut and response cards perforated.

STUDIO Kiku Obata & Co.

CLIENT California Academy of Sciences

ART DIRECTOR Amy Knopf

DESIGNER Amy Knopf

PHOTO MANIPULATION Amy Knopf

PAPER Ikonofix, Glama Natural

TYPE Cochin, AT Floridian, Shelley Allegro Script

COLOR Four-color process, two PMS

PRINTING Offset

SPECIAL VISUAL EFFECT The vellum envelope gave recipients the illusion of looking at the fish through clear water.

SPECIAL PRODUCTION TECHNIQUE The fish were photographed in-house, then collaged in Adobe Photoshop.

CONCEPT Brightly colored fish draw the eye to the invitation and printed collateral for Enchanted Pacific, an annual fundraising ball for the California Academy of Sciences. The invitation's vellum envelope reveals a school of bright fish printed on a sheet of translucent vellum wrapped around the invitation and reply card. The accordion-folded invitation, printed on thick coated paper, shows the same fish in a dynamic whirlpool, suggesting that missing the ball would be letting the big one get away.

Gala Invitation Package

STUDIO Grafik Communications, Ltd.

CLIENT Society for the Advancement of Women's Health Research

ART DIRECTORS Richard Hamilton, Judy Kirpich

DESIGNER Michelle Mar

PRODUCTION MANAGER Maria Wasowski

PAPER Mohawk Poseidon 100-lb. (288 g/m²) Cover

TYPE Lapidary, Nuptial

COLOR Two PMS

PRINTING Offset

CONCEPT The word "advance" inspired this piece, which celebrates advancement in women's healthcare. The cover illustration and stock photography represent healthcare, while the type graphically advances up and across the page. The accordion-folded invitation, cut at a slant so it rises as it unfolds, also represents advancement.

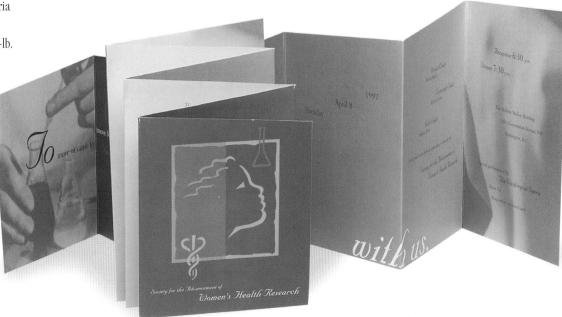

Renew Your Vows

STUDIO After Hours Creative

CLIENT Arizona Human Rights Fund

ART DIRECTOR After Hours Creative

DESIGNER After Hours Creative

PHOTOGRAPHER Tim Lanterman

PAPER Strobe 80-lb. (230 g/m²) Cover

TYPE Swiss 721 Extended, Extended Bold, Condensed, Condensed Bold

COLOR Two PMS

PRINTING Offset

CONCEPT Instead of an amusing or formal keepsake, this invitation for an awards dinner honoring human rights activists (including the designer) presents a powerful and moving challenge. The pages of the 5¾" (14.6cm) booklet show photographs representing activism, happy living and grief for the dead, juxtaposed with promises activists make: to do what's right, to always be there and to never forget. In the face of advances that make activists complacent, this invitation challenges recipients to remember their promises and "renew their vows."

COST-SAVING TECHNIQUE Printing was donated.

SPECIAL VISUAL EFFECT The photos are deliberately darkened and blurred, making their subjects anonymous and general, rather than specific people.

SPECIAL PRODUCTION TECHNIQUE Photographs were printed as duotones.

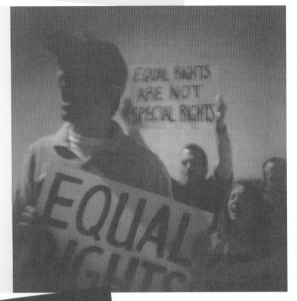

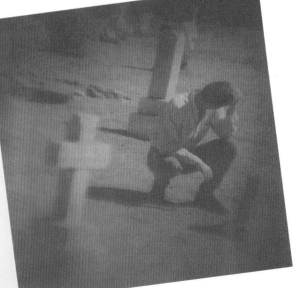

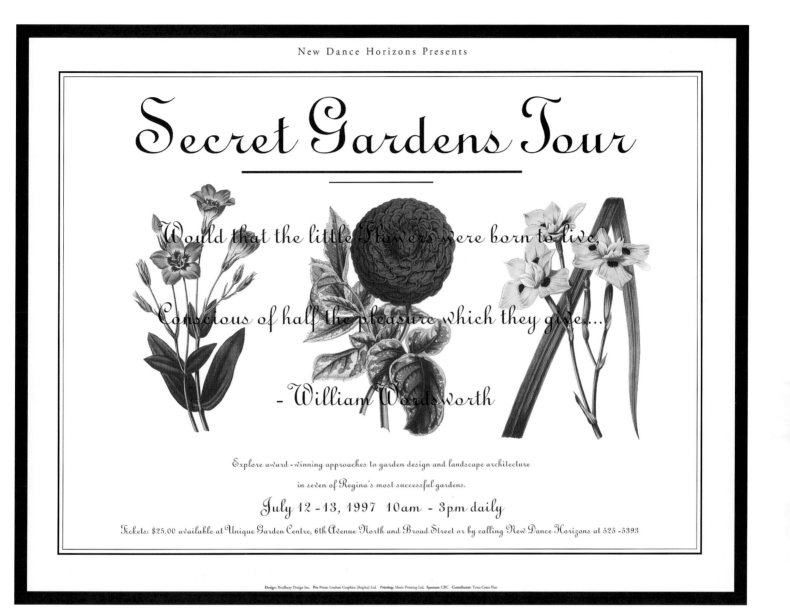

STUDIO Bradbury Design Inc.

CLIENT New Dance Horizons, Saskatchewan, Canada

ART DIRECTOR Catherine Bradbury

DESIGNER Catherine Bradbury

PRODUCTION Loubin Graphics, Regina, Canada

PRINTER Merit Printing Ltd., Regina, Canada

PAPER Potlatch Vintage Dull 100-lb. (288 g/m²) Text

TYPE Linoscript, Garamond

COLOR Four-color process

PRINTING Offset

CONCEPT The poster advertised a tour of private gardens in many different styles. The antique illustrations and the Wordsworth poem (both created in the same decade) were chosen to suggest an Old English-style garden, and offered people a taste of what they might expect at the event. The director largely attributed the success of the event, which raised twice the projected funds, to the popular poster.

COST-SAVING TECHNIQUES Design, production and printing were donated. Posters were printed on the same sheet with brochures and handbills.

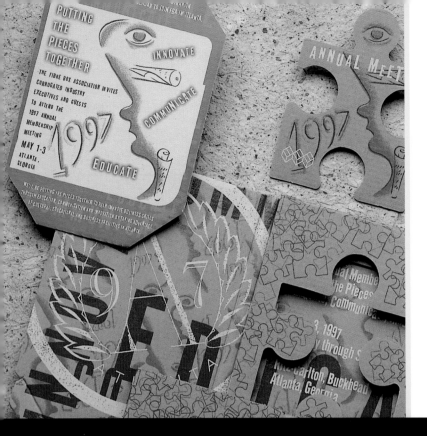

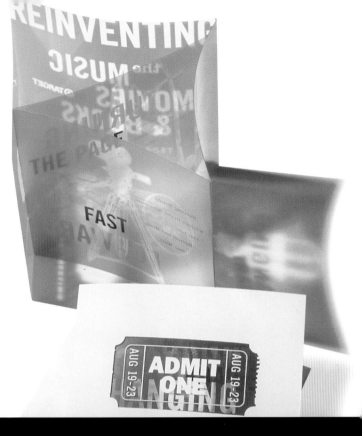

MISCELLANEOUS INVITATIONS

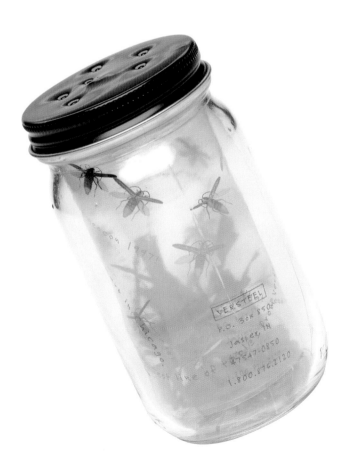

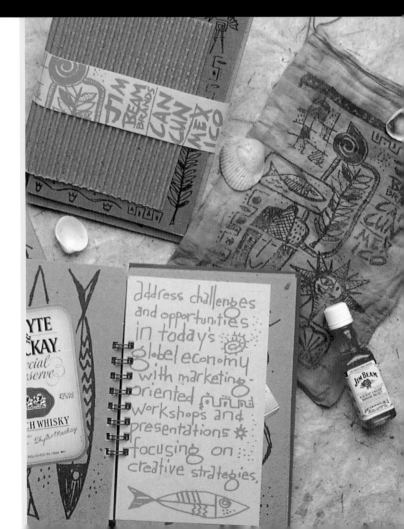

STUDIO Dupla Design

CLIENT Art Foundation of Niterói/Niterói City Hall

ART DIRECTOR Claudia Gamboa

DESIGNERS Claudia Gamboa, Ney Valle

PHOTOGRAPHER Magno Mesquita

DESIGN ASSISTANT Fernanda Paes

PAPER Couché Mate 180g, Vergê 180g White

TYPE Snell Roundhand, Peignot

COLOR Four-color process, two PMS

PRINTING Offset

CONCEPT This invitation contrasts a delicate design, chosen to honor the personality of the artist, with the bright boldness of the artist's work. The inset sheet, framed by the die-cut outer jacket, is printed in white and gray on a textured, off-white paper. Inside, the artist's photograph decorates the essential information about the exhibit's time and date. Below the inset is a four-color reproduction of a featured painting, along with the artist's biographical information.

SPECIAL VISUAL EFFECTS The cover image is a flower reproduced from the featured painting. Printed in gray and white, it has an ethereal look very different from the artist's earthy style.

SPECIAL PRODUCTION TECHNIQUES The die-cut invitation jacket holds the insert and frames the artist's name. A yellow fabric cord tied at the fold helps hold the insert in place.

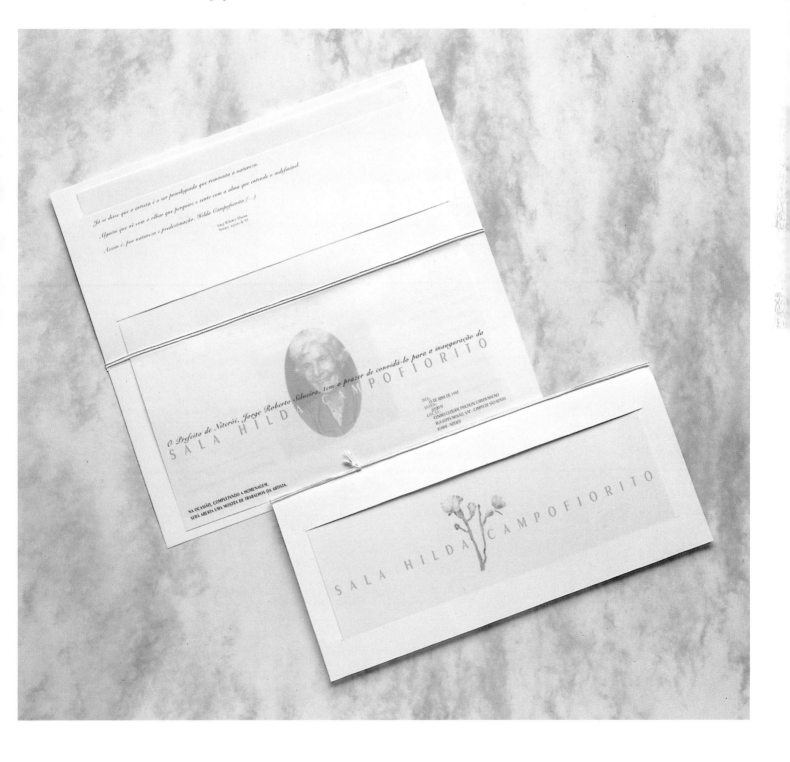

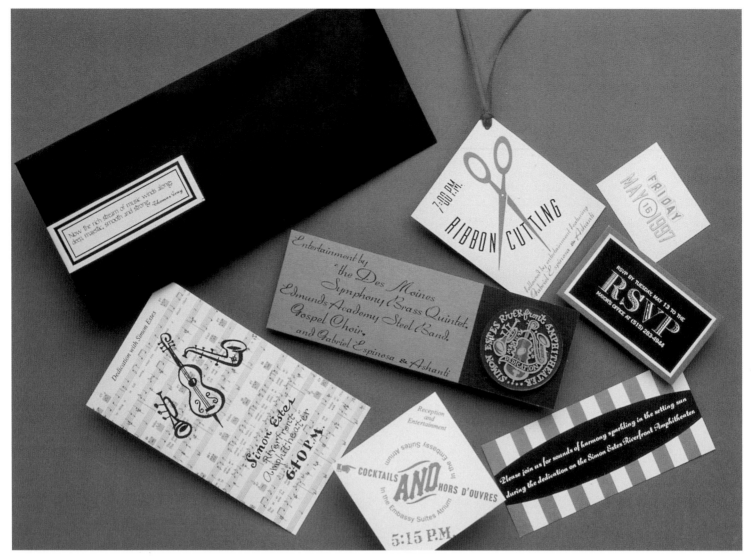

STUDIO Sayles Graphic Design

CLIENT Des Moines Parks & Recreation Commission

ART DIRECTOR John Sayles

DESIGNER John Sayles

ILLUSTRATOR John Sayles

COPYWRITER Jack Carey

PAPER Curtis Tuscan Antique

TYPE Various

COLOR One PMS, black

PRINTING Offset

CONCEPT This versatile invitation package for the dedication of a new theater includes a series of separate cards for numerous events including a ribbon cutting, a reception and a concert. Planners simply mailed the correct combination of cards to each recipient (not all guests were invited to all events). Every recipient also received a commemorative Lucite lapel pin printed with metallic copper and silver inks. All pieces fit into a No. 10 envelope and mailed for only thirty-two cents.

SPECIAL VISUAL EFFECTS Black and copper ink gives the pieces an elegant look for a small price. Black envelopes reinforce the effect.

SPECIAL PRODUCTION TECHNIQUES Ribbons tied to the ribbon-cutting event invitation add a fitting and festive touch.

STUDIO Boelts Bros. Associates

CLIENT The University of Arizona Foundation

ART DIRECTORS Jackson Boelts, Eric Boelts, Kerry Stratford

DESIGNER Ward Andrews

ILLUSTRATOR Ward Andrews

TYPE Hand-lettering, Weiss

COLOR One PMS, black

PRINTING Offset

CONCEPT The illustrations and hand-lettering convey the informal, intimate style of the event. The unusual right-opening invitation offers a mysterious sneak preview. Recipients must open it to find out what the gathering is about.

SPECIAL PRODUCTION TECHNIQUE Illustrations were created conventionally, then scanned and manipulated in Adobe Photoshop to achieve the final look.

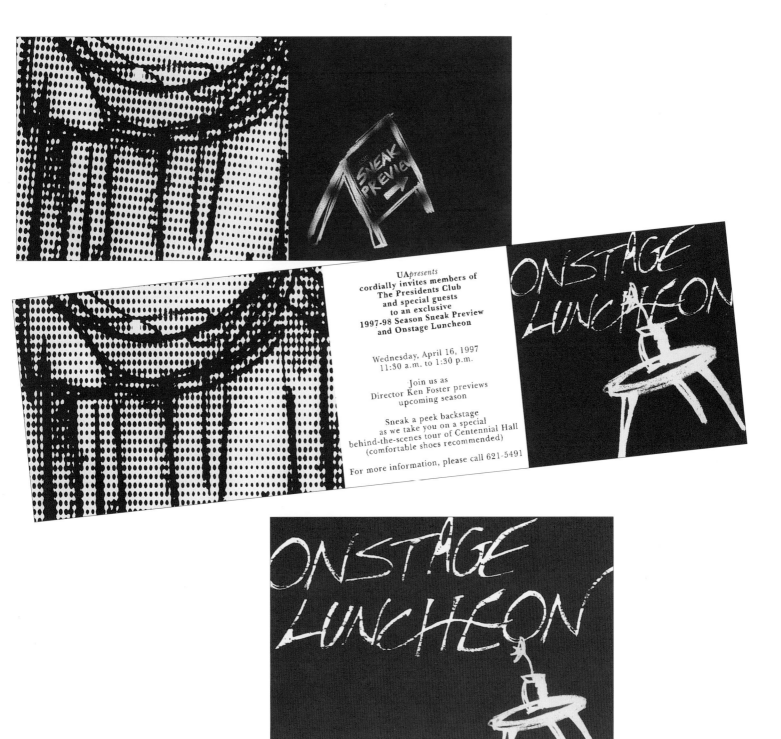

Canlis Restaurant Grand Re-Opening

STUDIO Foundation

CLIENT Canlis Restaurant

ART DIRECTOR David Edelstein and Lanny French

DESIGNER Giorgio Davanzo

PHOTOGRAPHER Nancy Edelstein

PAPER Neenah Classic Laid Ivorystone

TYPE Garamond, Custom

COLOR Four-color process, three spot colors

PRINTING Offset

CONCEPT This understated invitation contrasts "then" and "now," promising customers that the famed restaurant will lose nothing of the charm it held "then" (its opening in 1950), but will benefit from its reopening "now" (1996). The photograph of orchids, chosen as symbols of the restaurant's famed beauty, makes a lovely but unfocused cover. Inside, the photo is reproduced clearly, representing the owner's "new vision."

SPECIAL VISUAL EFFECTS The invitation is printed on a translucent vellum sheet inserted in the ivory laid booklet, which could be used alone for other promotions.

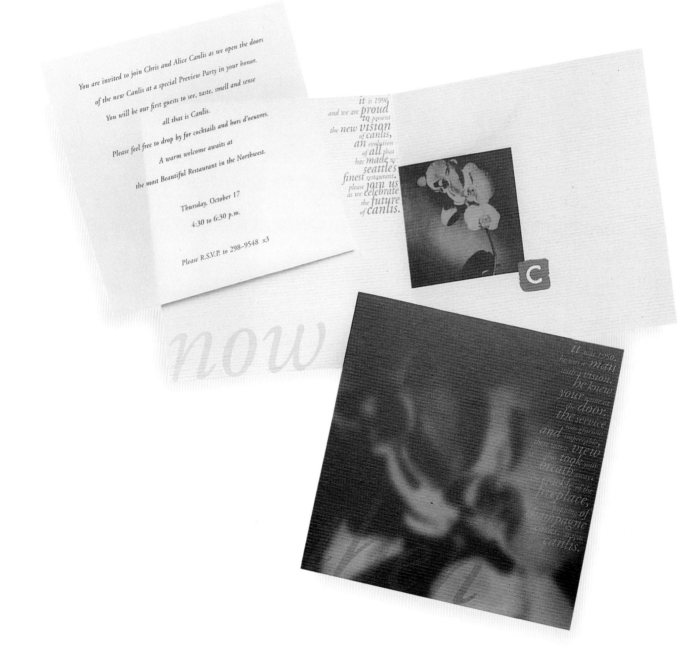

STUDIO Smullen Design Inc.

CLIENT Warner Bros. Studio Stores

ART DIRECTOR Maureen Smullen

DESIGNERS Maureen Smullen, Jennel Cruz, Jill Von Hartman

ILLUSTRATOR Maureen Smullen, Jill Von Hartman

COLOR Four-color process, plus yellow and red fluorescent added to process colors

PRINTING Offset

CONCEPT The hook for this piece is the store's nickname, "The Big Carrot." Warner Bros. Studio Stores had added six floors of retail space to the formerly three-floor store. To reinforce the idea of growth, each invitation included a die-cut carrot and a packet of carrot seeds.

SPECIAL PRODUCTION TECHNIQUES To preserve the cartoonish bright colors without using match colors, the printer added fluorescent inks to the process inks.

STUDIO Love Packaging Group

CLIENT The Fibre Box Association

ART DIRECTOR Brian Miller

DESIGNER Chris West

ILLUSTRATOR Chris West

STRUCTURE DESIGN Mitch McCullogh

JOB COORDINATOR Chuck Miller

CREATIVE RESOURCE Clark Jackson

ASSEMBLY Sue Arnold

PAPER Fasson/Corrugated E-Flute Crack 'n Peel Lunch Bag Brown, Kraft/Single Face Outback Crocodile

COLOR Three PMS

PRINTING Screenprinting (corrugated), Offset (Crack 'n Peel)

CONCEPT The client had no theme for its annual meeting other than the title, "Innovate, Communicate, Educate." Designers developed their own theme, a puzzle, for the marketing campaign. The removable puzzle piece from the invitation was redeemed at the convention for the program, where it fit in the cover to "complete the puzzle."

COST-SAVING TECHNIQUE All assembly was done by hand.

SPECIAL VISUAL EFFECT Once the puzzle piece is removed, a face printed on the information card (made of single-face corrugated board) is revealed.

SPECIAL PRODUCTION TECHNIQUE The single-face cards were cut by hand on a paper cutter using a special jig.

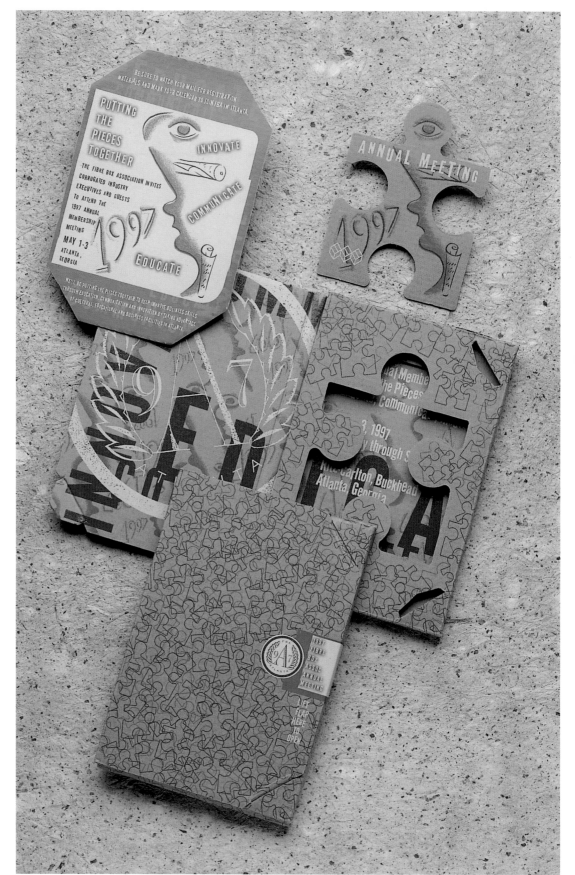

STUDIO Curry Design, Inc.

CLIENT Columbia TriStar

ART DIRECTOR Steve Curry

DESIGNER Jason Scheideman

PAPER Encore 130-lb. (375 g/m²) Gloss Cover, Environment Moonrock Cover, Gilclear 36-lb. (105 g/m²)

TYPE Augusta, Bell Gothic, Garamond

COLOR Four-color process plus matte UV varnish (covers); four-color process (inside/envelope); one PMS, black (Gilclear sheet)

PRINTING Offset

CONCEPT Because of the many styles of television shows that would be represented at Columbia TriStar's annual screening party, designers focused on the Columbia and TriStar logos artwork. Three weights and kinds of papers, including a vellum sheet that reveals the party details printed beneath it, are bound together with a metal grommet, allowing the papers to be spread out like a fan or opened like a book.

SPECIAL VISUAL EFFECT The two logos, printed on the front and back of the invitation, are shown being televised.

SPECIAL PRODUCTION TECHNIQUES The rounded, die-cut edges on the bound side recall the curve of a television screen. UV coating on both sides of the cover stock adds weight and texture.

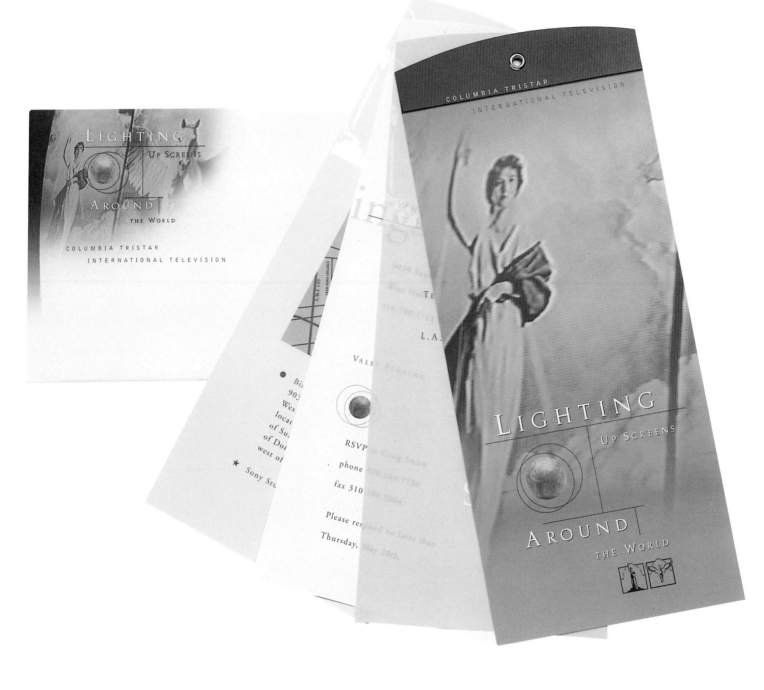

The Frye Art Museum Grand Opening

STUDIO The Traver Company

CLIENT The Frye Art Museum

ART DIRECTOR Anne Traver

DESIGNER Margo Sepanski

PHOTOGRAPHER Skip Howard

PAPER Gilclear, Starwhite Vicksburg

TYPE Futura, Trajan, Adobe Garamond

COLOR One metallic PMS, black

PRINTING Offset

CONCEPT A vellum shell showing a photo of the renovated Frye Art Museum, and explaining its new amenities, envelopes a two-sided invitation card. The same vellum sheet was used for other invitations and announcements, also printed as two-sided cards. The images and words, although pleasantly layered, remain easy to see and read.

SPECIAL VISUAL EFFECTS The gold bar behind the photograph covers another gold bar on the card below that reproduces one of the museum's paintings. Opening the cover sheet, like entering the museum, reveals artwork inside.

SPECIAL PRODUCTION TECHNIQUE The photo was printed as a black-and-gold duotone.

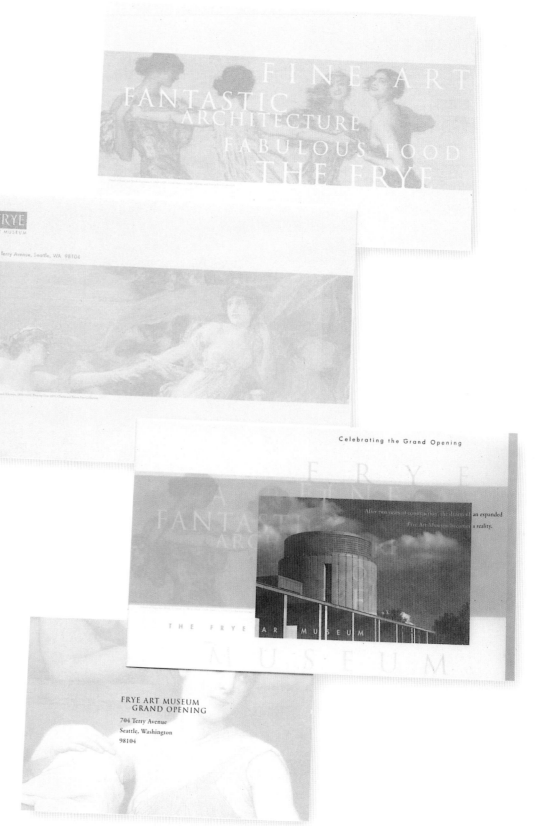

STUDIO Bullet Communications, Inc.

CLIENT Uhlich Children's Home and the Department of Human Services

DESIGNER Tim Scott

ILLUSTRATOR Tim Scott

COPYWRITER Tim Scott

PAPER Cougar Opaque 80-lb. (230 g/m²) Cover, white smooth

TYPE Berkeley Italic, Univers

COLOR One PMS, black

PRINTING Offset

CONCEPT The event's purpose, giving VIPs a preview of a not-yet-completed school, provided the inspiration for the invitation. The die-cut cover, printed in black with a construction barrier border, gives recipients a "peek" at the inside. In addition to the event information, the invitation also shows some of the construction plans.

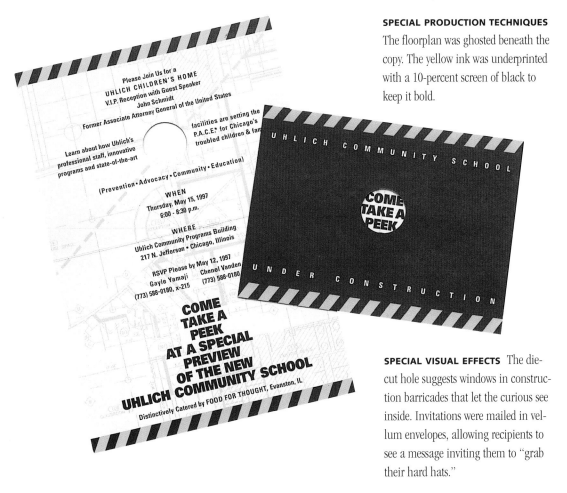

SPECIAL PRODUCTION TECHNIQUES The floorplan was ghosted beneath the copy. The yellow ink was underprinted with a 10-percent screen of black to keep it bold.

SPECIAL VISUAL EFFECTS The die-cut hole suggests windows in construction barricades that let the curious see inside. Invitations were mailed in vellum envelopes, allowing recipients to see a message inviting them to "grab their hard hats."

STUDIO 1185 Design

CLIENT PowerTV, Inc.

ART DIRECTOR Peggy Burke

DESIGNER Nhut Nguyen

ILLUSTRATOR Nhut Nguyen

SUBSTRATE Aluminum

TYPE Democratica, Orator

COLOR Two PMS, black

PRINTING Screenprinting

CONCEPT This screenprinted aluminum piece strikes an appropriately high-tech note. An invitation for a vendor reception at the National Cable Television Association's 1996 convention, it also served as a ticket for the event.

SPECIAL VISUAL EFFECTS The smooth screenprinting inks complement the unusual substrate, making a striking and memorable invitation that can also be a keepsake.

Harley Owners Group Fifteenth Anniversary

STUDIO Graphic Solutions, Inc.

CLIENT Harley Owners Group, a division of Harley-Davidson Motor Co.

ART DIRECTORS Marc Tebon, Dave Kotlan

DESIGNER Steven Radtke

COPYWRITER Mike Spanjar

PAPER Lustro Dull

TYPE Device, Officina Sans

COLOR Four-color process

PRINTING Offset

CONCEPT Although the organization's members had known about the anniversary event for months, the client wanted a piece that would inspire them to make reservations. Their directives were to create a sense of urgency and give the impression that "everyone" would come. The long, narrow invitation presents sequential information as it unfolds, building in intensity as it's opened.

SPECIAL VISUAL EFFECT Warm, muted photos create a nostalgic feeling, designed to remind members of the last reunion, held five years earlier.

REGISTER N

The members-only pre-sale period for 15ᵗʰ⁄
Packages ends June 30, 1997 – at which tim
to The Reunion go on sale to the general
The Rally and Reunion in Milwaukee, J
Take advantage of this unique op

1-800-84

WHAT DO YOU DO?

YOU HAVE ONLY UNTIL JUNE 30, 1997 TO RESERVE YOUR TICKETS.

Anniversary

H.O.G

HARLEY OWNERS GROUP

1983-1998

YOU'RE A H.O.G. MEMBER

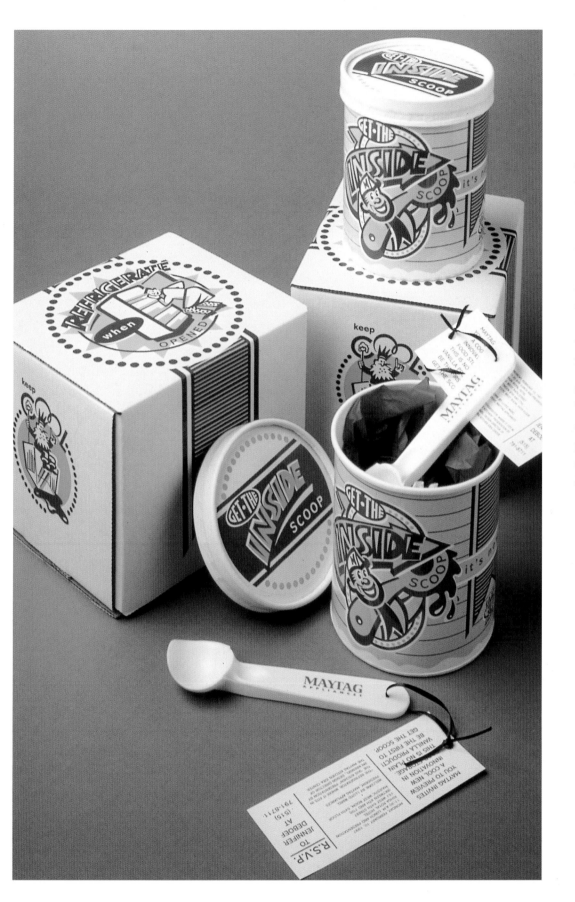

STUDIO Sayles Graphic Design

CLIENT Maytag Corporation

ART DIRECTOR John Sayles

DESIGNER John Sayles

ILLUSTRATOR John Sayles

COPYWRITER Wendy Lyons

PAPER Corrugated cardboard, ice cream cartons

TYPE Various, Hand-rendered

COLOR Two PMS

PRINTING Screenprinted

CONCEPT Introducing a new refrigerator line, this media invitation mailed in a cube-shaped box held an ice cream carton. Inside, recipients found an ice cream scoop and an invitation to the reception. In addition, a coupon for free ice cream consoled the hungry.

SPECIAL PRODUCTION TECHNIQUES The print run of fewer than one hundred was too small for container companies to produce. Sayles worked with a regional dairy, who custom-fabricated the cartons.

Zest Opening Invitation

STUDIO Vrontikis Design Office
CLIENT Global-Dining, Inc.
ART DIRECTOR Petrula Vrontikis
DESIGNER Kim Sage
ILLUSTRATOR Christina Hsiao
PAPER Simpson Quest
TYPE Modula Serif, Hip
COLOR Two PMS
PRINTING Offset

CONCEPT For this restaurant opening — the fifth Zest Mexican Restaurant in Tokyo — the designers created a two-piece invitation that combines American-Western motifs with other trendy graphics. Copy in English and Japanese invites guests to the opening and identifies staff and vendors. The designers, who have done all graphics for the restaurants and for the client's twenty-two other restaurants in numerous countries, understood exactly the image the client needed.

COST-SAVING TECHNIQUE Using two ink and paper colors and wrapping the two sheets around each other gives a sophisticated effect without a sophisticated price.

STUDIO JCPenney Co. Communications

DESIGNER Liz Tindall

PHOTOGRAPHERS Michelle Vaughn, Beth Bergman

WRITER/PROJECT MANAGER Tim Lyons

PAPER UV Ultra, Cream matte sheet

TYPE Classic Roman, Antique Roman

COLOR Two PMS

PRINTING Offset

CONCEPT This invitation to a reception for Beverly Sills, who was given a JCPenney company award for epitomizing the spirit of the American woman, evokes the pageantry of opera. The vellum cover depicts a theater curtain. Underneath the cover is a photo of Sills in one of her great roles. Additional pages depict music notation, clapping hands and flowers. The tan-and-burgundy color scheme recalls theater red and gold, and the piece is bound with a gold tassel.

COST-SAVING TECHNIQUE The piece was printed in JCPenney's in-house shop.

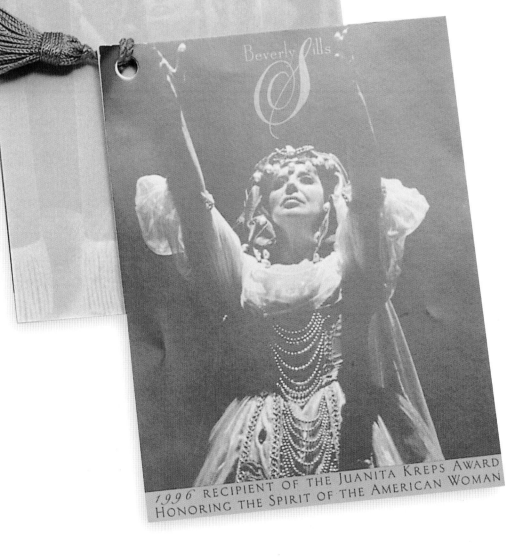

Versteel NeoCon Firefly Invitation

STUDIO Rauscher Design Inc.

CLIENT Versteel

ART DIRECTOR Janet P. Rauscher

DESIGNER Susan D. Morganti

ILLUSTRATOR Chris Lockwood

SUBSTRATE Clear plastic

TYPE Felt Tip

COLOR Four-color process, spot white and fluorescent yellow

PRINTING Offset

CONCEPT To grab recipients' attention and introduce a new line of tables with electrical hookups, designers created jars of fireflies. Copy inviting recipients to the vendor's booth at a trade show was printed in spiraling lines on a sheet of clear plastic, as were more than a dozen fireflies, their tails shining with a fluorescent yellow glow. Nestled into glass jars, the invitation gives the effect of a child's collection of fireflies. Air holes punched in the lids and paper "grass" at the bottom of the jars make the effect even more realistic.

COST-SAVING TECHNIQUE The invitations were assembled by Southern Indiana Rehabilitation Services, which employs disabled workers.

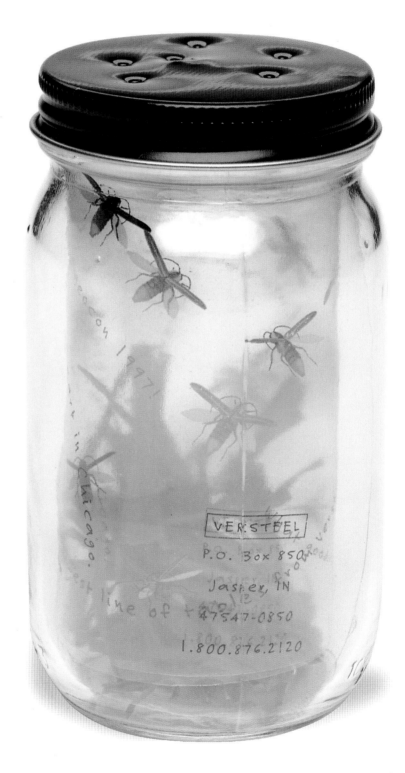

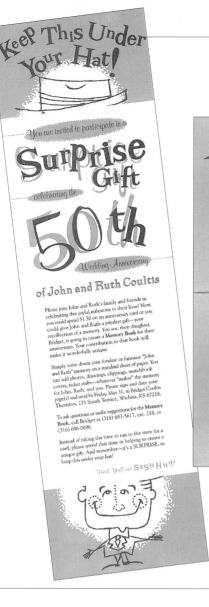

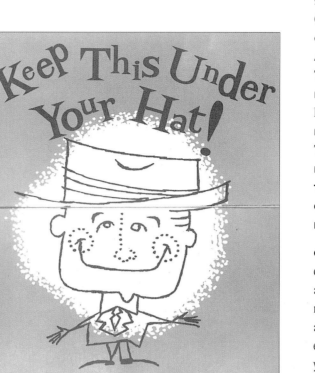

STUDIO Insight Design Communication

CLIENT Bridget Coultis

ART DIRECTORS Sherrie Holdeman, Tracy Holdeman

DESIGNERS Sherrie Holdeman, Tracy Holdeman

ILLUSTRATORS Sherrie Holdeman, Tracy Holdeman

PAPER House uncoated white

TYPE Adriatic, Murry Hill Bold

COLOR Two PMS

PRINTING Offset

CONCEPT This card for friends of a couple celebrating their fiftieth wedding anniversary invites them to send fond memories of the two for a surprise gift: a memory book. The couple collects eccentric hats, making "keep this under your hat" an ideal theme. The card's square folds makes the information a surprise kept under a hat.

Danbry's Opening Invitation

STUDIO Bradbury Design Inc.

CLIENT Danbry's Contemporary Cuisine

ART DIRECTOR Catherine Bradbury

DESIGNER Catherine Bradbury

PAPER Beckett Expression 80-lb. (230 g/m²) Cover

TYPE Franklin Demi, Helvetica

COLOR Three PMS

PRINTING Offset

CONCEPT For a new restaurant occupying a space long owned by a private men's club, designers created a graphic identity using three shapes from the already completed interior design. These shapes — a spiral, an asterisk and a squiggle — inspired a contemporary illustration of a vase of flowers. This casual image emphasizes the difference between the new restaurant and the old club. The invitation for an evening party to preview the space and menu features the identity.

SPECIAL VISUAL EFFECTS Metallic gold ink suggests a festive occasion without compromising the casual design.

We've hung up our hard hats, we've hammered the last nail!
(Well...almost!)

The curtain is ready to rise on the opening act of Regina's most exciting new restaurant, and we want you to be our first audience!
Please come to Danbry's, (1925 Victoria Avenue) on June 9 at 7:00 p.m. for a special preview night for our family and friends.
We want you to be the "dress rehearsal" for our great new servers and kitchen staff!
You won't find any prices on our special "taste-testers" menu that evening. We're delighted to have you as our guests and wish only
that you share with us your comments (good and "other" gratefully accepted), and that you have a marvellous evening.
Please RSVP to Danbry's (525-8777) by June 4th. Looking forward to seeing you there!

STUDIO Design Guys

CLIENT Target Stores

ART DIRECTOR Steven Sikora

DESIGNER Jay Theige

PAPER Cougar Polyester

TYPE Trade Gothic Condensed, Lubalin, Clarendon

COLOR Four-color process plus opaque white

PRINTING Screenprinting

CONCEPT The design of this invitation for a national sales meeting used transparent inks on sheet plastic to convey the message that three departments within Target Stores were combining forces. Each department is represented by a different ink color. When the piece is folded, it creates a pleasing and complex collage. Process white ink on the front and back "covers" creates a neutral shell for the colors inside.

SPECIAL VISUAL EFFECTS As the piece folds and unfolds, the simple process magenta, cyan and yellow blend together to make other colors. A translucent vellum envelope continues the theme.

SPECIAL PRODUCTION TECHNIQUE One end sheet is perforated, to be detached and used as an entrance ticket.

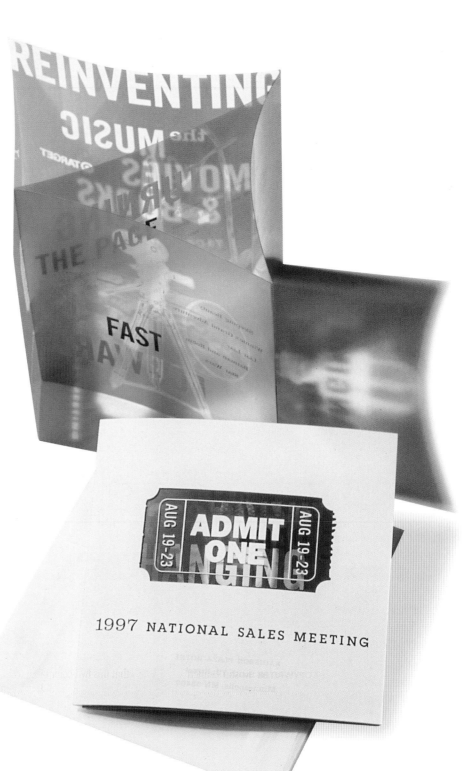

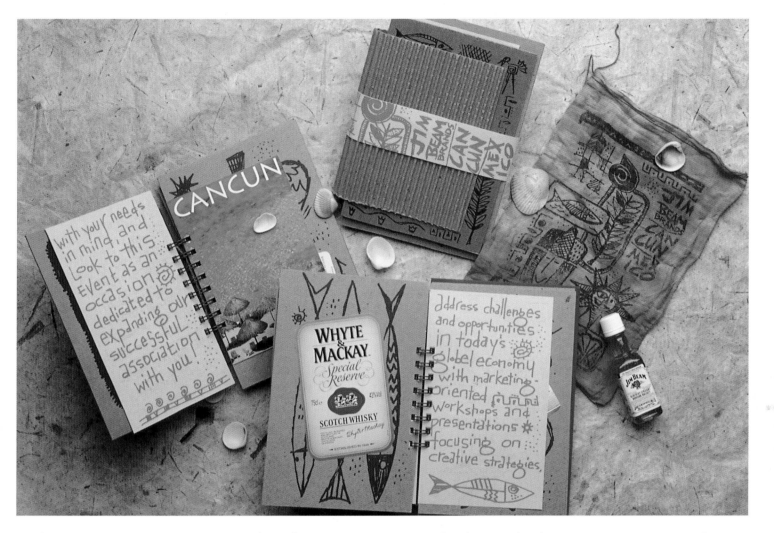

STUDIO Sayles Graphic Design

CLIENT Jim Beam Brands

ART DIRECTOR John Sayles

DESIGNER John Sayles

ILLUSTRATOR John Sayles

COPYWRITER Kristin Lennert

PAPER Chipboard, Curtis Tuscan Terra, single-wall corrugated board

TYPE Hand-rendered

COLOR Two PMS

PRINTING Screenprinting

CONCEPT Bound-in postcards and product labels give this limited-budget piece the illusion of four-color printing. Seashells, wire binding, a tie-dyed cloth bag and unusual papers ensure that this two-color piece packs a sensory punch. The enthusiastic, island-inspired graphic design adds the finishing touch.

COST-SAVING TECHNIQUE Because only seventy-five pieces were made, the piece was hand-assembled.

SPECIAL PRODUCTION TECHNIQUES Labels were tipped in by hand and postcards were bound in. Each invitation also includes a seashell hung from the spiral binding.

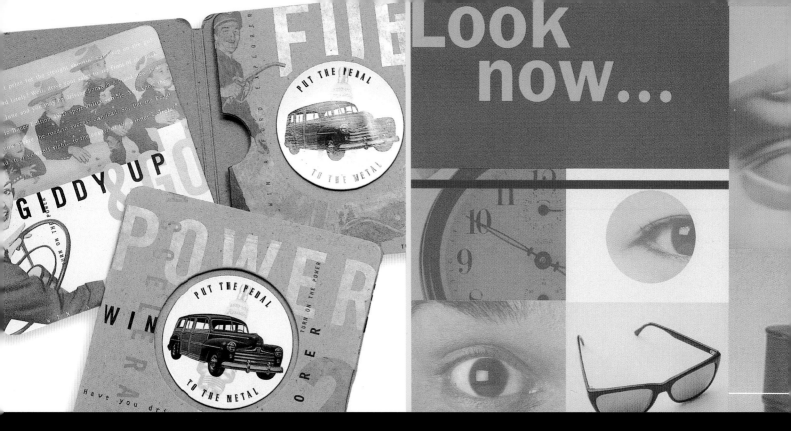

ANNOUNCEMENTS

41ST

Once you've seen the fight no doubt you'll have worked up an appettite. Something refreshing for you and your sweetie is await~ing you at our snack shop.

gone swimming

STUDIO Foundation

CLIENT Self

ART DIRECTORS David Edelstein, Lanny French

DESIGNERS Giorgio Davanzo (Gone Swimming), Abigail Fein (Suntan Lotion)

ILLUSTRATOR Todd Minderman (Suntan Lotion)

TYPE Avant Garde Condensed Book, Custom

COLOR Four-color process

PRINTING Digital

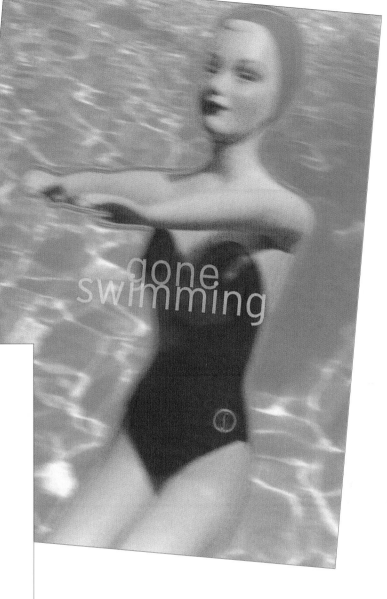

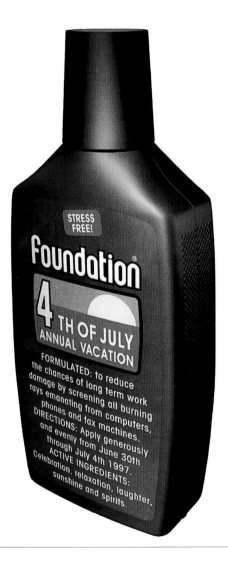

CONCEPT The design firm sends out humorous cards to remind clients of its annual summer vacation, when the office is closed for a week. Illustrations and copy communicate the theme in a playful, but professional way.

SPECIAL PRODUCTION TECHNIQUE The suntan lotion bottle is a three-dimensional rendering created on a computer using FORM-Z software.

Jake Cain Birth Announcement

STUDIO Communication Arts Company

CLIENT Joe and Meg Cain

ART DIRECTOR Anne-Marie Cain

DESIGNER Anne-Marie Cain

ILLUSTRATOR Art Parts clip art

PHOTOGRAPHER Mike Cain

PAPER Somerset Matte 100-lb. (288 g/m²) Text

TYPE Regular Joe

COLOR Process black

PRINTING Offset

CONCEPT The second in a "series" of birth announcements in this format, the accordion-folded piece pictures different "Cains," including "Sugar Cain" and "Citizen Cain" and ending with a photograph of new baby, Jake Cain. The first announcement, for Jake's big brother Ricky, was so popular the family made it a tradition.

COST-SAVING TECHNIQUE Illustrations were taken from clip art.

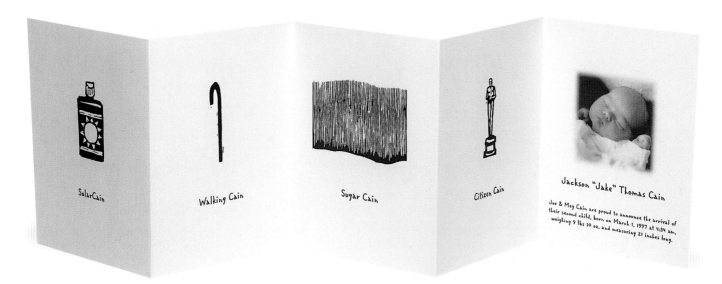

SolarCain

Walking Cain

Sugar Cain

Citizen Cain

Jackson "Jake" Thomas Cain

Joe & Meg Cain are proud to announce the arrival of their second child, born on March 1, 1997 at 4:34 am, weighing 9 lbs 10 oz, and measuring 21 inches long.

Max's Birth Announcement

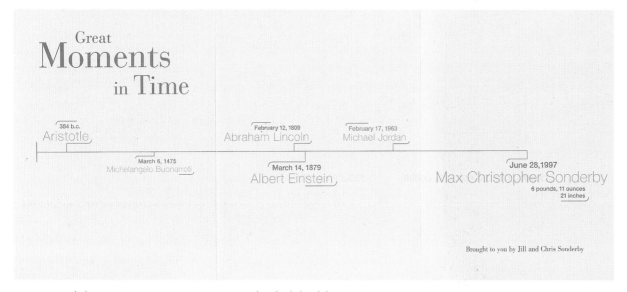

Great **Moments** in Time

384 b.c.
Aristotle

February 12, 1809
Abraham Lincoln

February 17, 1963
Michael Jordan

March 6, 1475
Michelangelo Buonarroti

March 14, 1879
Albert Einstein

June 28, 1997
Max Christopher Sonderby
6 pounds, 11 ounces
21 inches

Brought to you by Jill and Chris Sonderby

STUDIO Sonderby Design

CLIENT Max

ART DIRECTOR Jennifer Sonderby

DESIGNER Jennifer Sonderby

PAPER Champion Benefit, Vellum, Chalk, 80-lb. (230 g/m²) Cover

TYPE Bauer Bodoni, Helvetica Neue

COLOR One PMS

PRINTING Offset

CONCEPT The idea behind this announcement is a simple one: All parents believe that their child's birth is a moment of great historical significance. Here, Max Sonderby's birth is presented on a timeline with greats from Aristotle to Michael Jordan. The back of the invitation is printed with whimsical illustrations of toys.

COST-SAVING TECHNIQUE A screen tint gives the look of a second color.

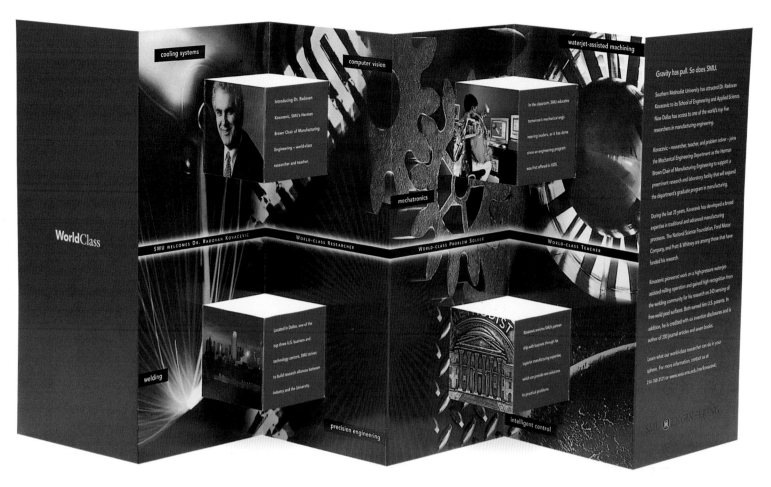

STUDIO May + Co.

CLIENT Southern Methodist University

ART DIRECTOR Douglas May

DESIGNERS Douglas May, John May, Patrick Amann

PHOTOGRAPHER Phototake

PAPER Tiara Starwhite Vicksburg Smooth Cover

TYPE Avenir

COLOR Four-color process, double bump of red

PRINTING Offset

CONCEPT This announcement has a double purpose: to introduce the new Herman Brown Chair of Manufacturing Engineering at SMU and to invite businesses to use the university's world-class research facility. The piece's complex folds give a mechanical look to match its subject. Background photos, printed in blue to recall blueprints and diagrams, represent fields of engineering study. Color photos represent subject in the accompanying copy: the new Chair, the city, classroom studies and the university's partnership with business.

SPECIAL VISUAL EFFECTS The complex die-cut accordion folds give the piece three dimensions. The announcement is printed yellow on the reverse side, contributing to its high-end look.

SPECIAL PRODUCTION TECHNIQUES When folded, the piece's full-color imagery is hidden by red "covers." The announcement was printed on a six-color, sheet-fed press and given a double bump of red to ensure its richness.

Check Him Out

STUDIO Sibley/Peteet Design
CLIENT Art, Beck and Dominic
ART DIRECTOR Art Garcia
DESIGNER Art Garcia
PHOTOGRAPHER Doug Write
PAPER Gilbert Esse
TYPE Triplex
COLOR Four PMS
PRINTING Offset

CONCEPT Born on a day his older brother Dominic took a field trip to the library, Daniel Garcia was given a commemorative book as a birth announcement. Written from his brother's point of view, the book gives the vital statistics along with photographs of the new baby's face, decorated with line art. "I'm really glad we checked him out," says Dominic, whose parents promise to give Daniel "all the love he's due."

COST-SAVING TECHNIQUES The book was printed 6/0 on a six-color press. Each page was folded and stitched.

SPECIAL VISUAL EFFECTS Each book was sealed with a "date due" sticker giving the baby's birth date. One of the photos inside shows the baby with the same sticker on his forehead. The textured paper and stitched binding recall the look of a baby blanket.

SPECIAL PRODUCTION TECHNIQUE A double hit of black ensured that the text pages (white or colored letters on a black ground) were evenly covered.

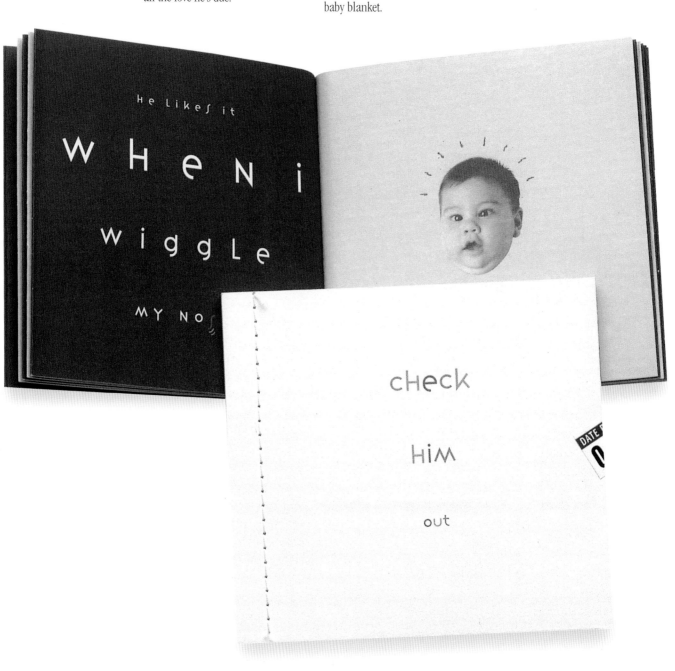

the evolution

ouattara's dream

STUDIO Odd's & End's

CLIENT Portfolio Gallery and Educational Center

ART DIRECTOR Shane W. Evans

DESIGNER Shane W. Evans

ILLUSTRATOR Shane W. Evans

TYPE Hand-rendered, Palatino, Avant Garde

COLOR Four-color process, black

PRINTING Offset

CONCEPT The designer created the mailer for a show of his artwork and photographs, exhibited with pieces by artists from Olorun, a West African art foundation that inspired his trip. The designer did the paintings after a one-month trip to Africa where he worked with African artists (some of their works were also shown). The cover painting, *Ouattara's Dream*, recalls the trip and the many artists represented in the show.

TSD Web Site

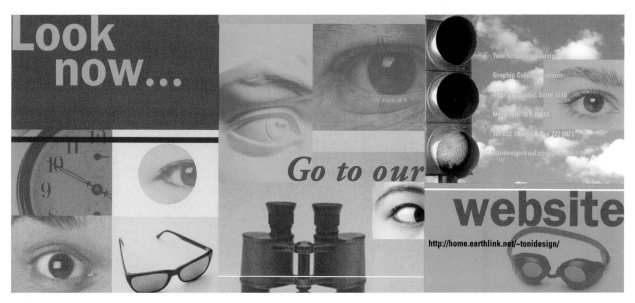

STUDIO Toni Schowalter Design

CLIENT Self

ART DIRECTOR Toni Schowalter

DESIGNER Toni Schowalter

PAPER Zanders 80-lb. (230 g/m²) Coated Cover

TYPE Univers

COLOR Four-color process

PRINTING Digital Offset

CONCEPT Stock photography provided the many images for this piece, which simultaneously announces the design firm's Web site and lets clients know the firm does Web site design. The layered and boxed art recalls Web design, while the eye images urge recipients to "take a look."

COST-SAVING TECHNIQUE The designer created computer-generated, film-free plates for digital printing.

SPECIAL PRODUCTION TECHNIQUE Stock photos from a compact disc, cropped and colored, give a custom look.

Cooking in Provence

STUDIO Teikna

CLIENT Hostellerie de Crillou le Brave

ART DIRECTOR Claudia Neri

DESIGNER Claudia Neri

ILLUSTRATOR Archive

PAPER Champion Benefit

TYPE Perpetuo, Linoscript

COLOR Two PMS

PRINTING Offset

CONCEPT This fold-out self-mailer serves a double purpose: It presents a cooking program and advertises the facilities at Crillou le Brave, a hotel belonging to the prestigious Relais Chateau Association. Recipients are invited to a five-day, hands-on cooking program (or one of several smaller demonstrations) or to simply relax. The archive art was inexpensive and evocative of a simple, old-fashioned setting.

COST-SAVING TECHNIQUE The piece required no envelope.

SPECIAL PRODUCTION TECHNIQUE The die-cut flaps are sealed with a round seal printed in the same match burgundy as the piece.

STUDIO Johnny Vitorovich

CLIENT Bengies Drive-In Theatre

DESIGNER Johnny Vitorovich

ILLUSTRATOR Johnny Vitorovich

PHOTOGRAPHER Johnny Vitorovich

PAPER Mead Signature Gloss 80-lb. (230 g/m²) Cover (Anniversary), French Butcher Natural 80-lb. (230 g/m²) Cover (10 Again)

TYPE Georgianna, Rosewood, Blackoak, Asswipe, Trade Gothic

COLOR Four-color process plus matte and gloss varnish (Anniversary), four-color process plus two PMS (10 Again)

PRINTING Offset

CONCEPT Retro-style type, colors and line art combine with real movie stills for these pieces advertising a drive-in movie theatre. The effect is at once hip and nostalgic.

COST-SAVING TECHNIQUES The designer ganged all images for the eight-page invitation on another project, and set the traps and varnish pages himself.

SPECIAL VISUAL EFFECTS Black-and-white images on the invitation have been printed with a dull varnish, adding to their aged look. For the poster, the designer digitally added the still from a monster movie to the photograph of the drive-in.

Birth Announcement for Christopher May MacFadyen

STUDIO Philographica, Inc.

CLIENT Lisa May and Tevere MacFadyen

ART DIRECTOR Sarah Stearns

DESIGNER Sarah Stearns

PHOTOGRAPHER Sarah Putnam

PAPER Monadnock Astrolite

TYPE Bembo

COLOR Two PMS

PRINTING Offset

CONCEPT The baby's large size was the design inspiration for this announcement. Three tiny close-up photos on the outside act as teasers for the centerfold: a life-size reproduction of the more than 21" (53 cm) baby Christopher. An advertising-style starburst declares that the photo is "actual size," an almost irresistible invitation for the recipient to pick up the announcement and imagine holding the baby.

SPECIAL PRODUCTION TECHNIQUE The trifold invitation hides the full-length photo until it's fully opened.

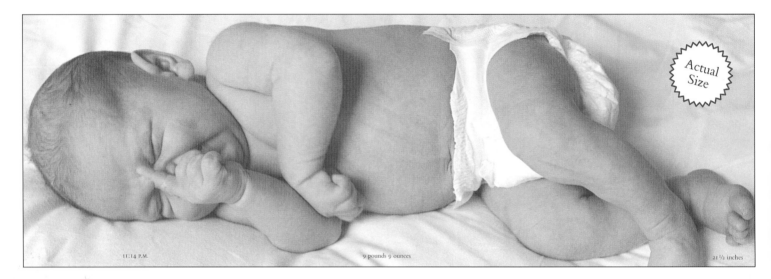

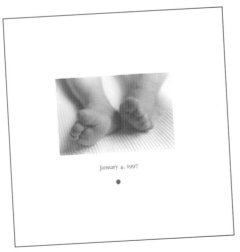

STUDIO Smart Works Pty. Ltd.

CLIENT Melbourne Airport

ART DIRECTOR Jane Jeffrey

DESIGNER Jane Jeffrey

PAPER Chromolux 700 1/s

TYPE Helvetica Neue Family

COLOR Four-color process plus varnish

PRINTING Offset

CONCEPT An invitation to an art show at the Melbourne Airport, this card had to have an elegant look that incorporated a relatively large amount of type. While the reproduction of the tapestry is straight, the tilted type and box give the tapestry a context without detracting from it.

COST-SAVING TECHNIQUES The back of the card is printed in black only. The same art was also used with a different back to promote the airport's artwork to patrons.

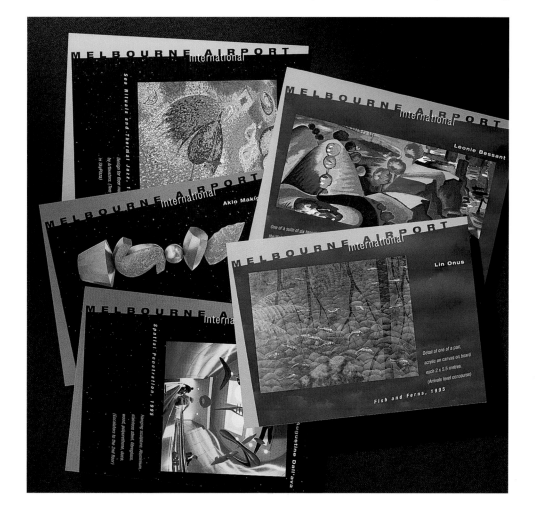

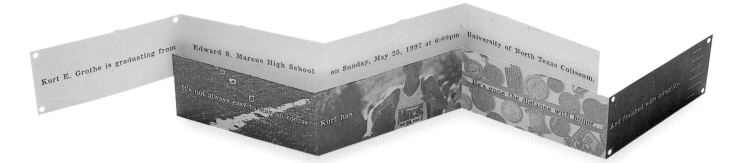

STUDIO Elena Design

CLIENT Kurt Grothe

ART DIRECTOR Elena Baca

DESIGNER Elena Baca

PHOTOGRAPHERS Dave Stock, Elena Baca

COPYWRITER Wendy Thomas

PAPER French Speckletone, Oatmeal

TYPE Attic

COLOR One PMS

PRINTING Offset

CONCEPT The client, who excelled academically and athletically, was particularly interested in cross country and track. The copy refers to his dedication and perseverance in both, while the artwork shows a race track, the client and his many medals. The formal announcement marks "the end of one exhilarating race, and the beginning of another." The back of the piece presents the standard information: name, school, graduation time and place.

SPECIAL VISUAL EFFECTS The long, narrow shape of the Z-folded piece refers to the literal and figurative distance the client has traveled. The final sheet, which includes the giant number 1997 in the background, has holes punched in all four corners. Safety pins are printed by the holes, so that the sheet mimics a race number pinned onto an athlete's shirt.

SPECIAL PRODUCTION TECHNIQUES Adobe Photoshop manipulation helped disguise low-res scans.

Pedal to the Metal #3, #4

STUDIO Vaughn Wedeen Creative

CLIENT US West Communications

ART DIRECTOR Steve Wedeen

DESIGNERS Steve Wedeen, Pamela Farrington

COMPUTER PRODUCTION Pamela Farrington, Stan McCoy

PAPER Domtar Natural Jute, Chipboard

TYPE Gothic, Times Roman

COLOR Two PMS metallics, black

PRINTING Offset

CONCEPT Part of a year-long sales promotion that featured car giveaways, these two cards advertised cars with nostalgia, an approach designed to appeal to women as well as men. Laminated to chipboard for an unusual look and feel, the Kraft-colored pieces feature layered type and metallic inks. On the backs of the cards, detailed information about rules and eligibility is printed in black over ghosted images in metallic ink.

COST-SAVING TECHNIQUE The fronts and backs of both the third- and fourth-quarter pieces were printed on the same sheet.

SPECIAL VISUAL EFFECT Metallic inks glint on Kraft-colored stock, creating an intriguing, textured look that is not slick or glossy.

SPECIAL PRODUCTION TECHNIQUES The fronts and backs were laminated to chipboard, which was too thick for the offset press. To vary their look, some of the metallics were run wet and others dry-trapped.

STUDIO Vaughn Wedeen Creative

CLIENT US West Communications

ART DIRECTOR Steve Wedeen

DESIGNERS Steve Wedeen, Pamela Farrington

COMPUTER PRODUCTION Pamela Farrington

PAPER Domtar Naturals Jute, magnets

TYPE Trade Gothic, Times Roman

COLOR Two PMS metallics, black; four-color process (magnets)

PRINTING Offset

CONCEPT As part of the same year-long sales promotion mentioned on page 82, this companion piece offers up a small gift. The CD-sized chipboard folder was die cut to reveal a tipped-in magnet. A glossy card inserted into the jacket explains rules and eligibility.

SPECIAL VISUAL EFFECTS The inks print differently on the Kraft-colored paper stock laminated to the folder and on the coated-paper insert, adding another visual layer.

SPECIAL PRODUCTION TECHNIQUES The chipboard folder was die cut to reveal the four-color magnet. Like the previous promotion, some of the metallics were run wet and others dry-trapped.

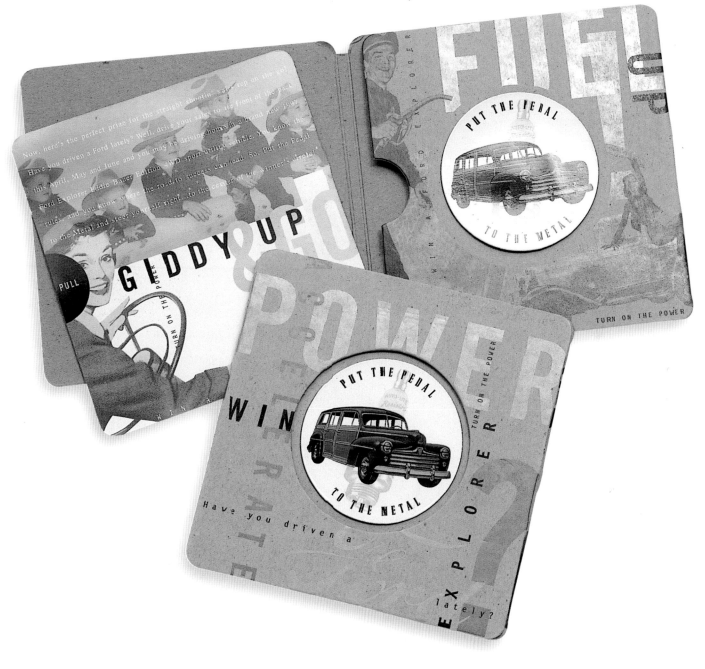

Tsister Birth Announcement

STUDIO Boelts Bros. Associates

CLIENT The Boelts Family

ART DIRECTOR Eric Boelts, Karen Boelts

DESIGNER Eric Boelts

ILLUSTRATOR Eric Boelts

PHOTOGRAPHER Karen Boelts

PAPER Bristol

TYPE Versailles

COLOR Black

PRINTING Photocopy

CONCEPT At age 2½, big sister Hallie Boelts tells great stories. So, her parents decided to let her tell the new baby's birth story, which they made into a book and illustrated with line drawings and photos. Unorthodox measurements ("she is five crayons long") and weights ("she is heavy like Play-Doh") add to the charm.

COST-SAVING TECHNIQUE The piece was photocopied.

> I hold my tsister and she is not big and she is heavy like play doh. She is five crayons long and I am gonna teach her to ride in a wagon. She will share her toys with me.

The Fascination

My baby tsister

Halle Lynn Boelts

Mackenzie's Birth Announcement

STUDIO Canary Studios

CLIENT Ken and Janis Roberts

ART DIRECTOR Ken Roberts

DESIGNER Ken Roberts

CREATIVE CONSULTANT Janis Roberts

PHOTOGRAPHER Janis Roberts

PAPER SihlClear, Confetti

TYPE Democratica

COLOR Black

PRINTING Laser

CONCEPT Throughout her pregnancy, the designer's wife wanted a "cool little birth announcement." Her only requirement was that it be small. After Mackenzie's birth, the designer decided to create something just as "tiny and precious" as Mackenzie was. The vellum sheet makes the little piece seem even more delicate while the orange wrapper, printed with baby faces and visible through the vellum envelope, piques interest.

COST-SAVING TECHNIQUE Laser printing eliminated printing costs, and the parents cut, folded and assembled each piece.

SPECIAL PRODUCTION TECHNIQUES The designer used hair spray "varnish" to darken the printing on the translucent sheet (he recommends X-Tra Firm Hold).

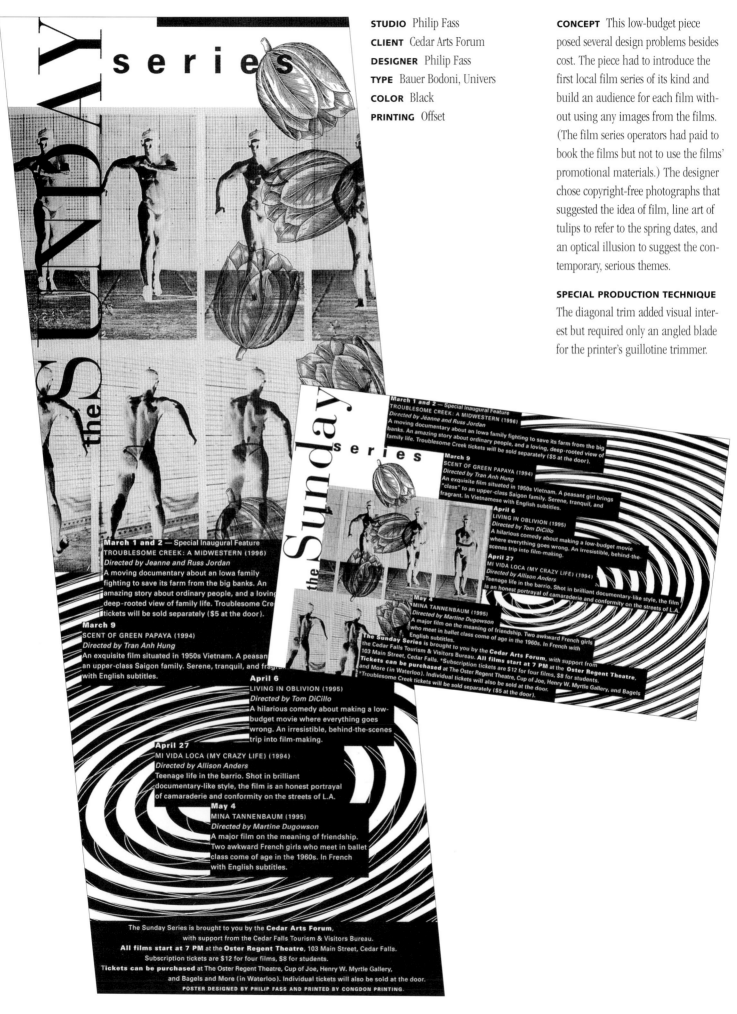

STUDIO Philip Fass

CLIENT Cedar Arts Forum

DESIGNER Philip Fass

TYPE Bauer Bodoni, Univers

COLOR Black

PRINTING Offset

CONCEPT This low-budget piece posed several design problems besides cost. The piece had to introduce the first local film series of its kind and build an audience for each film without using any images from the films. (The film series operators had paid to book the films but not to use the films' promotional materials.) The designer chose copyright-free photographs that suggested the idea of film, line art of tulips to refer to the spring dates, and an optical illusion to suggest the contemporary, serious themes.

SPECIAL PRODUCTION TECHNIQUE
The diagonal trim added visual interest but required only an angled blade for the printer's guillotine trimmer.

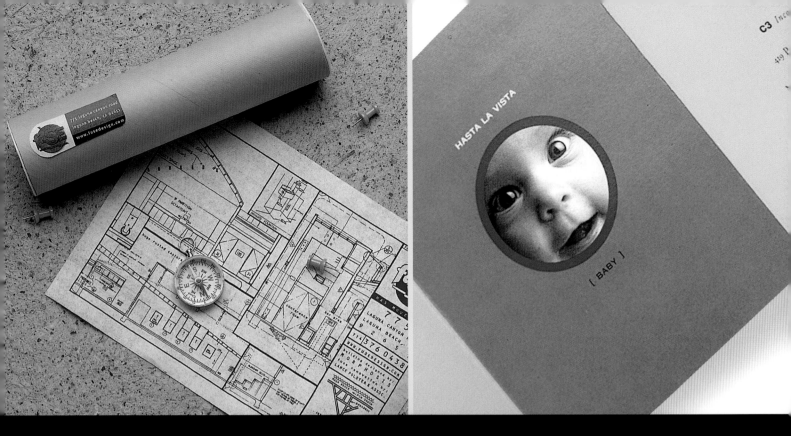

MOVING
ANNOUNCEMENTS

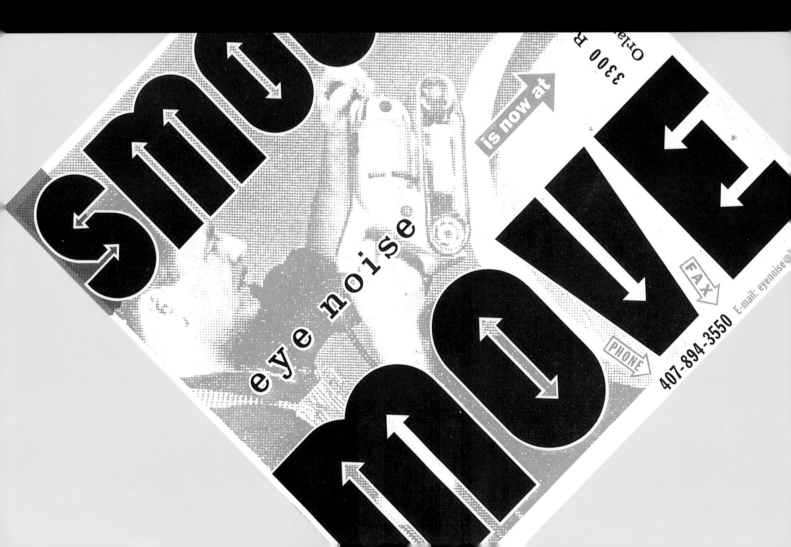

STUDIO Jeffrey Leder Inc.

CLIENT Self

ART DIRECTOR Jeffrey Leder

DESIGNERS Jeffrey Leder,
Carlos Teseda

PAPER Vintage Velvet 100-lb. (288
g/m²) Cover (card), Simpson Starwhite
Vicksburg Tiara (envelope)

TYPE Futura, Torino

COLOR Two process colors

PRINTING Offset

CONCEPT This announcement uses wit and humor to show the company's strong ties to New York City. Stock photos and well-known lyrics (paraphrased) strike a light note, while communicating love for the city.

SPECIAL VISUAL EFFECT An image from the announcement decorates the envelope, piquing the recipient's interest.

SPECIAL PRODUCTION TECHNIQUE The photos are reproduced as duotones.

Communication Via Design

STUDIO Communication Via Design

CLIENT Self

ART DIRECTOR Victoria Adyami

DESIGNERS Victoria Adyami/Elizabeth Swartz

PHOTOGRAPHER Craig Orsini

TYPE Meta, Matrix

COLOR Two PMS

PRINTING Offset

CONCEPT Photographs of a dove and her nest form the focal images of this piece, which doubled as a New Year's card. The dove on the cover symbolizes peace and the New Year, while the nest inside symbolizes the firm's new address. On the back, a tiny photo of the dove holding a feather in her beak decorates an invitation to see "new additions to our portfolio."

COST-SAVING TECHNIQUE The cards were printed with the firm's new business cards.

437 D Street | Suite 4B | Boston, Massachusetts 02210

As we celebrate our **new office** and **new beginning**, Communication Via Design would like to extend much thanks and appreciation for your ongoing business and support.

May the **new year** bring you peace enduring.

T 617.204.9500 | F 617.204.9520

new address

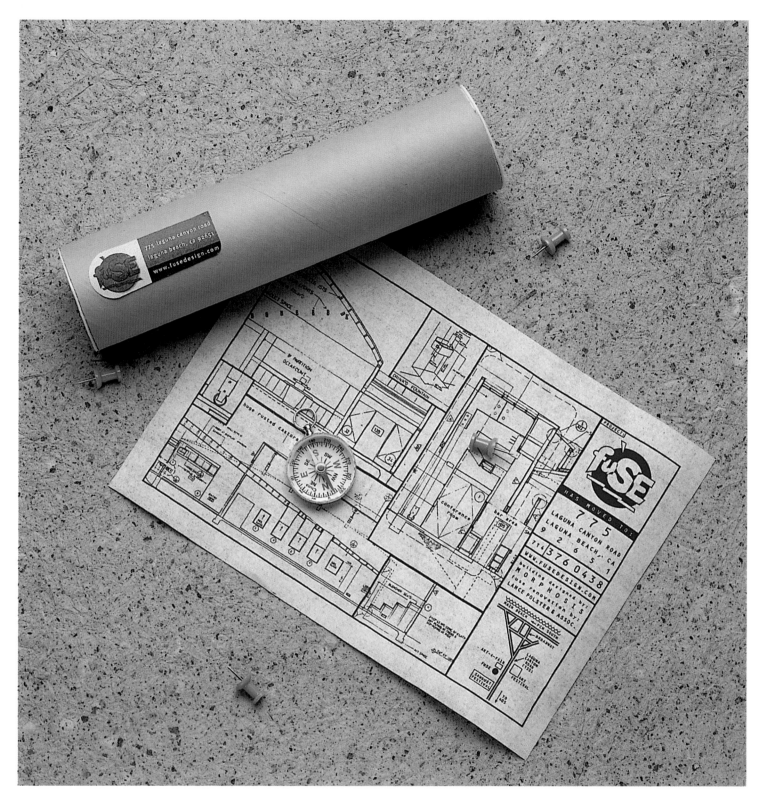

STUDIO FUSE

CLIENT Self

ART DIRECTOR Russell Pierce

DESIGNER Corinna Lietz

ORIGINAL DIAGRAMS Morphosis

PAPER Blueprint

TYPE OCRB

PRINTING Diazo

CONCEPT After staring for months at blueprints of the firm's new home, a former nightclub, the designers decided to share the experience with clients. They scanned and collaged diagrams and had their architect produce them as blueprints. The most expensive part of the invitation was the toy compass (one dollar each) mailed out with each announcement.

SPECIAL VISUAL EFFECT Each announcement was mailed in a tube with a toy compass and four blue thumbtacks.

SPECIAL PRODUCTION TECHNIQUE Because the first set of proofs from the architect was too clean, the designer used vellum to give the blueprints more texture and a darker color. Finding cheap compasses proved the most difficult challenge.

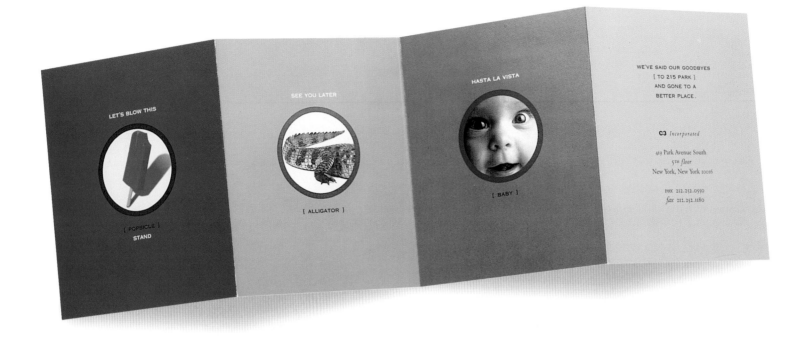

LET'S BLOW THIS

[POPSICLE]
STAND

SEE YOU LATER

[ALLIGATOR]

HASTA LA VISTA

[BABY]

WE'VE SAID OUR GOODBYES
[TO 215 PARK]
AND GONE TO A
BETTER PLACE.

C3 *Incorporated*

419 Park Avenue South
5th *floor*
New York, New York 10016

BOX 212.252.0550
fax 212.252.1180

STUDIO C3 Incorporated
CLIENT Self
ART DIRECTOR Randall Hensley
DESIGNER Peter Belsito, Scott Williams
CREATIVE DIRECTORS Randall Hensley, Billie Harber
PAPER Carolina 12 pt. CLS
TYPE Copperplate, Garamond, Helvetica Black
COLOR Four-color process
PRINTING Offset

CONCEPT This bright, accordion-folded piece communicates the firm's move through clichés about saying goodbye. Stock photography decorates the central circles, and each page is given a single bright color. The upbeat look minimizes the move and implies that business is proceeding as usual.

STUDIO Pensaré Design Group Ltd.

CLIENT Self

ART DIRECTOR Mary Ellen Vehlow

DESIGNER Camille Song

PAPER Carnival Red 80-lb. (230 g/m²) Cover, Yellow Grooved 80-lb. (230 g/m²) Cover

TYPE Bernhard Modern BT, Silhouette

COLOR Black

PRINTING Inkjet

CONCEPT This piece literally and figuratively announces that the firm has "moved around the corner." A brass fastener connects the smaller, smooth red square to the larger, grooved yellow square. The recipient turns the red square to reveal the message printed on the edges of the yellow one.

COST-SAVING TECHNIQUES The yellow paper was donated, printing was done on an office printer and the staff assembled all 250 announcements.

SPECIAL VISUAL EFFECT The head of the brass fastener takes the place of a lightbulb on the firm's logo.

SPECIAL PRODUCTION TECHNIQUE To help it turn better and to keep it from tearing the paper, each brass fastener passes through a brass washer on the back of the invitation.

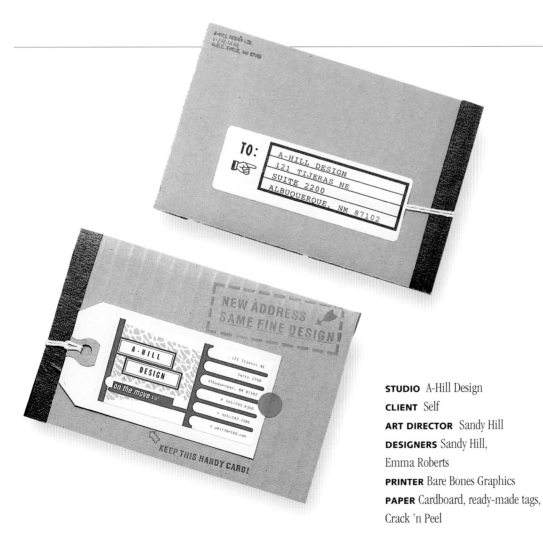

TYPE Franklin Gothic Condensed, Letter Gothic

COLOR One PMS, black

PRINTING Offset, rubber stamp

CONCEPT With a tight budget and only two weeks before a move to a temporary office, the designers decided on a tongue-in-cheek look that emphasized the short-term nature of the move. They had rubber stamps made for $14 each. They also purchased stock tags and mailing labels, and assembled the pieces into a collage of items. The only printing was the two-color, Crack 'n Peel labels, which are also used on the firm's stationery and business cards.

STUDIO A-Hill Design

CLIENT Self

ART DIRECTOR Sandy Hill

DESIGNERS Sandy Hill, Emma Roberts

PRINTER Bare Bones Graphics

PAPER Cardboard, ready-made tags, Crack 'n Peel

COST-SAVING TECHNIQUE The piece was assembled in-house.

SPECIAL PRODUCTION TECHNIQUE The black stripe on the edge of the cardboard is made with electrical tape.

STUDIO Keiler & Co.

CLIENT Risk Capital Reinsurance

ART DIRECTORS James Pettus, Mel Maffei, Mike Scricco

DESIGNER James Pettus

ILLUSTRATOR James Pettus

COPYWRITER Mel Maffei

PAPER Mohawk Superfine Ultra White Smooth Cover

TYPE Arbitrary, New Caledonia, Perpetua

COLOR Four-color process, one PMS

PRINTING Offset

HE'S NOT HELPING US REVOLUTIONIZE THE REINSURANCE INDUSTRY.

HE'S NOT HELPING US BUILD A GLOBAL IMAGE.

HE'S HELPING US MOVE OUR OFFICES ON DECEMBER 2ND.

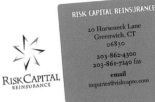

RISK CAPITAL REINSURANCE

20 Horseneck Lane
Greenwich, CT
06830

203-862-4300
203-861-7240 fax

email
inquiries@riskcapre.com

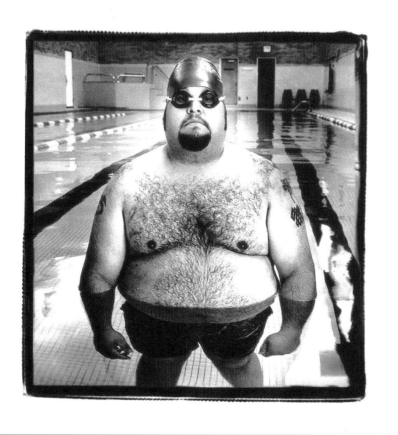

CONCEPT A striking stock photograph provides the cover image for this accordion-folded moving announcement, inspiring the recipient to open it. Inside is a humorous explanation ("He's helping us move our offices") and a die-cut, circular file card with the business's new address. The irreverent style matches the reinsurance company's advertising pieces.

SPECIAL PRODUCTION TECHNIQUE The circular file card is perforated so clients can remove it easily.

STUDIO Eye Noise

CLIENT Self

DESIGNER Thomas Scott

TYPE Direction (redrawn), Egyptian, Franklin Gothic

COLOR One PMS, black

PRINTING Offset

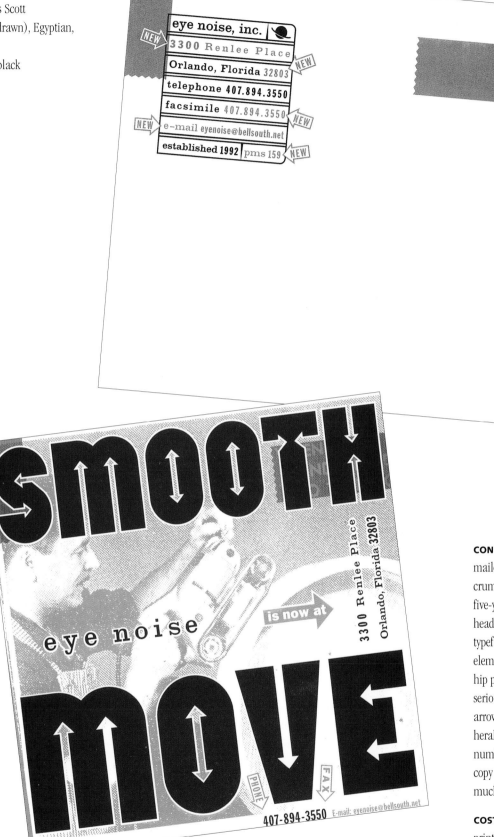

CONCEPT The designer calls this self-mailer "a perfect design marriage of a crummy photo swiped from a forty-five-year-old magazine, dumb joke headline and a really dumb display typeface." Somehow these "dumb" elements add up to a sophisticated and hip piece that doesn't take itself too seriously. On the reverse, orange arrows shouting the word "new" herald the new address, zip code, fax number and e-mail address, while copy printed in black emphasizes that much remains the same.

COST-SAVING TECHNIQUE Film and printing were donated. The uncoated cover stock was whatever the printer had available.

THinc Design

STUDIO Drive Communications
CLIENT Tom Hennes Inc.
ART DIRECTOR Michael Graziolo
DESIGNER Michael Graziolo/Frank Kiernan
PAPER Mohawk Satin Smooth Cool White 80-lb. (230 g/m²) Cover
TYPE Frutiger Condensed, Sabon
COLOR Two PMS
PRINTING Offset

CONCEPT This interactive announcement reveals its information gradually with stylish playfulness. Its kinetic design matches the client, an architectural design firm whose elegant, intelligent style doesn't lose a sense of fun. The copy and design work together to imply motion, as well as a literal move.

SPECIAL VISUAL EFFECTS The curve in the upper right-hand corner, made up of red dots, draws the eye to the red arrow that tells recipients to pull out the insert. Once the piece is fully extended, the curve lengthens and leads to the design firm's name.

SPECIAL PRODUCTION TECHNIQUES The die-cut rectangles reveal various messages: "THinc twice," "THinc again" and the apropos "THinc ahead."

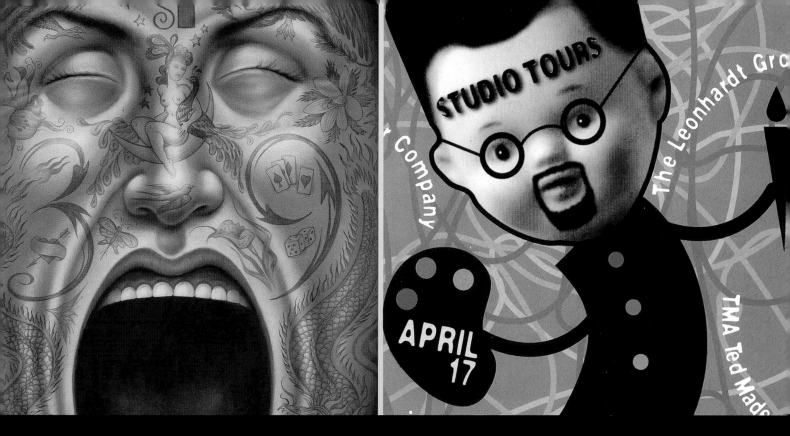

GRAPHIC DESIGN INVITATIONS AND ANNOUNCEMENTS

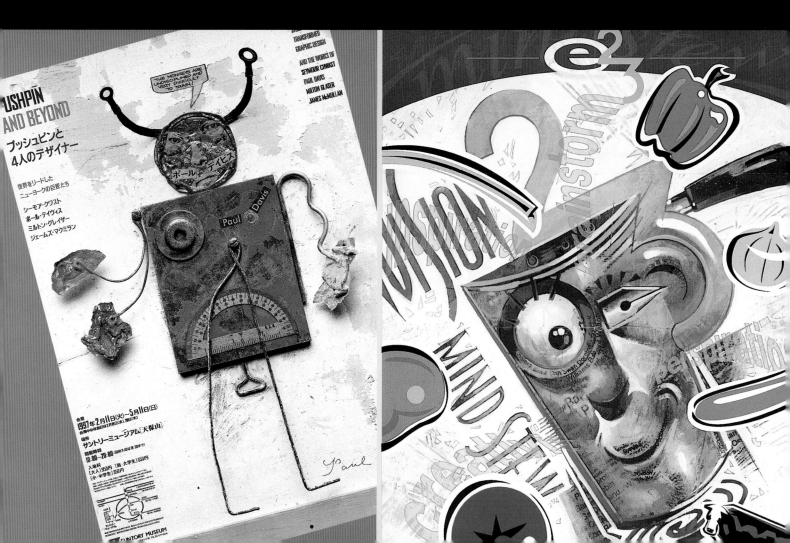

STUDIO D.J. Stout

CLIENT Society of Illustrators

ART DIRECTOR D.J. Stout

DESIGNER D.J. Stout

ILLUSTRATOR Anita Kunz

PAPER Cougar Opaque

TYPE Helvetica Bold, various sans serif faces from old posters

COLOR Four-color process (one side), two PMS (one side)

PRINTING Offset

CONCEPT Posters don't have to be pleasant. For this poster, the first time a woman had been asked to illustrate the call for entries for the Society, the illustrator and art director wanted to make an "in-your-face" statement that would be younger, hipper and very different from anything seen on previous posters. The "illustrated woman" can be interpreted as simply calling for entries or as a woman illustrator venting frustration with the business. However interpreted, it demonstrates the power of illustration to communicate.

STUDIO Lorig Design

CLIENT AIGA/Seattle

ART DIRECTOR James Clark

DESIGNER Steffanie Lorig/Lorig Design

ILLUSTRATOR Steffanie Lorig

TYPE Washout, Myriad

COLOR Two PMS

PRINTING Offset

Mix it up with **SIX of Seattle's HOTTEST design studios.** You have from 6 p.m. till 9 p.m. on Wednesday, April 17, 1996 to **check out their pads,** groove with the people who make it happen, and see some of their work. Don't miss this once-a-year chance to be a part of the AIGA Studio Tour! It promises to be **GROOVY.** Be there or be SQUARE. You can buy tickets at any of the participating studios. Your admission pays for all six studios (**$5** students and AIGA members with ID; **$10** non-members). Personal checks are accepted (no plastic please). Two colorful magic buses will make the rounds every 15 minutes to get you to each studio for FREE! **See you there!**

Acme Media Moving & Storage
1904 Third Avenue, Suite 800

The Leonhardt Group
1218 Third Avenue, Suite 620

Phinney Bischoff Design House
614 Boylston Avenue East

TMA Ted Mader & Associates
2562 Dexter North

The Traver Company
80 Vine Street, Suite 202

Sub-Pop Records
1932 First Avenue, Suite 308

American Institute
of Graphic Arts
Seattle Chapter
1809 7th Ave. Suite 500
Seattle, WA 98101

PRESORTED
FIRST-CLASS MAIL
U.S. POSTAGE PAID
SEATTLE, WA
PERMIT #467

F A R O U T

Muchas gracias Thumbprint Printing & Steffanie Lorig, Clark+Gable Design

CONCEPT To make AIGA/Seattle's annual tour of design firms fun and approachable, the designer based the main illustration on a Kokopelli figure she describes as "a god to some, a nuisance to others." She transformed the American Indian symbol into a stereotypical designer, complete with goatee, black clothes and round glasses. Six houses represent the six open studios the figure is visiting, and a moon swinging in the mod sky represents the tour's evening hours.

COST-SAVING TECHNIQUES Design was donated. The photo for the Kokopelli figure's face came from a stock photograph.

moo

STUDIO Mark Oldach Design, Ltd.

CLIENT Art Directors' Association of Iowa

ART DIRECTOR Mark Oldach

DESIGNERS Don Emery, Guido Mendez

PAPER Potlatch Quintessence

TYPE Syntax, Matrix Script

CONCEPT Designers love to collect the posters that designers/speakers create about themselves. Usually distributed to attendees after a presentation about the designer's work, the posters present a unique, noncommercial opportunity for self-expression. This two-color poster allowed the speaker, according to the tiny copy, "to take full advantage of the name that gave him so much trouble in junior high gym class" and at the same time say something about the presentation's Iowa setting.

STUDIO Paul Davis

CLIENT Suntory Museum, Osaka, Japan

ILLUSTRATOR Paul Davis

CONCEPT Each of the four artists celebrated in this exhibit (Paul Davis, Milton Glaser, Jim McMullan and Seymour Chwast) did a self-portrait depicting himself as a robot. Paul Davis's celebrated wit is evident in his piece, a humorous collage with a rather forbidding face and "found" quotation.

SPECIAL VISUAL EFFECT Making it look easy, Davis arranged the map and dense, two-language copy in a way that's not crowded or difficult to read.

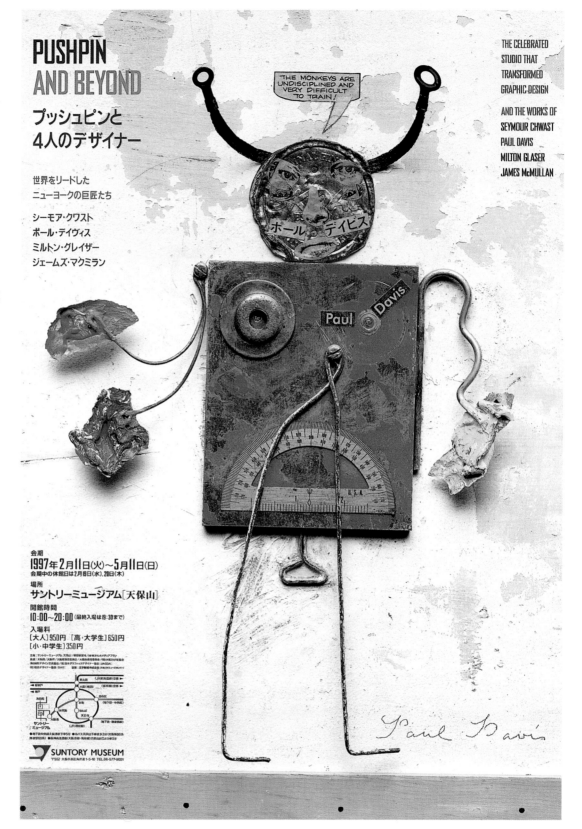

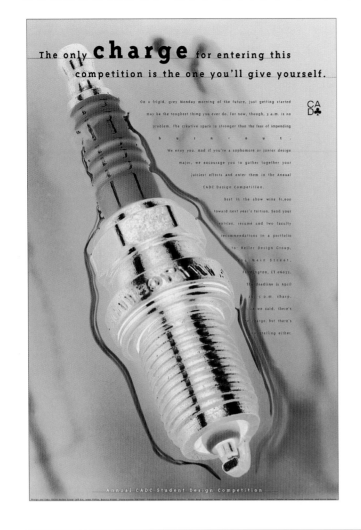

STUDIO Keiler & Co.

CLIENT Connecticut Art Directors Club

ART DIRECTORS Jeff Lin, James Pettus

DESIGNERS Jeff Lin, James Pettus

ILLUSTRATOR James Pettus

PHOTOGRAPHER Jim Coon

PAPER Mead Signature Gloss 80-lb. (230 g/m²) Cover

TYPE Triplex

COLOR Four-color process, varnish

PRINTING Offset

CONCEPT The giant sparkplug provides the focus image for this poster that advertises a free competition for student scholarships. Explanatory copy in small type is visible only from up close and is not meant to be read by anyone but the interested parties.

COST-SAVING TECHNIQUE For this probono project, designers did the image manipulation and colorization (to provide the glowing look) in Adobe Photoshop.

SPECIAL VISUAL EFFECT The sparkplug was photographed in water to help create its glow.

Fifth Anniversary Design Workshop

STUDIO University of Utah Graphic Design

CLIENT University of Utah Youth Education

ART DIRECTOR Scott Greer

DESIGNER Jay Hill

COPYWRITER Ted Brewer

PAPER Gilbert Voice Natural 80-lb. (230 g/m²) Cover

COLOR Two PMS

TYPE Typewriter Regular

PRINTING Offset

CONCEPT This piece, designed to attract high school students to a short class about careers in design fields, relies on simple images that suggest design without specifying any one discipline. Produced simply and on a low budget, it attracted record numbers of students, spilling over into a waiting list for the first time in the workshop's history.

STUDIO Kiku Obata & Co.

CLIENT AIGA/St. Louis

DESIGNERS Terry Bliss, Pam Bliss, Eleanor Safe

PHOTOGRAPHER David Stradal

COPYWRITER Carole Jerome, Simon & Schuster, Inc.

PAPER Lustro Dull Creme Cover, French Dur-O-Tone, Mohawk

TYPE Bakerville, Nobel, Egiziano

PRINTING Offset

CONCEPT A humorous answer to the question "Why enter design contests?" was the impetus for this call-for-entries poster and invitation. The invitation, a booklet with the cover of Dale Carnegie's classic *How to Win Friends and Influence People*, purports to deliver the "fundamental techniques of competition entry." The entry information is interspersed with quotations from Carnegie, all out of context.

Likewise, the poster offers "recognition of your true worth," leadership and even increased income.

COST-SAVING TECHNIQUE Most of the paper was donated, as was the printing and photography.

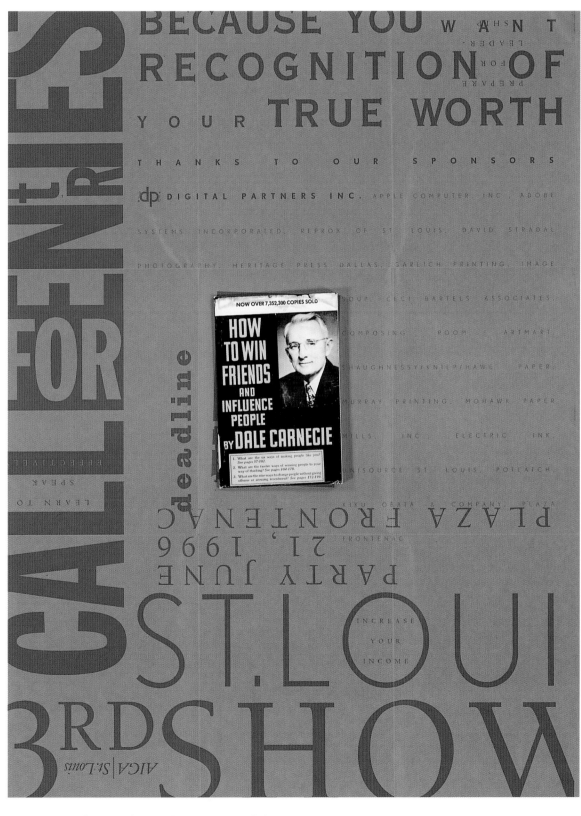

Gilbert G3 Call for Entries

STUDIO Miriello Grafico, Inc.
CLIENT Gilbert Paper Co.
ART DIRECTOR Ron Miriello
DESIGNERS Michelle Aranda,
Courtney Mayer
PHOTOGRAPHER Ken West
Photography
PAPER Gilbert Gilclear, Gilbert
Oxford, Gilbert Esse
TYPE Maximus, Agenda, Caslon,
Futura
COLOR Four-color process,
dull varnish
PRINTING Offset

CONCEPT This playful call for entries
for the paper company's new design
competition focuses on creativity. The
case, reminiscent of a sleeve for an old
45 record, holds a surprise: a toy.
Three translucent circles overlap in a
central cutout circle, making a kalei-
doscope. Designers hold the toy up to a
light and turn the circles, making new
images each time. The result is a tan-
gible reminder that ideas come from
play, experiment and accident, as well
as from hard work.

SPECIAL VISUAL EFFECT The kalei-
doscope is an ideal demonstration of
the translucent paper's strengths,
showing both how it holds up to four-
color printing and how it allows light
to pass through.

SPECIAL PRODUCTION TECHNIQUE
Metal grommets hold the disks in
place and allow them to turn.

STUDIO T.P. Design, Inc.

CLIENT Art Directors and Artists Club

ART DIRECTOR Missy Anapolsky

DESIGNER Dorthea Taylor-Palmer

ILLUSTRATOR Charly Palmer,
Dorthea Taylor-Palmer

BACK OF POSTER DESIGN Jeff
Clinton, Stump Removal Graphics

COPYWRITER Melissa Thurber,
Shawn Turner

PAPER Potlatch Vintage Velvet Creme
80-lb. (230 g/m²) Text

TYPE Times, Gill Sans

COLOR Four-color process

PRINTING Offset

CONCEPT Designers began their work
for this piece by creating a logo for the
"Mindstew" conference, a graphic
combining a boiling pot, a face, the
event title and a slogan. Instead of
using the logo for the main image,
they redrew the main image as a con-
ventional illustration using various
media. For fun, they added lots of
ingredients — words ("perspiration,"
"creativity," "brainstorm") and
food (a pepper, an onion, a tomato).
The reverse side of the fold-out
poster, designed by a different firm,
gives all the speaker and registration
information.

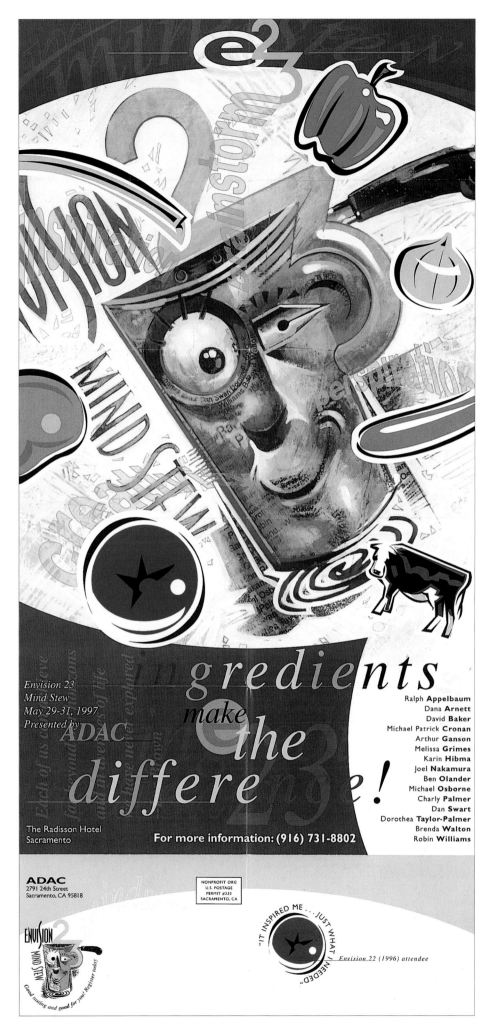

STUDIO Sayles Graphic Design
CLIENT AIGA/St. Louis
ART DIRECTOR John Sayles
DESIGNER John Sayles
ILLUSTRATOR John Sayles

PAPER Curtis Parchment
TYPE Typewriter, various
COLOR Four PMS
PRINTING Offset

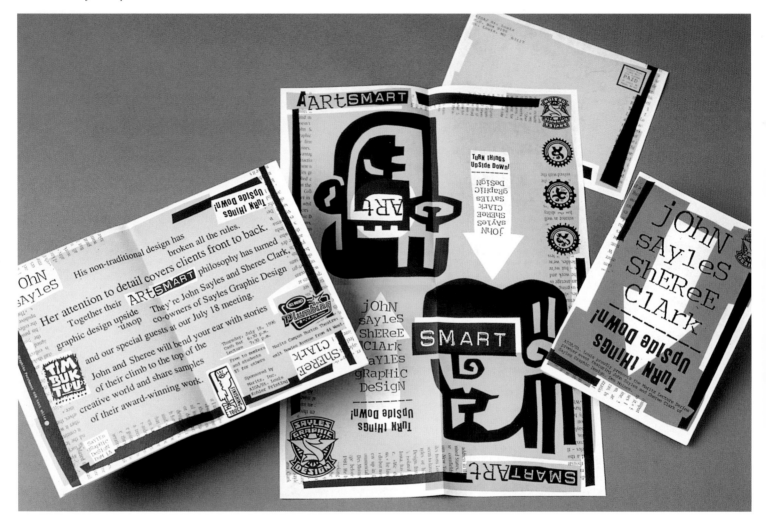

CONCEPT This self-mailing, fold-out poster advertising a presentation by the designers was printed in one common color on both sides with fluorescent accents to give the feel of more colors. It features the firm's signature style, a bold graphic look. In keeping with the title, several images were inverted.

STUDIO Philip Fass

CLIENT Gallery of Art, University of Northern Iowa

DESIGNER Philip Fass

PHOTOGRAPHER Darci Bechen

PAPER Neenah Ultra

TYPE Bauer Bodoni, Frutiger Family

COLOR One PMS metallic

PRINTING Offset

CONCEPT Designed for a visually literate audience, this piece plays on the translucent sheet and metallic ink with layered, masked type and the image of a cloudy sky. Not readable at a distance, the poster demands an audience familiar with the event, one that enjoys a graphic challenge.

COST-SAVING TECHNIQUE Two posters fit on each press sheet.

SPECIAL VISUAL EFFECT The 100-percent border creates a frame for the piece, keeping the many-shaded image in context and eliminating the printing problems of a full bleed.

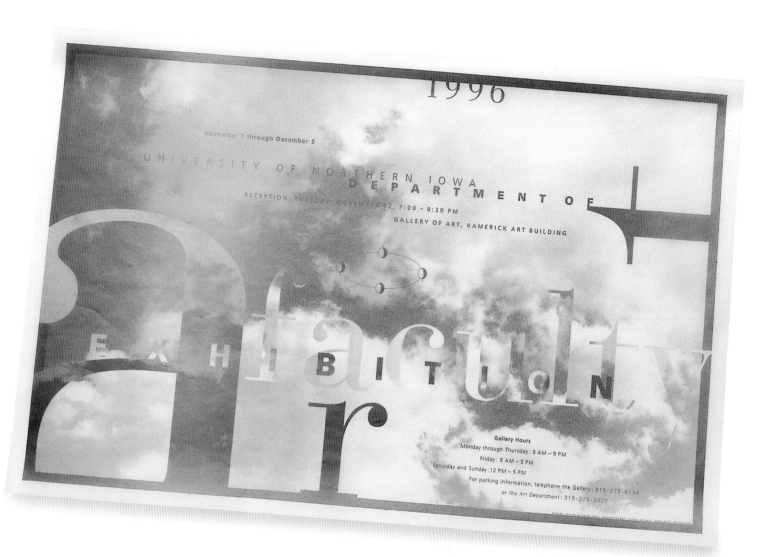

Ann Willoughby AIGA Event Mailer

STUDIO Gardner Design

CLIENT AIGA/Wichita

ART DIRECTOR Bill Gardner

DESIGNERS Bill Gardner, Jason Gardner

ILLUSTRATORS Bill Gardner, Jason Gardner

COPYWRITER Gail Tamerius

PAPER Mead Offset Mate 80-lb. (230 g/m²) Cover

TYPE Trixie, Triplex

PRINTING 4/1 offset lithography

CONCEPT The attention-grabbing cover promises a great lunch speech and at the same time references one of the designer's recent projects, a promotion for Lee Apparel's Riveted line of jeans. The layered type and unusual colors catch the eye, the quotation and question catch the reader's interest, and the reverse side answers all questions succinctly. Key words (the designer's name, the date and the words "lunch included") appear reversed out of black boxes.

SPECIAL PRODUCTION TECHNIQUE To get four colors, the cards were run through two passes on a small two-color press.

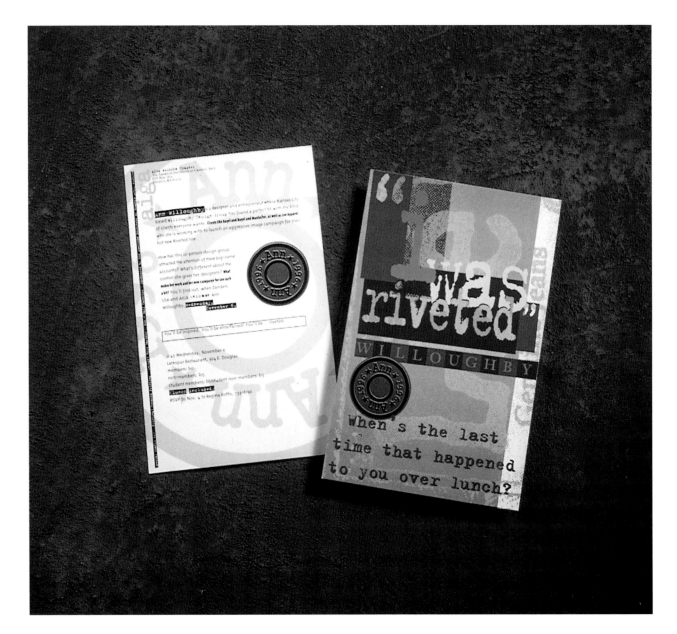

STUDIO Todd Childers

CLIENT Bowling Green State University School of Art Gallery

ART DIRECTOR Todd Childers

DESIGNER Todd Childers

ILLUSTRATOR Todd Childers

PHOTOGRAPHER Todd Childers

HAND MODEL Jennifer Karches

TYPE OCR B, Fraktura, Usher

PRINTING Offset

CONCEPT This two-sided card announced two simultaneous events: the American Center for Design 100 Show and a faculty show. Devoting one side to each event might mean that one would be overlooked. The designer included both events on each side, giving the majority of space to one but clearly mentioning the other. Whichever side the recipients chose to post would remind them of both events.

SPECIAL VISUAL EFFECT The layered visuals suggest more ink colors than were actually used and also hint at the variety of design styles in both shows.

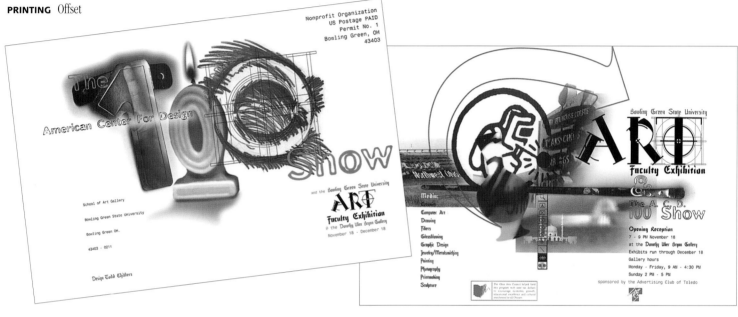

STUDIO Sommese Design

CLIENT AIGA/Jacksonville

ART DIRECTOR Jefferson Rall/Robin Shepherd Studios, Lanny Sommese

DESIGNER Lanny Sommese

ILLUSTRATOR Lanny Sommese

PAPER Warren Patina Matt 80-lb. (230 g/m²) Cover

TYPE Futura Bold

COLOR Two PMS

PRINTING Two editions, screenprinted and offset

CONCEPT Sommese used an illustration he had created for an earlier presentation — a dog being erased as it jumped over a pencil — changing it to reflect the new locale. The designer added a horizon line, enlarged the lower part of the pencil and added a sandy color to represent Florida beaches, all to say that he was leaving his Pennsylvania home to "do his tricks" in Jacksonville.

SPECIAL PRODUCTION TECHNIQUES The advertisement poster, backed with ticket information and mailed folded, was offset printed. A second run of commemorative posters was screenprinted and given away to everyone who attended the lecture.

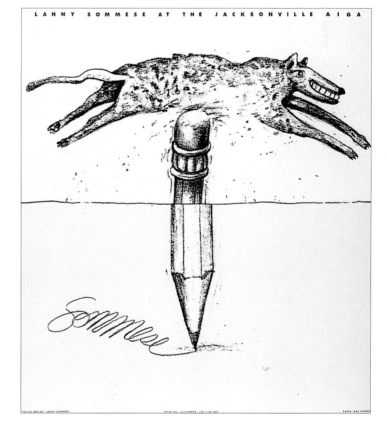

AIGA/New York Poster/Calendar

STUDIO J. Graham Hanson Design

CLIENT AIGA/New York

ART DIRECTOR J. Graham Hanson Design

DESIGNERS J. Graham Hanson, Dani Piderman

PHOTOGRAPHY Photodisk, Inc.

PAPER Utopia Premium Blue White Silk 90-lb. (260 g/m²) Cover

TYPE Frutiger

COLOR Four-color process, one PMS

PRINTING Offset

CONCEPT The long, narrow poster was designed to fit cubicles and other small workstations. The designers sought practicality and a clean, readable look, but still handled the calendar design creatively. The image conveys the idea of time and dates, setting the scene for the unconventional calendar arrangement.

American Institute of Graphic Arts
New York Chapter
Calendar of Events 1996-97
AIGA**NY**

American Institute of
Graphic Arts
New York Chapter
545 West 45 St
New York, New York 10036

SEPTEMBER 1996
17 A Night at the Movies
Co-sponsored by Potlatch Corporation
Sony Imax Theater

OCTOBER 1996
16 From the Spoon to the City:
An Evening with
Leila and Massimo Vignelli
Katie Murphy Amphitheatre, FIT

21 Small Talk: Multicultural Design
Peter Cooper Suite, The Cooper Union

NOVEMBER 1996
07 New Members Reception
Location to be announced

18 Small Talk: Small Press Books
Peter Cooper Suite, The Cooper Union

DECEMBER 1996
Happy Holidays!

JANUARY 1997
15 Information Graphics
Katie Murphy Amphitheatre, FIT

FEBRUARY 1997
03 Small Talk: Spec Work
Peter Cooper Suite, The Cooper Union

26 Business Breakfast Seminar 1: Marketing
Student Lounge, FIT

MARCH 1997
08 Multimedia: Hands On
Location to be announced

12 Point/Counterpoint
Katie Murphy Amphitheatre, FIT

26 Business Breakfast Seminar 2: Estimating
Student Lounge, FIT

APRIL 1997
14 Small Talk: Portfolios Review
Peter Cooper Suite, The Cooper Union

16 Food for Thought
Location to be announced

30 Business Breakfast Seminar 3:
Financial Planning
Student Lounge, FIT

MAY 1997
01 3rd Annual Job Fair
Location to be announced

14 Fresh Dialogue and Annual Meeting
Katie Murphy Amphitheatre, FIT

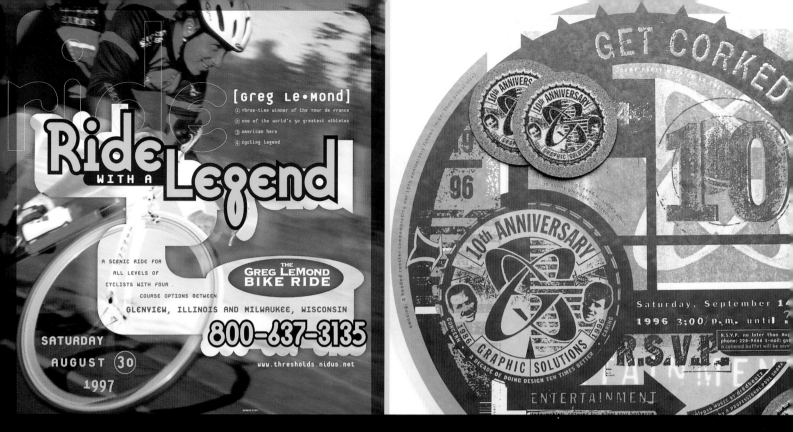

POSTERS

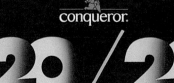

Leeches

STUDIO Free-Range Chicken Ranch

CLIENT Genentech Access Excellence Program

ART DIRECTOR Kelli Christman

DESIGNER Kelli Christman, Toni Parmley

ILLUSTRATOR Donna Gilbert

SPECIAL PRINTING Cities West

PAPER Gloss Book 100-lb. (288 g/m²)

TYPE Flaco Solid, Helvetica Black, Bank Gothic, Slaughterhouse

COLOR Five PMS, varnish

PRINTING Offset

CONCEPT The ostensible design challenge for this two-sided poster was to intrigue biology students without offending their teachers. The solution was a combination of bloodthirsty type and copy, horror movie colors and X-rays of leeches and their organs. The poster's second side, a study guide, includes information about how to access the client's Web site and online forum for biology teachers. Therefore, the real design challenge was to create three separate pieces (a classroom poster, a class study guide and an advertisement) on one sheet of paper.

SPECIAL VISUAL EFFECT The combination of layered colors, metallic inks and varnish creates a nightmarish, horror film look.

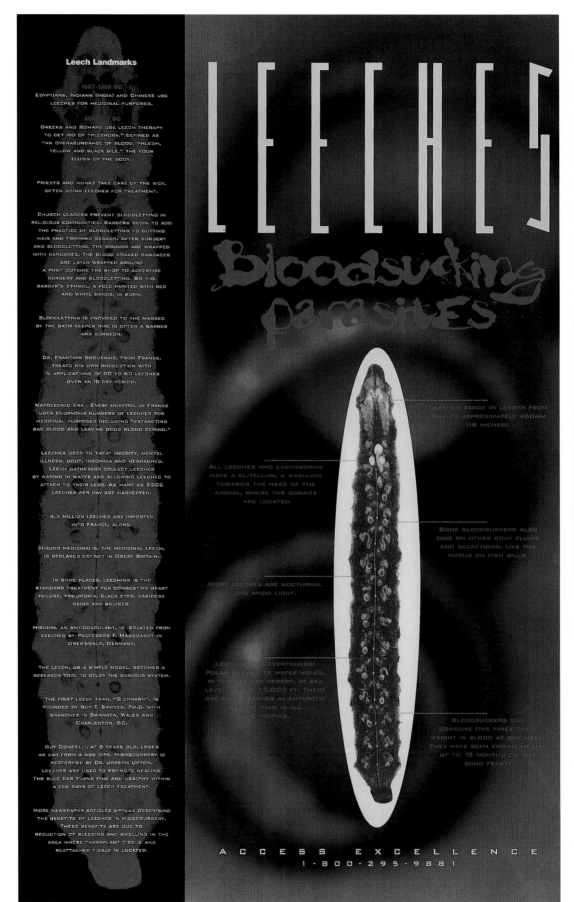

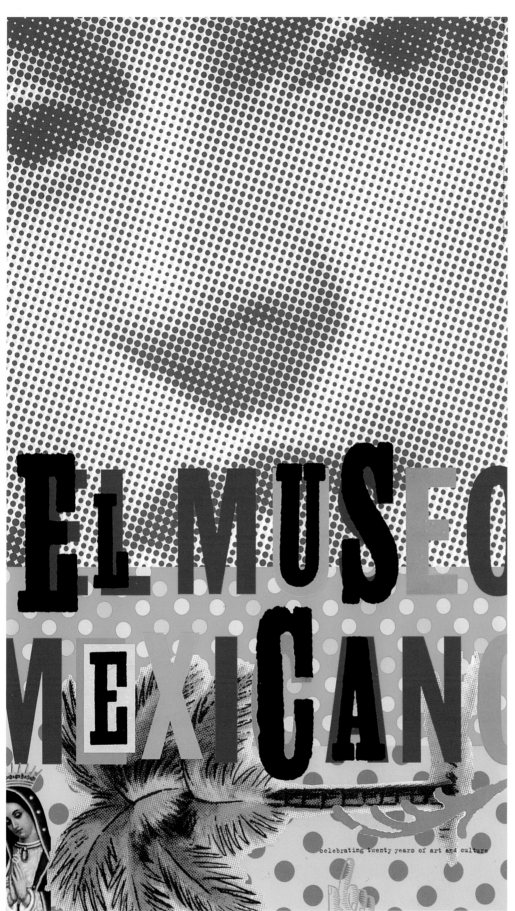

STUDIO Morla Design

CLIENT The Mexican Museum/Bacchus Press, San Francisco

ART DIRECTOR Jennifer Morla

DESIGNERS Jennifer Morla, Craig Baily

PHOTOGRAPHY Courtesy of International Museum of Photography at George Eastman House

PAPER Simpson Coronado SST Recycled 65-lb. (187 g/m²) Cover

TYPE Franklin Gothic Extra Condensed, various Mexican wood-block faces

COLOR Four-color process, one PMS

PRINTING Offset

CONCEPT Meant to be given away before a major capital fund drive, this poster commemorating the museum's twentieth anniversary includes icons from traditional and contemporary Mexican art. A portrait of artist Frida Kahlo and an image of Our Lady of Guadalupe, both quintessential Mexican images, complement the woodblock type and art from "lotteria" bingo games. The mixture both represents and celebrates Mexican art and its presence in the United States.

STUDIO Viva Dolan Communications + Design

CLIENT Conqueror Fine Papers

ART DIRECTOR Frank Viva

DESIGNER Frank Viva

ILLUSTRATOR Frank Viva

WRITER Doug Dolan

PAPER Conqueror Bright White and Lightspeck

TYPE Monotype Gill Sans (20/20), custom (Lightspeck)

COLOR Four-color process

PRINTING Offset (20/20), offset with stochastic screen (Lightspeck)

CONCEPT Both pieces use similar colors and retro imagery, marking the papers they advertise as part of a whole line. Yet they also perform important and different functions. The poster for Lightspeck papers served to introduce a new, pale-flecked paper to the North American market. The Lightspeck poster's graphics emphasize the paper's newness and its "amazing" properties. The poster for 20/20, on the other hand, emphasizes the company's precision engineering with the poster's unusual die-cut shape. The 1930s British/French style is used throughout the company's North American promotional materials.

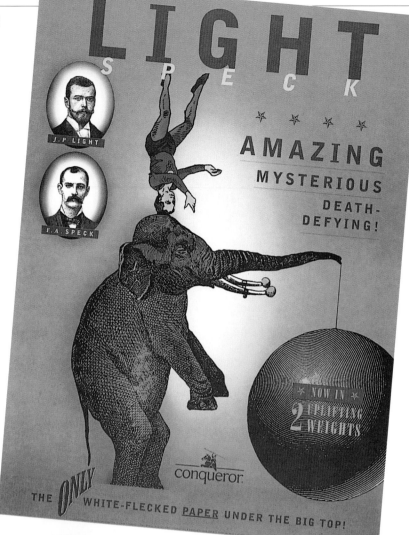

COST-SAVING TECHNIQUE The designer provided film used to make the die.

SPECIAL PRODUCTION TECHNIQUE The designer created the illustration for 20/20 by hand, then used Adobe Photoshop to integrate the scanned photograph of human eyes.

Great American Insurance
ATP Championship

presented by RELCO Resources

July 30 – August 10, 1997

Cincinnati

For Tickets
Tournament Office
(513) 651-0303
Ticketmaster
(513) 562-4949

STUDIO Design Mill

CLIENT Tennis for Charity, Inc.

ART DIRECTOR David Mill

DESIGNER David Mill

PHOTOGRAPHERS Tom Guenther, Tom Fey, Russ Adams

PREPRESS AND PRINTING The Nielsen Company

PAPER Productolith Gloss 80-lb. (230 g/m²) Text

TYPE Frutiger Bold, Frutiger Roman

COLOR Four-color process

PRINTING Offset

CONCEPT The designer had to upgrade his computer to create the image-intensive design he roughed out for his client. Existing photos of the stadium and popular players competing at a tournament provide the "hook" for tennis fans, who are already familiar with the annual championship. Unusual colors, layered imagery and an industrial style give the poster a fresh look.

COST-SAVING TECHNIQUE The designer used the same high-res photo scans provided by the printer for related collateral items, including a program cover, ticket booklets, brochures and displays.

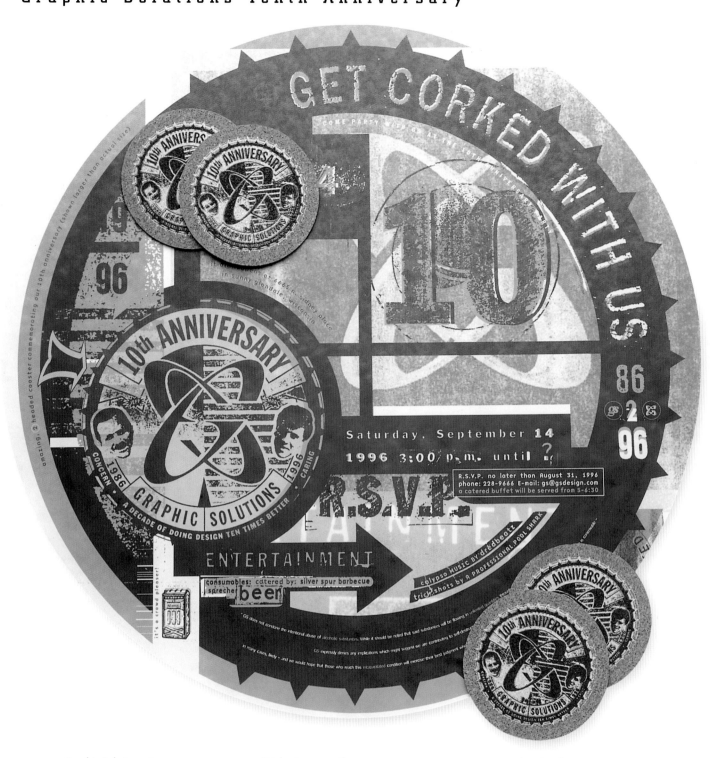

STUDIO Graphic Solutions, Inc.

CLIENT Self

ART DIRECTOR Mike Magestro

DESIGNER Mike Magestro

COASTER DESIGN Dave Kotlan

COPYWRITER Mike Spanjar

PAPER French Butcher White

TYPE Franklin Gothic (modified), Blur, Base 9 (regular and modified)

COLOR Three PMS

PRINTING Offset

CONCEPT It takes ten years, the designers learned through "unconventional" research, for a cork tree to grow one layer of cork. Graphic Solutions found this fact to be the perfect theme for invitations to its tenth anniversary bash. Real, screenprinted cork coasters adorned the round, many-layered invitation posters, punched up with snappy copy. Cost was no object, so the designer specified premium paper and a full-sized die cut.

SPECIAL VISUAL EFFECT A real cork coaster topped its own enlarged imaged.

SPECIAL PRODUCTION TECHNIQUE
The scratchy, used-coaster look was created by multiple photocopies, hand-roughing and old-fashioned cutting and pasting.

STUDIO Hal Apple Design
CLIENT Self
ART DIRECTOR Hal Apple
DESIGNER Jason Hashmi

PAPER Vicksburg Starwhite
TYPE Monolein
COLOR One PMS metallic, black
PRINTING Offset

CONCEPT This self-promotion advertises both the design firm and its Web site. The Web address is arranged so the firm's name is central, on top of the apple graphic, which compounds the visual message. The Web address is simple to read and remember; the firm's phone number, however, is not. Printed in tiny gray type at the bottom center, the phone number is there for anyone who needs it, but is not a design element. A short paragraph on the back of the poster introduces the site in more detail.

SPECIAL PRODUCTION TECHNIQUE The designer and printer tried several paper colors and metallic inks before settling on the final combination.

![http://www.halappledesign.com/halapple]

STUDIO University of Utah Graphic Design
CLIENT University of Utah
ART DIRECTOR Scott Greer
DESIGNERS Sheryl Dickert
ILLUSTRATOR Sheryl Dickert

COPYWRITER Lee Belavance
PAPER Fortune Gloss
TYPE Hotsy Totsy, Lithos
COLOR Four-color process
PRINTING Offset

CONCEPT The simple idea of linking "summer school" with a school of fish provided opportunity for fun illustrations and bright colors. It also allowed designers to allude to the university's diverse students, faculty and classes. The horizontal shape further helps the poster stand out.

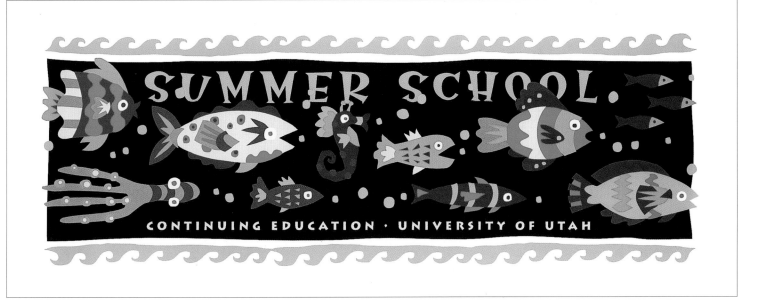

STUDIO Ted Bertz Graphic Design, Inc.

CLIENT Aetna Life Insurance and Annuity Co.

ART DIRECTORS Ted Bertz, Richard Uccello

DESIGNERS Various

PHOTOGRAPHER Frozen Images, Inc.

PAPER Productolith 80-lb. (230 g/m²) cw Dull

TYPE Bauer Bodoni, Univers

COLOR Four-color process, one PMS metallic

PRINTING Offset

CONCEPT Because many people don't like to think about financial planning, the designers used warm images and encouraging copy for a series of six posters advertising financial planning seminars. Ghosted headlines and small text keep the images paramount, while the low position of the company logo makes it stand out without detracting from the message. The red ovals call attention to the client's slogan, "Build for retirement. Manage for life."

COST-SAVING TECHNIQUES Stock photography made the posters affordable. The six posters were printed on three sheets of paper, one per side, so the customer could change images by simply turning a poster over.

STUDIO Segura Inc.

CLIENT [T-26]/Digital type foundry

ART DIRECTOR Carlos Segura

DESIGNER Carlos Segura

ILLUSTRATORS Carlos Segura, Tony Klassen, Mark Ratting, Hatch, Colin Metcalf

PHOTOGRAPHER Greg Heck

PAPER Appleton Utopia

TYPE Tema Cantante, Oculus, various [T-26] fonts

COLOR Four-color process

PRINTING Offset

CONCEPT Recalling diverse influences, from Mexican lotteria to tattoo sample cards, this poster for distinctive fonts from a digital type foundry only hints at the letters themselves. Each small square illustrates a particular font's name in an edgy style, showing the type of design for which the fonts were created. The reverse side gives a more traditional display of each font, along with ordering information.

A Morning in Washington Square

STUDIO New York University Art Department

CLIENT NYU Office of Undergraduate Admission

ART DIRECTOR NYU Advertising and Publications Department

DESIGNERS Melanie Grossberg, Allan Espiritu

PHOTOGRAPHER NYU Photo Collection

PAPER Mohawk

TYPE Avenir, Sabon

COLOR Two PMS, black

PRINTING Offset

CONCEPT This low-budget poster aimed at students combined stock photography and type in an innovative way. Purple, in several strengths, is the main color with black and green as accents.

COST-SAVING TECHNIQUE To emulate the look of a fourth color, the designers revealed the white paper in several places.

SPECIAL VISUAL EFFECT The designers created the background pattern by enlarging part of the main photo and blurring it.

"A MORNING AT WASHINGTON SQUARE"

To learn about programs offered at New York University, join us for "A Morning at Washington Square" for African American and Latino Students.

Coles Sport Center
181 Mercer Street

Friday
November 15, 1996
9:00 a.m.

For further information, call the Office of Undergraduate Admissions at (212) 998-4531.

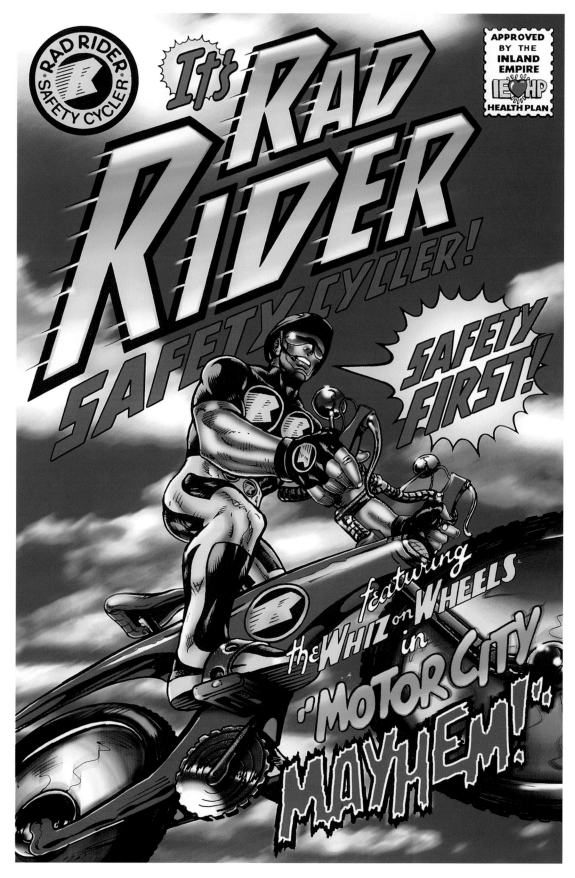

STUDIO The Dynamic Duo Studio
CLIENT Inland Empire Health Plan
AGENCY AL+Z Advertising
DESIGNER Arlen Schumer
BLACK AND WHITE ILLUSTRATOR Arlen Schumer
HAND-LETTERING Arlen Schumer
COMPUTER COLOR Sherri Wolfgang
COLOR Four-color process
PRINTING Offset

CONCEPT The insurance company client asked for a promotion for its teen-targeted bicycle safety program and got a hit character. "Rad Rider," a superhero cyclist, was based on comic book art of the 1960s. The poster does not just emulate a comic book cover, it is one — an enlargement from the twenty-page Rad Rider comic distributed at doctors' offices, health centers and hospitals. The campaign was so successful that the client has ordered a Web site and a second comic, hired an actor to dress up as Rad Rider for events, and commissioned an industrial design firm to create prototypes of Rad Rider's bike.

SPECIAL PRODUCTION TECHNIQUE In classic comic book style, black-and-white illustrations were created and lettered by hand. The art was then scanned and colored in Adobe Photoshop.

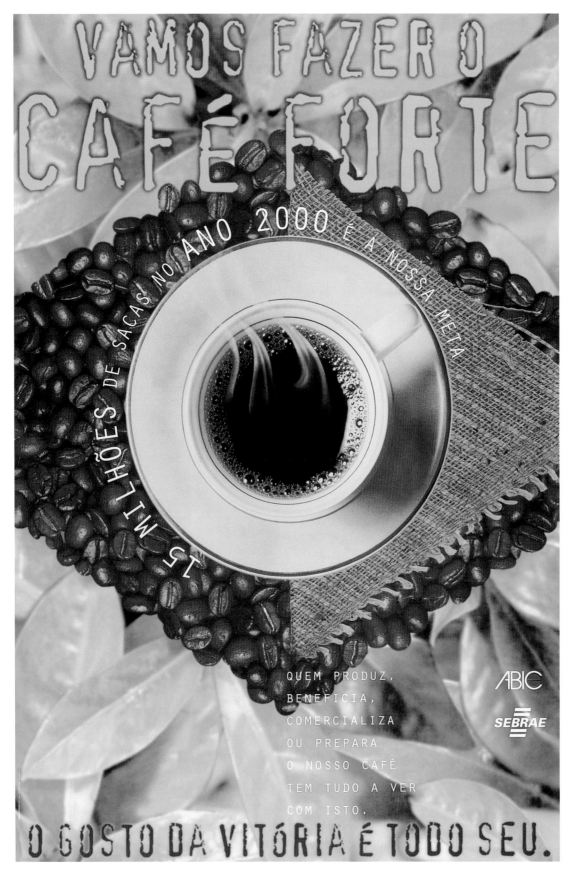

STUDIO Dupla Design

CLIENTS ABIC (a Brazilian coffee association), SEBRAF (small business service)

ART DIRECTOR Claudia Gamboa

DESIGNERS Claudia Gamboa, Ney Valle

PHOTOGRAPHERS Floriano Vieira, Image Bank

IMAGE TREATMENT Rogéro Varela

PAPER Couché 150g

TYPE Confidential, Orator

COLOR Four-color process

PRINTING Offset

CONCEPT The title, "Let's Make Coffee Strong," is meant to mobilize people to grow, roast, prepare and drink more and better coffee, both to strengthen coffee as a business and build Brazil as a nation. The image, which represents Brazil's flag, shows the stages of coffee production and focuses on the final product ready to drink.

SPECIAL VISUAL EFFECT The background began as a photograph of leaves, manipulated and repeated in Adobe Photoshop to form a pattern.

STUDIO Merge Design Inc.

CLIENT American Cancer Society

DESIGNER Michael Taylor

ILLUSTRATOR Catherine Bennett

PHOTOGRAPHY FPG stock

PAPER Monadnock Astrolite

TYPE Burnout, Alternate Gothic, Franklin Demi

COLOR Four-color process, two PMS

PRINTING Offset

CONCEPT The client wanted its skin cancer prevention campaign to have a fresh, original look that would eschew scare tactics. This series of posters uses hip humor with photos, graphics and text that even "knuckleheads" can understand.

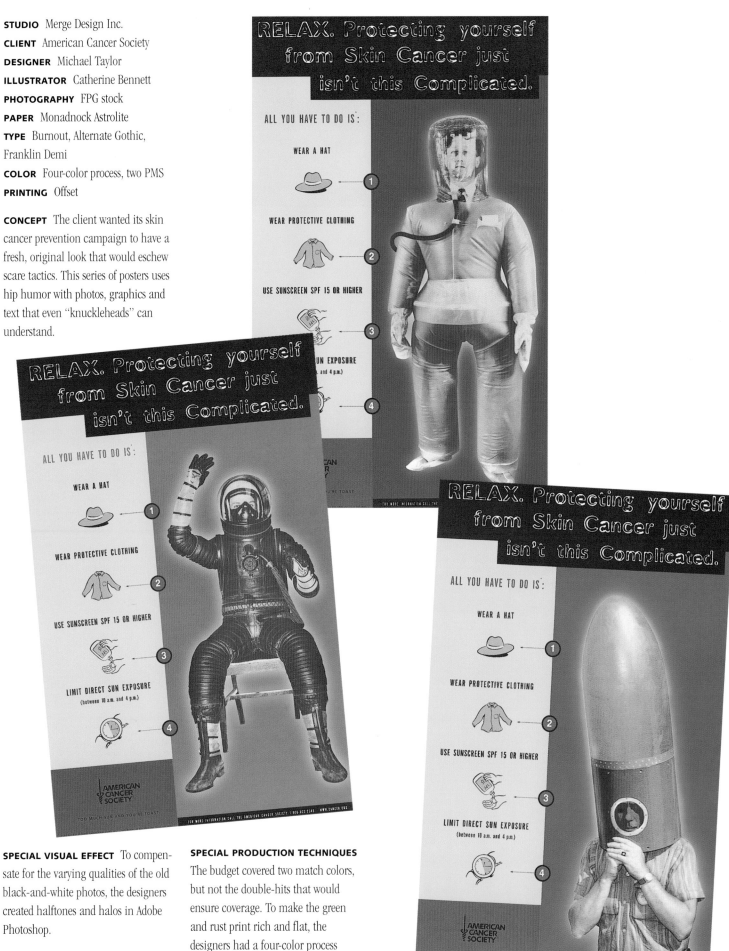

SPECIAL VISUAL EFFECT To compensate for the varying qualities of the old black-and-white photos, the designers created halftones and halos in Adobe Photoshop.

SPECIAL PRODUCTION TECHNIQUES The budget covered two match colors, but not the double-hits that would ensure coverage. To make the green and rust print rich and flat, the designers had a four-color process screen build printed under the PMS colors. The printer also prepared and adjusted the film to compensate for dot gain on the uncoated paper.

STUDIO Mires Design

CLIENT Hot Rod Hell Rod and Custom Shop

ART DIRECTOR Jose Serrano

DESIGNERS Jose Serrano, Jeff Samaripa

ILLUSTRATOR Tracy Sabin

PAPER Centura Dull 80-lb. (230 g/m²) cover

TYPE Brody, Folio Condensed

COLOR Four-color process

PRINTING Offset

CONCEPT The designers based this piece on 1950s car culture, using stereotypical imagery in an imaginative way. The shop's attention-getting name has most of the space, but the balance is given to a dynamic image and slogan. The devilish logo and explanatory copy promise a no-nonsense sort of shop for daring, no-nonsense car owners.

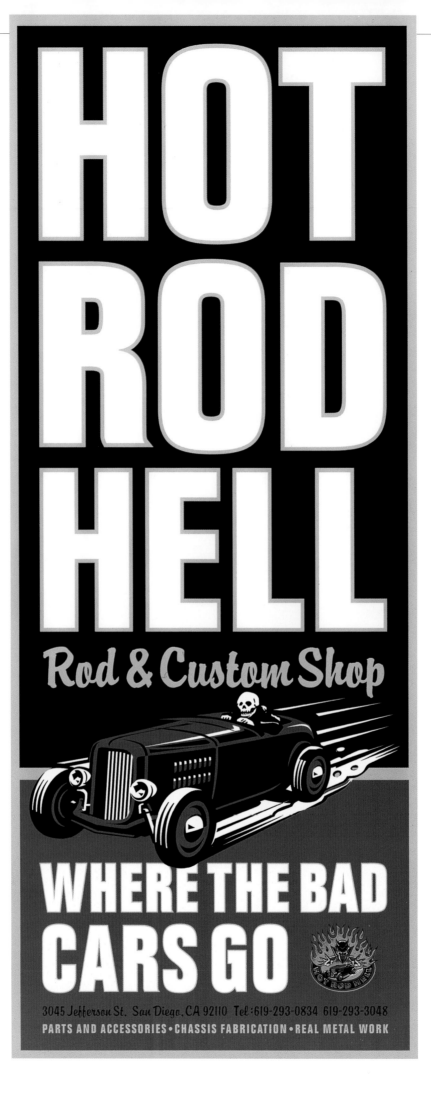

STUDIO Terry Vine Photography

CLIENT Self

ART DIRECTOR Lana Rigsby Design

DESIGNER Trisha Rausch

PHOTOGRAPHER Terry Vine

PRINTER IPP Printing

PAPER Fox River Archiva #110 Cover Plus

TYPE Helvetica Black, Garamond Italic

COLOR Five PMS, dull spot varnish

PRINTING Offset

CONCEPT This fold-out, self-promotional poster for the photographer and International Printing and Publishing doubles as a series of tear-out postcards. The evocative pictures of Europe are reproduced as tritones using numerous match grays. Spot varnish gives the pictures even greater depth. Even the back of the poster is carefully printed. The overall image of the Eiffel Tower is done in a match cream with copy in three match grays.

SPECIAL VISUAL EFFECT The piece was tied in string, with a metal tag identifying the title and photographer, and mailed in a vellum envelope.

SPECIAL PRODUCTION TECHNIQUES Each image was printed in matte inks at a 175 dpi linescreen, opened up in mid, 3/4 and shadow areas to compensate for the heavy ink density. All were printed in two match blacks plus a match gray. To get the darkest shadows black enough, a second pass through the printer dry-trapped a dark gray in key areas and applied an overall spot varnish. The edges of the postcards were also perforated.

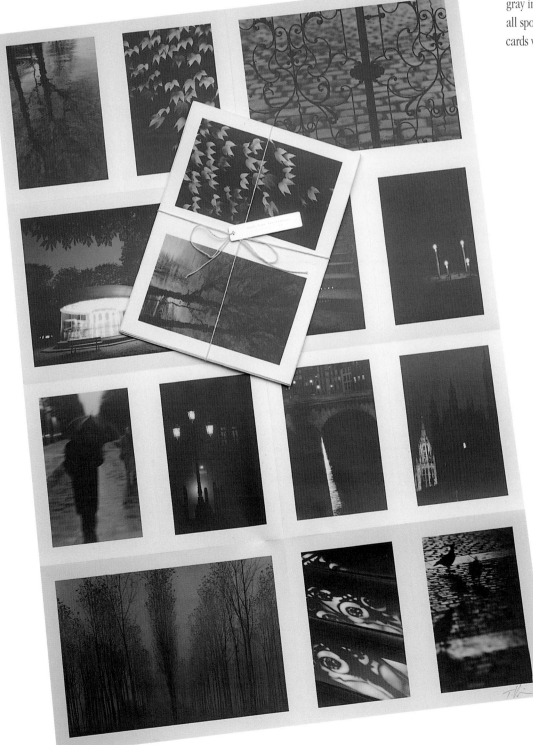

STUDIO Phinney/Bischoff Design House

CLIENT ACT Theatre

ART DIRECTOR Leslie Phinney

DESIGNER Dean Hart

ILLUSTRATOR Ed Fotheringham

PAPER Strathmore Natural White

TYPE Estro, Stone Sans, Letter Gothic

COLOR Four-color process

PRINTING Offset

CONCEPT The poster's illustration literally invites viewers to the hotel room where, it seems to promise, mayhem will ensue. The illustrator took care to recall the classic Marx Brothers film the play is based on and to depict its stars, The Flying Karamazov Brothers. Ticket and sponsor information is clear but of secondary importance.

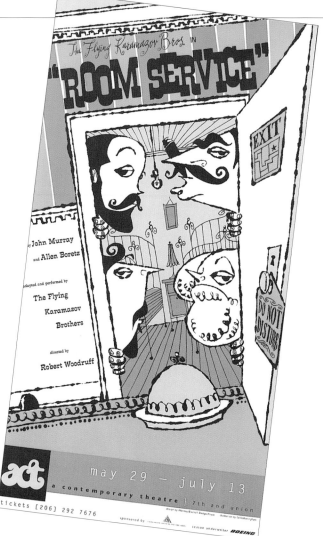

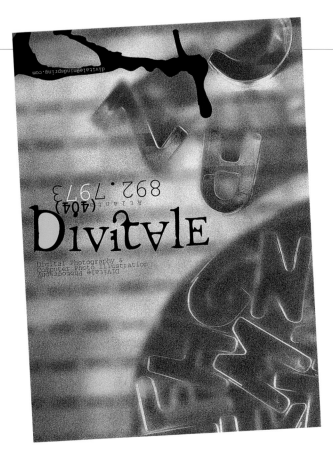

STUDIO DiVitale Photography

CLIENT Self

ART DIRECTOR Sandy DiVitale

DESIGNERS Rich Godfrey, Joanna Duryea/FUSE Inc.

PHOTO DESIGN Sandy DiVitale

PHOTOGRAPHY Jim DiVitale

PAPER Biberest Allegro Gloss 45-lb. (130 g/m²)

TYPE Various

COLOR Four-color process

PRINTING Offset

CONCEPT Originally created for a page in "Workbook's Single Image 22," the image was conceived as a way to demonstrate how the photographers understand and use type, a common concern of design firm clients. Although the type is not easy to read at first glance, the photo captures the viewer, and the pleasing type arrangement takes only an extra moment to decipher.

SPECIAL PRODUCTION TECHNIQUES To create the neon effect, the photographer changed the lights between the three exposures needed for a digital camera to create a composite image. The blotted black ink effect was created by blotting black ink on paper, scanning it and placing the image on the computer layout.

STUDIO The Leonhardt Group
CLIENT ACT Theatre
DESIGNERS Tim Young, Jon Cannell
PHOTOGRAPHER Marc Carter
PAPER Mountie Matte 65-lb.
(187 g/m²) Cover
TYPE Metropole, Gill Sans
COLOR Four-color process
PRINTING Offset

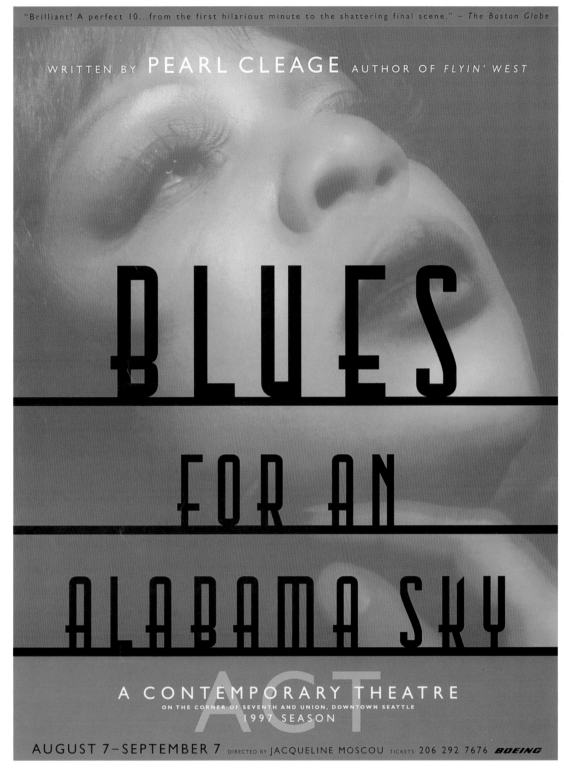

"Brilliant! A perfect 10...from the first hilarious minute to the shattering final scene." — *The Boston Globe*

WRITTEN BY PEARL CLEAGE AUTHOR OF *FLYIN' WEST*

BLUES

FOR AN

ALABAMA SKY

A CONTEMPORARY THEATRE
ON THE CORNER OF SEVENTH AND UNION, DOWNTOWN SEATTLE
1997 SEASON

AUGUST 7–SEPTEMBER 7 DIRECTED BY JACQUELINE MOSCOU TICKETS 206 292 7676 *BOEING*

CONCEPT This poster for a play grabs at its audience in several ways. The photo and deco type refer to the play's setting, the Harlem Renaissance, while the woman's facial expression hints at powerful emotions. Though taking up little space, the copy manages to include the playwright's name, the name of a previous work, a line from a great review, the important ticket information and a corporate sponsor's logo.

COST-SAVING TECHNIQUES Printing and photography were donated. Promotional postcards were printed on the same sheet as the poster.

Time/Risk

STUDIO Scorsone/Drueding

CLIENT Self

ART DIRECTORS Joe Scorsone, Alice Drueding

DESIGNERS Joe Scorsone, Alice Drueding

PAPER Cross Point Genesis, Tortoise

TYPE Agenda, Bank Gothic

COLOR Two PMS

PRINTING Offset

CONCEPT For a series of self-promotion posters, the designers focused on common life experiences to show they understood and shared their clients' problems and challenges. The simple, typographic style and bold imagery emphasize the posters' themes, while the extensive blank space gives the posters a thoughtful, quiet air that counters their stressful copy. Old-fashioned illustrations add humor.

COST-SAVING TECHNIQUE Brown paper adds a third color.

STUDIO JCPenney Co. Communications

CLIENT *Seventeen Magazine* and JCPenney Co.

DESIGNER Liz Tendall

PHOTOGRAPHER Jodi Gambill

PROJECT MANAGER Shannon Dawson

PAPER Chrome Ultra

TYPE Christmas Gift Script

COLOR Three PMS, varnish

PRINTING Offset

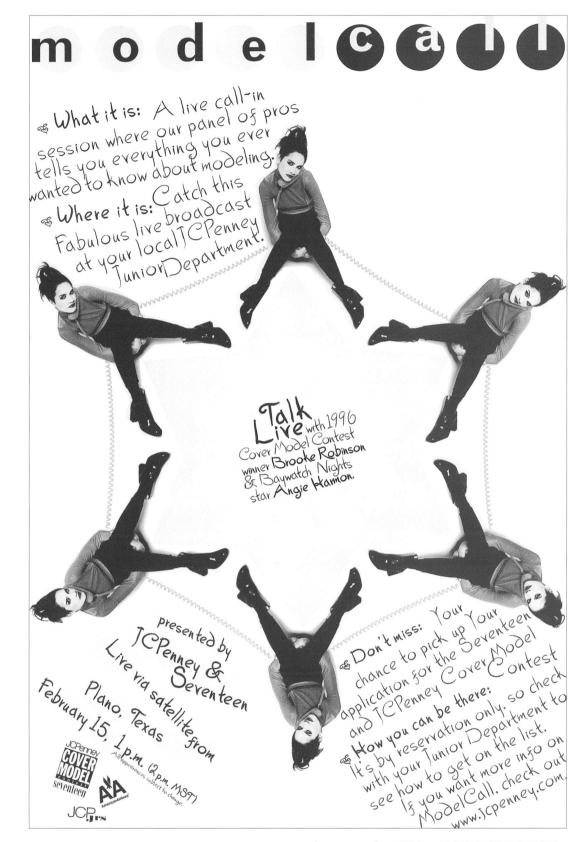

CONCEPT To capture the attention of young "junior" teenagers, the designer used brash colors, bold elements, a font that emulates youthful hand-writing and trendy styling. However, the look is grounded in history, paying a sly tribute to Busby Berkely's chorus girls.

SPECIAL PRODUCTION TECHNIQUE
A quick-drying varnish gives this piece a high gloss that adds extra crispness.

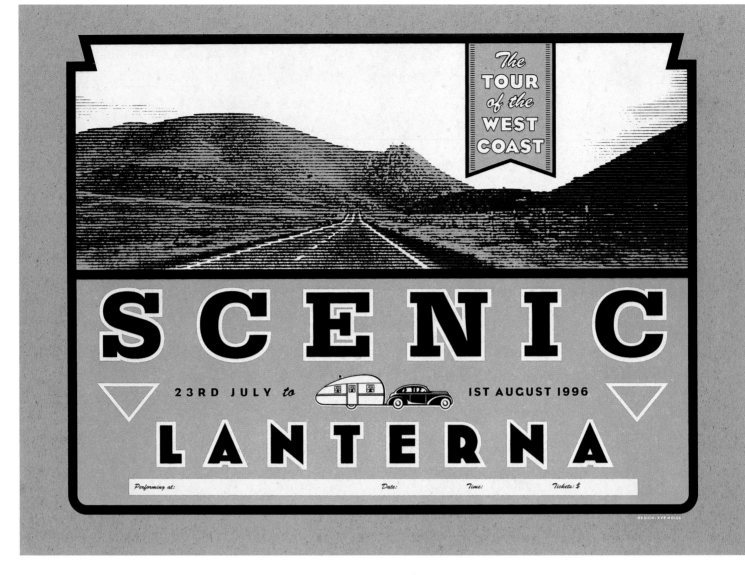

STUDIO Eye Noise

CLIENT Independent Project Records

DESIGNER Thomas Scott

PHOTOGRAPHER Bruce Licher

PAPER Chipboard

TYPE URW Egyptienne, Bovine Poster, Eagle Bold, Brush Script

COLOR Two PMS, one PMS metallic

PRINTING Screenprinting

CONCEPT This poster for instrumental rock band Scenic's first tour uses postcard imagery to create a memorable look, strikingly different from that of most band posters. The crisp lines, monochromatic color scheme and photograph of a broad vista invoke a satisfying and relaxing mood. The typography, layout, line art and frame shape all conjure up a mythical time when all travel was leisurely and all drives were "scenic."

STUDIO Odd's & End's

CLIENT Kansas City International Jazz Festival

ART DIRECTORS Shane W. Evans, Jo Boehr

DESIGNER Shane W. Evans

ILLUSTRATOR Shane W. Evans

TYPE Helvetica Compressed, Futura

COLOR Four-color process

PRINTING Offset

CONCEPT Jazz album covers from the 1950s to the 1970s were the inspiration for this poster, which relies on a striking painting to make its initial impression. Secondary emphasis is on the performers' names, but stylish rectangular boxes ensure that they're easy to read. Except for the major sponsor identified on the painting itself, sponsor logos are tiny and printed in black and white for maximum readability.

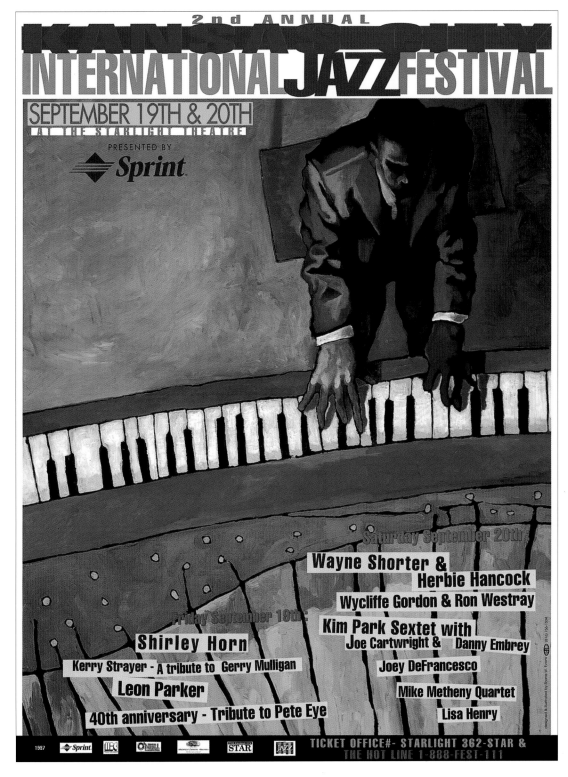

Anti-Boredom Month

STUDIO Callahan & Co.

CLIENT Self

ART DIRECTOR Gene Valle

DESIGNER Gene Valle

ILLUSTRATOR Gene Valle

COPYWRITER Elise Kolaja

PAPER Kimdura-fpg 250

TYPE Helvetica, Caslon 540

COLOR Four-color process

PRINTING Offset

CONCEPT One of a series of monthly self-promotion pieces based on unusual holidays, this poster was designed to be displayed or made into a hat. The type, diagrams and photographs were meant to look attractive in either incarnation. This self-promotion worked on several levels. Like all posters, it was meant to be hung on a wall, but not all recipients keep or display posters. For them, this piece offered a fun and memorable diversion from a busy day.

COST-SAVING TECHNIQUE Designers used paper left over from another job, and employees trimmed posters and stuffed mailing tubes.

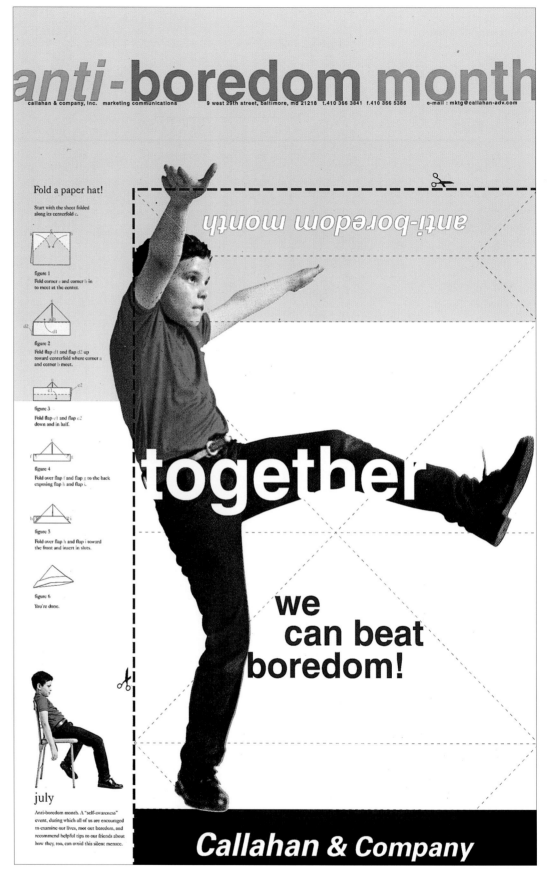

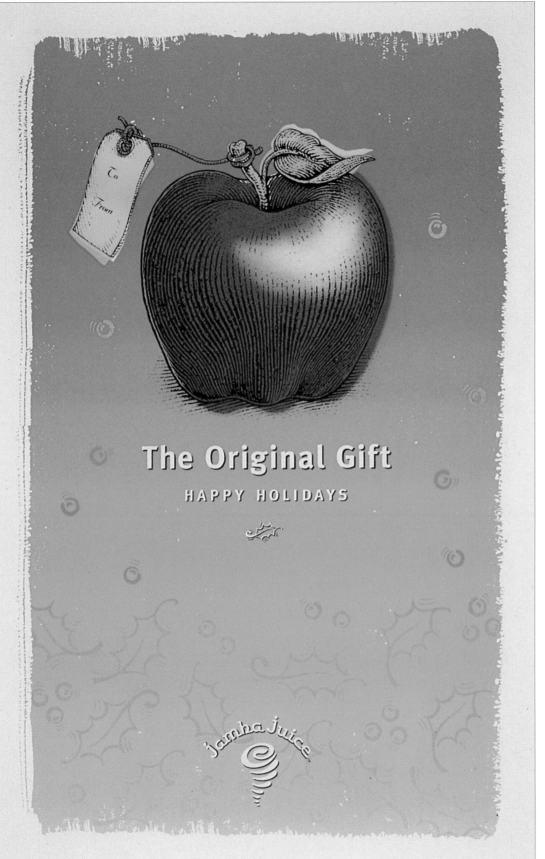

STUDIO Hornall Anderson Design Works, Inc.

CLIENT Jamba Juice

ART DIRECTOR Jack Anderson

DESIGNERS Jack Anderson, Lisa Cerveny, Suzanne Haddon

ILLUSTRATOR Abe Girvin, Mits Katayama

PAPER French Speckletone

TYPE Meta, Bembo

COLOR Six PMS

PRINTING Screenprinting

CONCEPT This amusing poster for a company selling juices and fruit smoothies was one of a series of three, all part of a marketing effort to develop the company's identity as "the authority on juice and nutrition." The design objectives were to be festive and fun, but not trendy. Bright colors and friendly typefaces make the poster playful, while the central image and high-quality printing give it sophistication.

SPECIAL PRODUCTION TECHNIQUE Graded color in both background and overall pattern adds distinction.

Polo

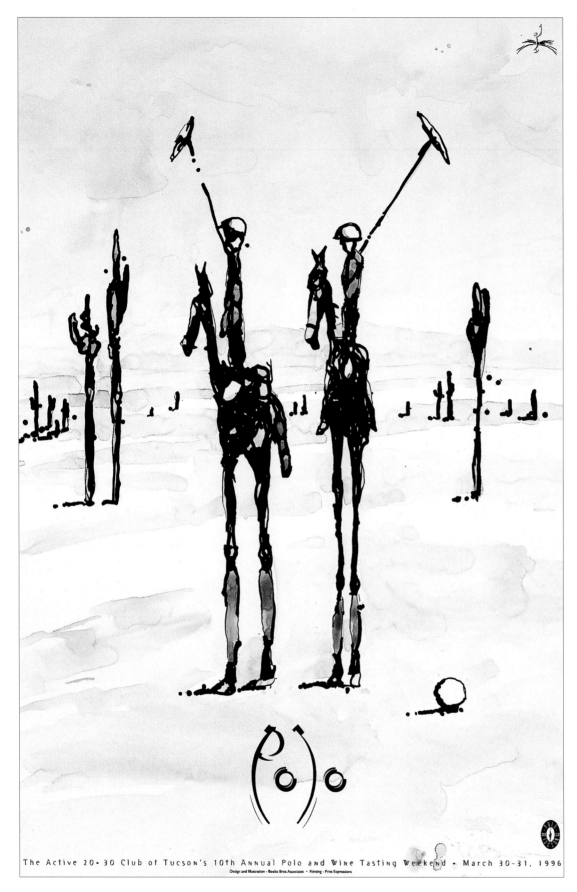

The Active 20-30 Club of Tucson's 10th Annual Polo and Wine Tasting Weekend · March 30-31, 1996

Design and Illustration · Boelts Bros.Associates · Printing · Print Expressions

STUDIO Boeltz Bros. Associates

CLIENT 20/30 Club of Tucson

ART DIRECTORS Eric Boelts, Kerry Stratford

DESIGNER Jackson Boelts

ILLUSTRATOR Jackson Boelts

PRODUCTION Deanne Perry

PAPER Productolith

TYPE Hand-constructed

COLOR Four-color process

PRINTING Offset

CONCEPT If Picasso had painted Don Quixote and Sancho Panza playing polo in the American Southwest, he might have produced this illustration. The desert inspired this piece, which advertises a polo and wine-tasting weekend for a Tucson polo club. The arresting image, an inkblotter and watercolor painting, takes up all but an inch of the paper, which lists only the event name and date.

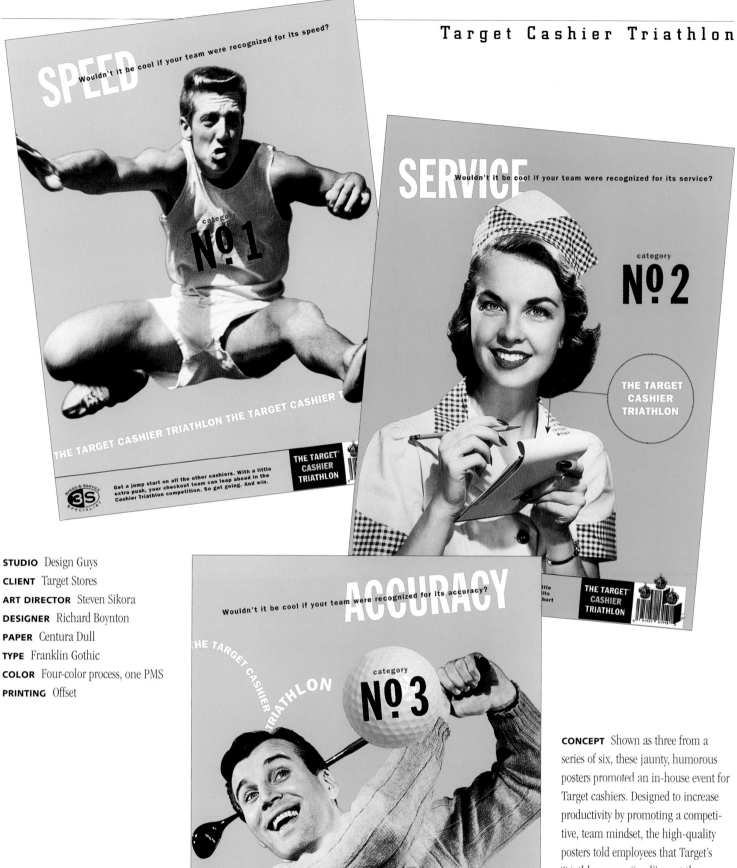

STUDIO Design Guys

CLIENT Target Stores

ART DIRECTOR Steven Sikora

DESIGNER Richard Boynton

PAPER Centura Dull

TYPE Franklin Gothic

COLOR Four-color process, one PMS

PRINTING Offset

CONCEPT Shown as three from a series of six, these jaunty, humorous posters promoted an in-house event for Target cashiers. Designed to increase productivity by promoting a competitive, team mindset, the high-quality posters told employees that Target's Triathlon was a "real" event they should aspire to win, not a Dilbert-style management tactic. Copy identified the contest categories, six important goals for the cashiers in their work.

COST-SAVING TECHNIQUE The designers used stock photography CDs for their imagery.

STUDIO Graphic Solutions Inc.

CLIENT Thresholds Psychiatric Rehabilitation Centers

ART DIRECTOR Steven Radtke

DESIGNER Steven Radtke

PHOTOGRAPHER John Laptad

PRINTING/SEPARATIONS Burton & Mayer, Inc.

COPYWRITER Mark Spanjar

PAPER Centura Gloss 100-lb. (288 g/m²) Text

TYPE Platelet, Suburban

COLOR Four-color process

PRINTING Offset

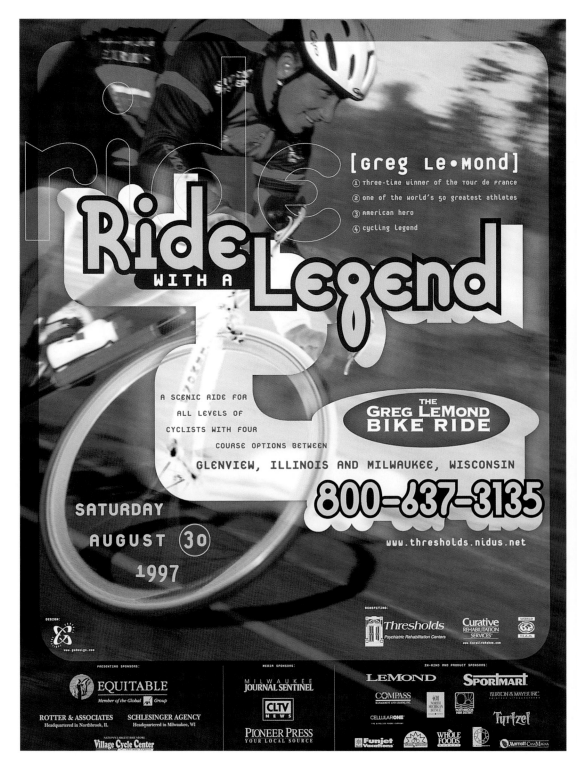

CONCEPT Neon colors grab attention, while the placement of the photo of road racer Greg LeMond, the headline and the event's title ("The Greg LeMond Bike Ride") hook the target audience. Dynamic styling and mod typefaces also match the profile of young, fit and hip road racing enthusiasts. The bottom four inches are devoted to sponsor logos, printed in gray to lessen their overall impact without sacrificing recognition. The design, created to help bring a fresh look to the growing regional event, was also used in ads and T-shirts, and helped the ride get record attendance.

COST-SAVING TECHNIQUE Design, prepress and printing were all donated.

SPECIAL VISUAL EFFECTS The designer altered the color spectrum in Adobe Photoshop to achieve the edgy look and "blew out" much of the photo's details to get more pure color.

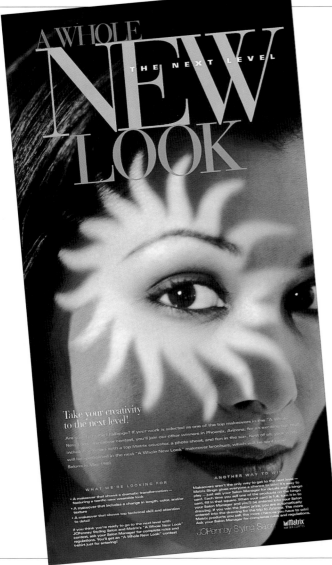

STUDIO JCPenney Co. Communications

CLIENT JCPenney Styling Salon/Matrix

ART DIRECTOR JCPenney Co. Communications

DESIGNER Tim Asher

PHOTOGRAPHER Jodi Gambill

HAIR/MAKEUP Jeffrey Martin

COPYWRITER Shannon Dawson

PAPER Fortune Gloss Book 100-lb. (288 g/m²)

TYPE Bauer Bodoni, Univers Extended

COLOR Three PMS

PRINTING Offset

CONCEPT The imagery for this poster for a makeover contest features both key elements: the contest's subject and prize. The model, photographed by in-house photographers, is positioned on the page so that most of her face is covered or hidden, suggesting a makeover without defining a particular look. The central sunburst symbolizes the prize, a trip to Phoenix, often called "The Valley of the Sun."

STUDIO Automatic Art and Design

CLIENT Prototype

ART DIRECTOR Charles Wilkin

DESIGNER Charles Wilkin

ILLUSTRATOR Charles Wilkin

POET Megan Crawford

PAPER Cross Point Aquarius

TYPE Pink Outlink, Interstate 60, Superchunk

COLOR Two PMS

PRINTING Offset

CONCEPT Designed to advertise a type foundry's Web site, this two-sided poster is meant to pose the question: "What type are you?" In keeping with the disquieting design style best suited to the fonts, however, it asks the question indirectly, without words. One side features a short, harsh poem displaying a font modeled on the kind of untrained, decorative printing done by adolescents. The other displays a collage with the contact information squeezed into a vertical space in the lower left corner. The design is a test: If you don't want to go to that much work, you probably don't want these fonts.

STUDIO Mark Oldach Design, Ltd.

CLIENT The Educational Foundation
of the National Restaurant Association

ART DIRECTOR Mark Oldach

DESIGNER Guido Mendez

ILLUSTRATOR Chris Lensch

TYPE Univers, Berling, Imago

COLOR Four-color process

PRINTING Offset

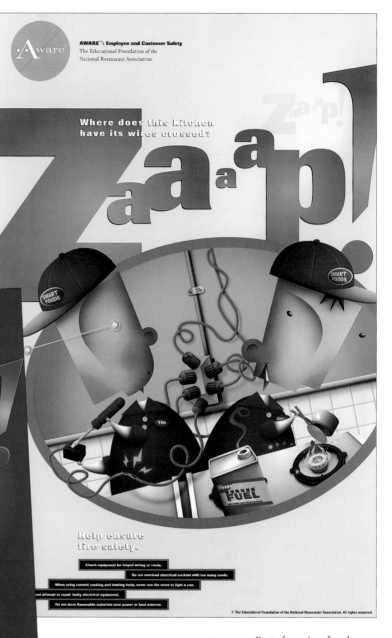

CONCEPT Part of a series of twelve safety posters for restaurants, these feature humorous illustrations aimed at catching the eye of employees. Each poster features a "what's wrong with this picture?" illustration, headline word and catchy phrase that together communicate the idea in a glance. Specific instructions appear at the bottom — one short sentence for each rectangle.

STUDIO Team One Advertising

CLIENT Lexus

ART DIRECTOR Alec Vianu

ILLUSTRATOR Michael Schwab

DESIGN DIRECTOR Scott Bremner

TYPE Gill Sans

COLOR Four PMS

PRINTING Screenprinting

CONCEPT For this poster advertising a team for a pro-skiing world tour, the designer chose a classic 1930s European style to fit the luxury image of both the company and the sport. Lexus requested that all team members be given equal treatment, so they are depicted as heroic figures with no individual features. Their names and home countries are listed on the border along with the tour's dates.

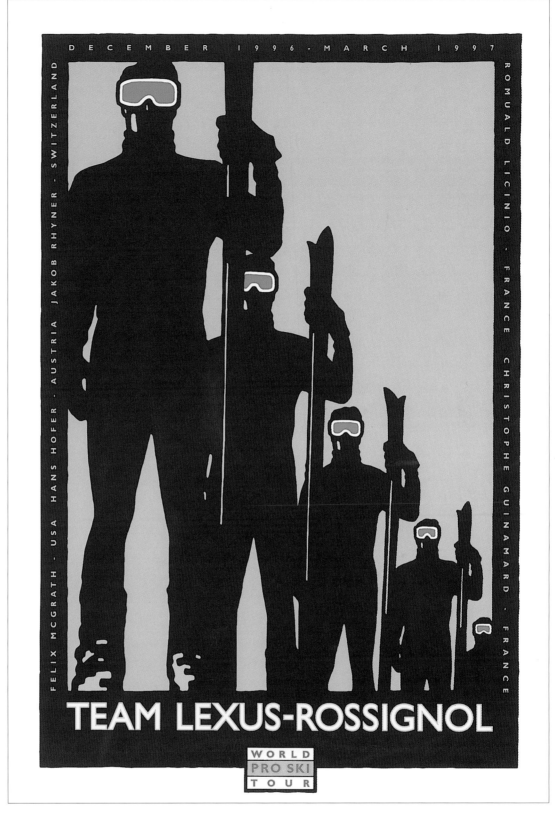

Strike a Match

STUDIO Vaughn Wedeen Creative

CLIENT/SERVICE US West
Communications

ART DIRECTOR Steve Wedeen

DESIGNERS Steve Wedeen, Adabel
Kaskiewicz

COMPUTER PRODUCTION Adabel
Kaskiewicz

TYPE Futura

COLOR Eight PMS

PRINTING Screenprinting

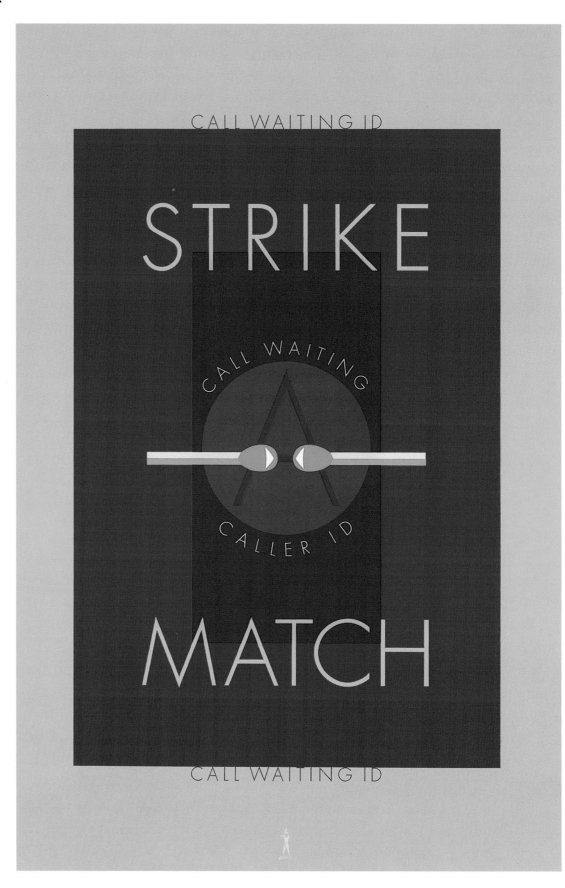

CONCEPT Heat was the theme that tied this striking poster to the company's year-long international sales promotion, "Heat it Up." The poster urged sales staff to sell two matching tele-phone service products, caller ID and call waiting. The meaning may not be immediately clear to the general public, but because it was meant for internal sales, it didn't have to be.

SPECIAL VISUAL EFFECTS The simple geometric design emphasizes the brilliance of the screenprinting inks.

studio directory

1185 Design
119 University Avenue
Palo Alto, CA 94301

30sixty design, inc.
2801 Cahuenga Blvd. West
Los Angeles, CA 90068

A-Hill Design
121 Tijeras NE, Suite 2200
Albuquerque, NM 87102

After Hours Creative
1201 East Jefferson, Suite B-100
Phoenix, AZ 85034

Hal Apple Design
1112 Ocean Drive #203
Manhattan Beach, CA 90266

The Atlantic Group
63 Glover Avenue
Norwalk, CT 06850

Automatic Art and Design
2318 N. High Street, #9
Columbus, OH 43202

Back Yard Design
211 East 49th Street
New York, NY 10017

Ted Bertz Graphic Design, Inc.
190 Washington Street
Middletown, CT 06457

Boelts Bros. Associates
345 E. University
Tucson, AZ 85705

Bradbury Design Inc.
#330-1933 8th Avenue
Regina, SK S4R 1E9
Canada

Brown Design
6204 N. Tuxedo
Indianapolis, IN 46220

Bullet Communications, Inc.
200 S. Midland Avenue
Joliet, IL 60436

C3 Incorporated
419 Park Ave. South
New York, NY 10016

Callahan & Co.
9 West 29th Street
Baltimore, MD 21218

Canary Studios
600 Grand Avenue, Suite 307
Oakland, CA 94610

Todd Childers
407 N. Main Street
Bowling Green, OH 43402

Communication Arts Company
P.O. Box 175
Jackson, MS 39205-0175

Communication Via Design
437 D Street, Suite 4B
Boston, MA 02210

Crain Communications
1400 Woodbridge Avenue
Detroit, MI 48207

Curry Design, Inc.
1501 S. Main Street
Venice, CA 90291

Paul Davis
14 East 4th Street
New York, NY 10012

Design Guys
119 North Fourth Street, #400
Minneapolis, MN 55401

Design Mill
19 Garfield Place, Suite 422
Cincinnati, OH 45202

Designation Inc.
53 Spring Street
New York, NY 10012

Drive Communications
133 West 19th Street, 5th Floor
New York, NY 10011

Dupla Design
Rua Gaviao Peixoto
183/sala 1403 Icaraí
Niterói (RJ) 24-230-091
Brazil

The Dynamic Duo Studio
95 Kings Highway South
Westport, CT 06880

Elena Design
3024 Old Orchard Lane
Bedford, TX 76021

Eye Noise
3300 Renlee Place
Orlando, FL 32803

Philip Fass
1310 State Street
Cedar Falls, IA 50613-4128

Foundation
1715 East Olive Way, Top Floor
Seattle, WA 98102

Free-Range Chicken Ranch
330 A East Campbell
Campbell, CA 95008

Fullburner Design
5808 Pimlico Road
Baltimore, MD 21209

FUSE
775 Laguna Canyon Road
Laguna Beach, CA 92651

FUSE, Inc.
483 Moreland Avenue NE, #4
Atlanta, GA 30307

Gardner Design
3204 E. Douglas
Wichita, KS 67208

J. Graham Hanson Design
307 E. 89 Street, No. 6G
New York, NY 10128

Grafik Communications, Ltd.
1199 N. Fairfax Street, Suite 700
Alexandria, VA 22314

Graphic Solutions, Inc.
6665 N. Sidney Place
Milwaukee, WI 53209

Greteman Group
142 N. Mosley
Wichita, KS 67202

Wendy Hemphill
655 Central Ave. Apt. 2A
Highland Park, IL 60035

Hornall Anderson Design Works, Inc.
1008 Western Avenue, Suite 600
Seattle, WA 98104

Ingalls Moranville Advertising
530 Bush Street
San Francisco, CA 94108

Ingalls one to one marketing
One Design Center Place
Boston, MA 02210

Insight Design Communications
322 S. Mosley
Wichita, KS 67202

JCPenney Co. Communications
6501 Legacy Drive
Plano, TX 75024-3698

Jendras Design
1 Riverside Road, Suite 3A
Riverside, IL 60546

Keiler & Co.
304 Main Street
Farmington, CT 06032

Ellen Kendrick Creative, Inc.
6646 Garlinghouse Lane
Dallas, TX 75252

Klassen Graphic Designs
5524 Bee Caves Road, Suite D-2
Austin, TX 78746

Labbé Design Co.
606½ Larkspur Avenue
Corona del Mar, CA 92625

Jeffrey Leder Inc.
200 Varick Street, Suite 902
New York, NY 10014

The Leonhardt Group
1218 3rd Avenue, No. 620
Seattle, WA 98101

Lightner Design
9730 SW Cynthia Street
Beaverton, OR 97008

David Lomeli
818 Crescent Dr.
Vista, CA 92084

Lorig Design
22431 30th Avenue South
Des Moines, WA 98198

Love Packaging Group
410 E. 37th Street North
Wichita, KS 67219

May + Co.
5401 North Central Expressway #325
Dallas, TX 75205

Merge Design Inc.
1708 Peachtree Street, Suite 100
Atlanta, GA 30309

Mires Design
2345 Kettner Blvd.
San Diego, CA 92101

Miriello Grafico, Inc.
419 West G Street
San Diego, CA 92101

Stewart Monderer Design, Inc.
10 Thacher Street, Suite 112
Boston, MA 02113

Morla Design
463 Bryant Street
San Francisco, CA 94107

New York University Art Department
25 W. 4th Street
New York, NY 10012

Kiku Obata & Co.
5585 Pershing Avenue, Suite 240
St. Louis, MO 63112

Odd's & End's
4032 Holmes Street
Kansas City, MO 64110

Oh Boy, A Design Company
49 Geary Street, Suite 530
San Francisco, CA 94108

Mark Oldach Design, Ltd.
3316 N. Lincoln Avenue
Chicago, IL 60657

Pea Pod Creative
2720 Steppig Road
Columbia, IL 62236

Pensaré Design Group Ltd.
729 15th Street NW, 2nd Floor
Washington, DC 20005

Perfectly Round Productions
322 S. Mosley
Wichita, KS 67202

Philographica, Inc.
32 Pearl Street
Cambridge, MA 02139

Phinney/Bischoff Design House
614 Boylston Avenue East
Seattle, WA 98102

Pollard Creative
1431 Lanier Place
Atlanta, GA 30306

Rauscher Design Inc.
1501 Story Avenue
Louisville, KY 40206

Andrea Rutherford
Unit 8, 102 Park Street
St. Kilda, Victoria 3182
Australia

Sayles Graphic Design
308 Eighth Street
Des Moines, IO 50309

Toni Schowalter Design
1133 Broadway, Suite 1610
New York, NY 10010

Scorsone/Drueding
212 Greenwood Avenue
Jenkintown, PA 19046

Segura Inc.
1110 N. Milwaukee Avenue
Chicago, IL 60622-4017

Shapiro Design Associates Inc.
10 E. 40th Street
New York, NY 10016

Shelby Designs & Illustrates
155 Filbert Street, Suite 216
Oakland, CA 94607

Sibley/Peteet Design
3232 McKinney Avenue, Suite 1200
Dallas, TX 75204

Smart Works Pty. Ltd.
113 Ferrars Street
Southbank, Victoria 3006
Australia

Smith & Jones
76 Webster Street
Worcester, MA 01603

Smullen Design Inc.
85 N. Raymond Avenue, Suite 280
Pasadena, CA 91103

Sommese Design
481 Glenn Road
State College, PA 16803

Sonderby Design
219 Clayton Street
San Francisco, CA 94117

D.J. Stout
P.O. Box 1569
Austin, TX 78767

T.P. Design, Inc.
7007 Eagle Watch Court
Stone Mountain, GA 30087

Team One Advertising
1960 E. Grand Avenue, Suite 700
El Segundo, CA 90245

Teikna
366 Adelaide Street East, #541
Toronto, Ontario M5A 3X9
Canada

Scott Thares Design
5408 Emerson Avenue South
Minneapolis, MN 55419

The Traver Company
80 Vine Street, #202
Seattle, WA 98121

Uncommon Design
6805 Mayfair Road
Laurel, MD 20707

University of Utah Graphic Design
1901 E. South Campus Drive
Salt Lake City, UT 84112-9359

Vaughn Wedeen Creative
407 Rio Grande NW
Albuquerque, NM 87104

Terry Vine Photography
2417 Bartlett
Houston, TX 77098

Johnny Vitorovich
17 E. Bellefonte Avenue, Apt. 203
Alexandria, VA 22301

Viva Dolan Communications + Design
1216 Yonge Street, Suite 203
Toronto, ON M4T 1W1
Canada

Vrontikis Design Office
2021 Pontius Avenue
Los Angeles, CA 90025

Nancy Yeasting Design
1819 Grandview Drive
Victoria, BC V8N 2T8
Canada

permissions and credits

P. 9 © Back Yard Design.
Used by permission.

P. 10 © 30sixty design, inc.
Used by permission.

P. 11 © Ingalls one to one marketing.
Used by permission.

P. 11 © Mires Design.
Used by permission.

P. 12 © Smart Works Pty. Ltd.
Used by permission.

P. 13 © The Atlantic Group.
Used by permission.

P. 14 © Lightner Design.
Used by permission.

P. 15 © Wendy Hemphill.
Used by permission.

P. 16 © Pea Pod Creative.
Used by permission.

P. 17 © Uncommon Design.
Used by permission.

P. 17 © Shelby Designs & Illustrates.
Used by permission.

P. 18 © Ingalls Moranville Advertising.
Used by permission.

P. 19 © Design Guys.
Used by permission.

P. 20 © Stewart Monderer Design, Inc.
Used by permission.

P. 21 © Gardner Design.
Used by permission.

P. 22 © Crain Communications.
Used by permission.

P. 23 © Designation Inc.
Used by permission.

P. 23 © Oh Boy, A Design Company.
Used by permission

P. 24 © Insight Design
Communications.
Used by permission..

P. 26 © Andrea Rutherford.
Used by permission.

P. 27 © A-Hill Design.
Used by permission.

P. 28 © Shelby Designs & Illustrates.
Used by permission.

P. 29 © Labbé Design Co.
Used by permission.

P. 30 © Brown Design.
Used by permission.

P. 31 © Shapiro Design Associates Inc.
Used by permission.

P. 31 © Jendras Design.
Used by permission.

P. 32 © Keiler & Co.
Used by permission.

P. 33 © Sibley/Peteet Design.
Used by permission.

P. 34 © Sibley/Peteet Design.
Used by permission.

P. 35 © Pollard Creative.
Used by permission.

P. 36 © David Lomeli.
Used by permission.

P. 37 © Scott Thares Design.
Used by permission.

P. 38 © Ellen Kendrick Creative, Inc.
Used by permission.

P. 39 © Nancy Yeasting Design.
Used by permission.

P. 39 © Lightner Design.
Used by permission.

P. 40 © Fullburner Design.
Used by permission.

P. 42 © Vaughn Wedeen Creative.
Used by permission.

P. 43 © Kiku Obata & Co.
Used by permission.

P. 44 © Design Guys.
Used by permission.

P. 45 © Shelby Designs & Illustrates.
Used by permission.

P. 45 © Mark Oldach Design, Ltd.
Used by permission.

P. 46 © Klassen Graphic Designs.
Used by permission.

P. 47 © Sayles Graphic Design.
Used by permission.

P. 48 © Greteman Group.
Used by permission.

P. 49 © The Traver Company.
Used by permission.

P. 50 © Smith & Jones.
Used by permission.

P. 51 © Kiku Obata & Co.
Used by permission.

P. 51 © Grafik Communications, Ltd.
Used by permission.

P. 52 © After Hours Creative.
Used by permission.

P. 53 © Bradbury Design Inc.
Used by permission.

P. 55 © Dupla Design.
Used by permission.

P. 56 © Sayles Graphic Design.
Used by permission.

P. 57 © Boelts Bros. Associates.
Used by permission.

P. 58 © Foundation.
Used by permission.

P. 59 © Smullen Design Inc.
Used by permission.

P. 60 © Love Packaging Group.
Used by permission.

P. 61 © Curry Design, Inc.
Used by permission.

P. 62 © The Traver Company.
Used by permission.

P. 63 © Bullet Communications, Inc.
Used by permission.

P. 63 © 1185 Design.
Used by permission.

P. 64 © Graphic Solutions, Inc.
Used by permission.

P. 65 © Sayles Graphic Design.
Used by permission.

P. 66 © Vrontikis Design Office.
Used by permission.

P. 67 © JCPenney Co.
Communications.
Used by permission.

P. 68 © Rauscher Design Inc.
Used by permission.

P. 69 © Insight Design
Communications.
Used by permission.

P. 69 © Bradbury Design Inc.
Used by permission.

P. 70 © Design Guys.
Used by permission.

P. 71 © Sayles Graphic Design.
Used by permission.

P. 73 © Foundation.
Used by permission.

P. 74 © Communication Arts
Company.
Used by permission.

P. 74 © Sonderby Design.
Used by permission.

P. 75 © May + Co.
Used by permission.

P. 76 © Sibley/Peteet Design.
Used by permission.

P. 77 © Odd's & End's.
Used by permission.

permissions and credits

P. 77 © Toni Schowalter Design.
Used by permission.

P. 78 © Teikna.
Used by permission.

P. 79 © Johnny Vitorovich.
Used by permission.

P. 80 © Philographica, Inc.
Used by permission.

P. 81 © Smart Works Pty. Ltd.
Used by permission.

P. 81 © Elena Design.
Used by permission.

P. 82 © Vaughn Wedeen Creative.
Used by permission.

P. 83 © Vaughn Wedeen Creative.
Used by permission.

P. 84 © Boelts Bros. Associates.
Used by permission.

P. 84 © Canary Studios.
Used by permission.

P. 85 © Philip Fass.
Used by permission.

P. 87 © Jeffrey Leder Inc.
Used by permission.

P. 88 © Communication Via Design.
Used by permission.

P. 89 © FUSE.
Used by permission.

P. 90 © C3 Incorporated.
Used by permission.

P. 91 © Pensaré Design Group Ltd.
Used by permission.

P. 91 © A-Hill Design.
Used by permission.

P. 92 © Keiler & Co.
Used by permission.

P. 93 © Eye Noise.
Used by permission.

P. 94 © Drive Communications.
Used by permission.

P. 96 © D.J. Stout.
Used by permission.

P. 97 © Lorig Design.
Used by permission.

P. 98 © Mark Oldach Design, Ltd.
Used by permission.

P. 99 © Paul Davis.
Used by permission.

P. 100 © Keiler & Co.
Used by permission.

P. 100 © University of Utah
Graphic Design.
Used by permission.

P. 101 © Kiku Obata & Co.
Used by permission.

P. 102 © Miriello Grafico, Inc.
Used by permission.

P. 103 © T.P. Design, Inc.
Used by permission.

P. 104 © Sayles Graphic Design.
Used by permission.

P. 105 © Philip Fass.
Used by permission.

P. 106 © Gardner Design.
Used by permission.

P. 107 © Todd Childers.
Used by permission.

P. 107 © Sommese Design.
Used by permission.

P. 108 © J. Graham Hanson Design.
Used by permission.

P. 108 © Photodisk, Inc.
Used by permission.

P. 110 © Free-Range Chicken Ranch.
Used by permission.

P. 111 © Morla Design.
Used by permission.

P. 112 © Viva Dolan
Communications + Design.
Used by permission.

P. 113 © Design Mill.
Used by permission.

P. 114 © Graphic Solutions, Inc.
Used by permission.

P. 115 © Hal Apple Design.
Used by permission.

P. 115 © University of Utah
Graphic Design.
Used by permission.

P. 116 © Ted Bertz Graphic
Design, Inc.
Used by permission.

P. 117 © SEGURA INC.
Used by permission.

P. 118 © New York University
Art Department.
Used by permission.

P. 119 © The Dynamic Duo Studio.
Used by permission.

P. 120 © Dupla Design.
Used by permission.

P. 121 © Merge Design Inc.
Used by permission.

P. 122 © Mires Design.
Used by permission.

P. 123 © Terry Vine Photography.
Used by permission.

P. 124 © Phinney/Bischoff
Design House.
Used by permission.

P. 124 © DiVitale Photography.
Used by permission.

P. 125 © The Leonhardt Group.
Used by permission.

P. 126 © Scorsone/Drueding.
Used by permission.

P. 127 © JCPenney Co.
Communications.
Used by permission.

P. 128 © Eye Noise.
Used by permission.

P. 129 © Odd's & End's.
Used by permission.

P. 130 © Callahan & Co.
Used by permission.

P. 131 © Hornall Anderson
Design Works, Inc.
Used by permission.

P. 132 © Boelts Bros. Associates.
Used by permission.

P. 133 © Design Guys.
Used by permission.

P. 134 © Graphic Solutions, Inc.
Used by permission.

P. 135 © JCPenney Co.
Communications.
Used by permission.

P. 135 © Automatic Art and Design.
Used by permission.

P. 136 © Mark Oldach Design, Ltd.
Used by permission.

P. 137 © Team One Advertising.
Used by permission.

P. 138 © Vaughn Wedeen Creative.
Used by permission.

index of design firms